ANGLO-SAXON
CRAFTS

ANGLO-SAXON CRAFTS

KEVIN LEAHY

TEMPUS

First published 2003

Tempus Publishing Ltd
The Mill, Brimscombe Port
Stroud, Gloucestershire GL5 2QG

British Library Cataloguing in Publication Data.
A catalogue record for this book is available from the British Library.

ISBN 0 7524 2904 3

Typesetting and origination by Tempus Publishing.
Printed in Great Britain by Midway Colour Print, Wiltshire

CONTENTS

For my parents
Tim and Rosemary Leahy

ACKNOWLEDGEMENTS

Firstly I must acknowledge the work of the many people on whose publications this review is based. I have always believed that one's own work is only enhanced by giving due credit to others and, while I appreciate the value of omitting all of the *ibids.* and *op.cits.* which litter academic publications, I feel uncomfortable in not directly acknowledging the work of colleagues. Some people have been particularly helpful and must be acknowledged. Penny Walton Rogers was a great help in preparing the section on textiles, correcting my errors and adding new material; Angela Evans helped obtain the illustrations from the British Museum. The staff at the York Archaeological Trust were unfailingly helpful. Joanne Turner of the Dumfries Museum provided information on the Stidriggs hoard. Other people are acknowledged with the illustrations that they kindly provided.

The major sources on which this study was based are included in the bibliography. These are excellent publications of which I have only been able to give a synopsis and I strongly recommend anyone who wants to look further at the topics discussed to consult them. All are clearly written and well illustrated. A number of people assisted with the drawings and illustrations used in this book; my colleagues Mike Hemblade and Steve Thompson gave their own time to help with the digital images. Mike also helped check the text. Rachel Gardner and my wife, Dianne, also assisted with this necessary, but onerous task. As is always the case, any remaining errors must be attributed only to me.

INTRODUCTION

'Craft' is a word that the Anglo-Saxons themselves would have understood, *cræft* in Old English meaning strength or skill. The strength we can now only recognise indirectly – someone felled the trees, dug the ore or pumped the bellows; craft we can see in the thousands of objects that have come down to us from the Anglo-Saxon period. This book will review the evidence for how these objects were made, the materials employed, and the tools used.

Some important aspects of Anglo-Saxon life are not included in this book. No mention is made of agriculture, or the tools used in cultivation. This is an important topic but one which, for comprehensibility, needs to be integrated with the work of landscape and environmental archaeologists. Building in stone has also been omitted; this only really becomes important in the Later Saxon period and most studies are concerned more with architecture than building techniques. It was still a shame to leave out the remarkable Northampton cement mixers!

The Anglo-Saxon period cannot be seen as a single homogeneous entity – it lasted 650 years, almost twice as long as Roman Britain. The groups who arrived from northern Europe during the fifth century were not homogeneous; it is possible to recognise regional patterns in dress and burial practice reflecting different cultural groups, Angles, Saxons and Jutes. During the centuries that followed, the tribal groups of this settlement period coalesced to form kingdoms and, eventually, the single state which formed the basis of medieval England. Towns and cities grew, the arts and crafts flourished, sometimes, as in the case of textiles and gold working, achieving fame throughout Europe.

The Anglo-Saxons did not move into an empty land, and elements of sub-Roman and Celtic culture must have survived. What the end of Roman Britain meant in terms of crafts is an interesting question. The end of the coin economy would have made it impossible for people to sell their work and specialist craft workers may have found it difficult to support themselves. Towns, which had been centres of production and trade, declined and were in some cases abandoned. The withdrawal of the Roman Army would have removed its prodigious buying power from the Province and big military contracts would be a

thing of the past. Our best evidence for the fate of Roman crafts is the pottery industry which, no longer able to market the large numbers of pots needed to make it viable, collapsed to be replaced by domestic products. In other crafts there seems to have been no marked fall in the quality of the goods being made, but a change to a more dispersed production. Some sub-Roman crafts, such as the use of enamelling, may have been inherited by the Anglo-Saxons.

The Early Anglo-Saxon period ended with the abandonment of the pagan cemeteries at the end of the seventh century. This occurred as a result of the spread of Christianity which also brought Frankish and Byzantine influences into England. Christianity became a very important element in Middle Anglo-Saxon society and the period seems to have been marked by a cultural renaissance. Arts flourished and, if the finds we see are anything to go by, England was very prosperous. In the absence of grave finds, evidence for the Middle Anglo-Saxon period was, until comparatively recently, thin, but excavations together with large numbers of metal detector finds have done much to fill this gap in our knowledge. The Late Anglo-Saxon period is generally seen as starting when the Vikings conquered large areas of England in the second half of the ninth century. Conventionally it ends with the Norman Conquest but in this study I have taken the Late Anglo-Saxon period to extend to the end of the eleventh century, the events of 14 October 1066, while politically devastating, brought no great changes in crafts. This extended date also allows some important and useful illustrative material to be included.

Sources of evidence

Archaeology and artefact studies are our prime source of evidence about crafts. While we have long had large amounts of material from Early Anglo-Saxon graves, it is only comparatively recently that we have started to see later Saxon finds in any quantity. Much of this has come from urban excavations on sites in Lincoln, York, Southampton, London and Winchester. This has now been supplemented by metal detector finds recorded by the Portable Antiquities Scheme, and we are seeing Anglo-Saxon objects in unprecedented numbers, some of which are technologically informative. The greatest gap in our knowledge is the shortage of workshop sites. Anglo-Scandinavian Coppergate, York and Flaxengate, Lincoln are useful, but to date we have nothing to compare to sites like Helgö, Sweden, Ribe, Denmark or Dunadd, Argyll. Using modern analytical methods it is possible to determine the composition of objects, for example the survey by Catherine Mortimer of the alloys used in making cruciform brooches has provided important evidence, and Justine Bayley has done much important work on metalworking waste.

In looking at Anglo-Saxon crafts I have drawn mainly on evidence from England, but have also looked at evidence from other contemporary cultures in Scandinavia, Europe and Ireland. These peoples had a similar level of technological development and comparisons are valid. The work of the growing number of re-enactment groups is providing useful evidence. A search for authenticity has led these people to carry out some excellent research and experimental work. I have made some use of early modern evidence in interpreting tools. Publications like Salaman's encyclopaedic *Tools Used in the Wood Working Trades* and *Tools Used in the Leather Working Trades* provide valuable comparative material. In view of the conservatism of many crafts, these are valid sources that we ignore at our peril. The physical nature of the materials being used imposed constraints upon the person working them, which provides a source of information on the processes used. I have tried to look at the scientific basis of these processes and reactions that needed to occur. The Anglo-Saxons, of course, had no knowledge of what was happening inside a furnace, kiln or a hearth, but physics and chemistry are unforgiving of ignorance. Skill and experience would allow them to judge when a crucible of molten bronze was hot enough to be cast into a mould. They knew that the prolonged heating of iron gave improvements in the quality of the metal but they had no idea that the iron was absorbing carbon to form steel.

Technical treatises

The manuscript evidence for Anglo-Saxon crafts is indirect and limited. A document preserved at Lucca, the *Compositiones variae*, contains recipes for making up alloys and instructions on some processes such as the making of gold leaf. It dates to between AD 787 and 816 and, while continental, must reflect workshop practice in England. A second text is the *Mappae Clavicula* 'little key to the chart' and is first mentioned in AD 821-2. This early version repeats some of the recipes that appear in the *Compositiones*, but other copies repeat them all. Medieval English copies of this manuscript exist, and a twelfth-century continental copy in the Corning Museum of Glass, New York State, contains features suggesting that its ancestry contained Anglo-Saxon elements. It is, however, unlikely that either of these texts was used in workshop practice: repeated copying introduced errors which were uncritically perpetuated. They also refer to ingredients that occur only around the Mediterranean. These documents are best seen as revered classical texts that were of no value to an artisan.

Around AD 1000 Ælfric of Eynsham wrote his *Colloquy* which was intended as a way of introducing students of Latin to the basic vocabulary of the language. Ælfric's method of instruction was an old one – conversations (*colloquia*) in which various craftsmen introduced their work but, most usefully, Ælfric was teaching Latin through the medium of English and gave both the

English and Latin words for the things he describes. There is little in the way of technology in the *Colloquy*, but it serves to show what skills were available and, to some extent, how they were valued. *Gerefa*, an eleventh-century manuscript dealing with estate management provides some clues as to what equipment was considered necessary for the running of a large estate giving, for example, a list of tools used in the preparation of cloth.

Theophilus' *De Diversis Artibus* 'The Various Arts' dates from the twelfth century and was written on the continent but is of outstanding importance. 'Theophilus' was probably the German Benedictine monk Roger of Helmarshausen who wrote 'The Various Arts' between AD 1100 and 1140, making the methods he describes relevant to Anglo-Saxon workshop practice. A reading of Theophilus' text leaves no doubt that we are in the hands of a practical man of outstanding knowledge and skill, examples of whose work still survive, in particular a remarkable portable altar in the Cathedral Treasury at Paderborn. Theophilus includes detailed recipes and procedures for painting, glass and metalworking, most of which are sound good sense; the exception is a piece of hardcore alchemy on the preparation of 'Spanish gold'. This involves the use of powdered basilisk, human blood (from a red-headed man) and vinegar to convert copper into gold.

Manuscript illustrations provide some useful evidence, but must be used with care. These were prepared in the restricted environment of a monastery

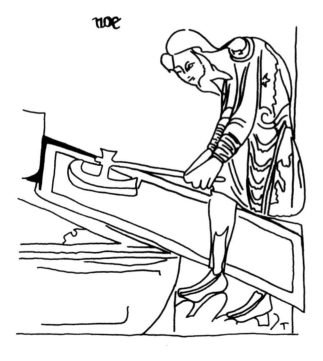

1 *Dressing axe in use.*
Noah building the Ark from
British Library manuscript Cotton
Claudius B.iv, Canterbury, c.AD
1000. Illustration by Michael Lewis

where, if one needed to see a particular image, it was easiest to copy it from another manuscript which may have been based on a sixth-century Italian original. In spite of this, manuscripts provide some insights, for example the eleventh-century drawings of a cart (**21**) and the smith at an anvil (**60**) are both well observed and useful. The Bayeux Tapestry, although stylised, shows some interesting scenes of woodworking (**3**), and an eleventh-century Noah (**1**) using an interesting type of 'T'-shaped axe-hammer.

Law codes and legal documents provide limited help. The knowledge that the owner of a weapon was not responsible if a repairer used it in an assault is interesting if not particularly useful; however, a ruling that shields should not be covered with sheepskin has some useful implications: shields must have generally been faced with leather.

1

WOOD AND TIMBER

Trees were one of the foundations upon which Anglo-Saxon society rested: the material they provided gave shelter, warmth, tools, means of transport and heat for industrial processes, making it an age of wood. Our tragedy is that so little of it has come down to us: wood will only survive in ground that is waterlogged, giving an anoxic environment. Even then, wood, while appearing well preserved, has lost most of the cellulose from its cell walls, and intensive conservation measures are required if it is to survive in a recognisable condition. In spite of what we have lost, excavation has produced remarkable evidence for wooden objects and structures, which, together with surviving tools, allows us to start to understand something of the Anglo-Saxons' use of wood.

England was not a heavily wooded country even in Anglo-Saxon times: Oliver Rackham has estimated that in AD 1086 only around 15 per cent of England was wooded. Large-scale clearance had already taken place during the Roman period and earlier. During the Roman period, the size of the timber used decreased from the first to the third centuries, suggesting that all the conveniently placed large trees had been felled. Some woodland regeneration is likely to have taken place in the aftermath of the Romans leaving. The tree-ring sequences for timber used in the Middle Saxon period show that the trees felled all started life in the early fifth century, perhaps as woods spread over abandoned agricultural land.

A distinction is made between wood and timber, the latter coming from trees large enough to yield beams and planks used in building, and 'wood' consisting of round wood, poles and smaller trees with diameters of less than 280mm. While timber came from trees that were some hundreds of years old, much of the wood came from fast grown coppice. Coppicing involves cutting down a tree to a stump (a stool). As the tree's root system is fully developed and still intact, it pushes up shoots which grow quickly into poles. These can be harvested in rotation and can give a constant source of wood and fuel.

Coppice cycles recorded in eastern England between the thirteenth and twentieth centuries ranged between four and twenty-five years. Poles are a prerequisite for wattle-and-daub construction. An examination of the wood surviving inside the sockets of Anglo-Saxon spearheads has shown them to be made from hazel and ash, both of which produce poles if coppiced.

Woodworking tools

Tools are rare in Anglo-Saxon graves and it is not until the Late Saxon period that we begin to get appreciable numbers of tools from urban excavations. To some extent this problem has been remedied by the excavations at Flixborough, a rich Middle Saxon settlement in Lincolnshire, but we are still left with a dearth of evidence for the early part of the period. Hoards are, potentially, informative but most of the six hoards of iron objects from Anglo-Saxon England contain scrap tools telling us little about working practices, certainly when compared to the great Late Viking, Mästermyr hoard from Gotland, Sweden. Our best English hoard is the eighth- to ninth-century deposit of carpenter's tools from Flixborough, North Lincolnshire. (**colour plates 7a** & **b**). This, and the other English hoards, are described below. We have one important craftsman's grave, the seventh-century burial of a metal-worker from Tattershall Thorpe, Lincolnshire.

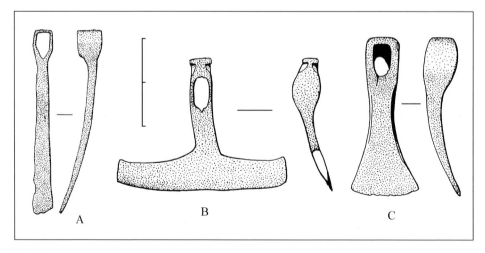

2 *Adzes.*
Anglo-Saxon adzes: **A** *from the Hurbuck, Durham hoard, late ninth- or early tenth-century;* **B** *and* **C** *from the Flixborough, Lincolnshire hoard, eighth- to ninth-century.*
Drawings by author, **A**, from Wilson, 1976

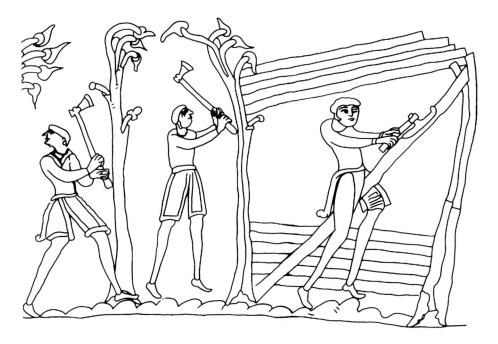

3 *Tree felling as shown on the Bayeux Tapestry.*
Two forms of axe are shown in use; the heavier fan-shaped blade is used for felling while the light 'T'-shaped axe is employed in the dressing of the timbers.
Drawing courtesy of Michael Lewis

Axes and adzes

The axe forms a basic part of the Anglo-Saxon woodworker's tool kit, complemented by the adze, an axe with a transverse blade (**2**). Two forms of axe and adze appear to have been used by the Anglo-Saxons: a light axe with an expanded 'T'-shaped blade, and a heavier tool with a fan-shaped blade. Both can be seen in use on the Bayeux tapestry, the fan-shaped axe used for felling and the 'T'-shaped axes used for dressing timber (**3**). In skilled hands, a 'T'-shaped axe would be capable of producing an almost planed finish. 'T'-shaped axes seem to have been introduced in the Middle Saxon period, being absent in the Roman period and not occurring in pagan graves (although tools are rare in graves anyway). The best-dated 'T'-axes are the broken examples in the Stidriggs, Annandale, Dumfries hoard where associated wood gave a radiocarbon date of AD 775-892 at one standard deviation. The way in which axes were sharpened is important as it allows the 'side axe' to be identified. These axes are characterised by being sharpened on only one side of their blade, giving an asymmetrical cutting edge useful when smoothing a flat surface, as the blade could attack at a low angle allowing thin shavings to be removed. Axes with asymmetrical sharpening were found in Mound 3 at Sutton Hoo

and in the eleventh-century Nazeing hoard. A further refinement of this tool appeared on an eleventh- to twelfth-century 'T'-shaped side axe from Milk Street, London on which the wooden haft was bent so as to keep the user's hand clear of the surface being smoothed. The head of this axe had been secured with a small iron wedge inserted down the side of the socket.

It is often difficult to distinguish between an axe intended to be used as a tool and a battle-axe. Decorated axes, as in the case of the Viking axe from Mammen, are almost certainly weapons, and the *francisca*, a distinctive throwing axe, can only be seen as a weapon. There is also a small group of axes with sharply expanding blades and elongated hammer heads, as seen on the example found in a grave at Horton Kirby, Kent. This blade form may have been the ancestor of the 'T'-axe but it is also possible to parallel it with the axe-hammer from Mound 1 at Sutton Hoo. The blade on the Sutton Hoo axe droops in a way reminiscent of a *francisca* war-axe, but the hammer element resembles the Horton Kirby axe-hammer. The Sutton Hoo axe had an iron haft which would have made it very unpleasant to use as a tool; its associations in the grave and the ring on the end of the haft (for a wrist-strap) show it to have been a weapon. It is likely that the Horton Kirby type axe-hammers should also be seen as weapons.

Two other tools that may have been used in the preparation of wood are the bill and the shave. The bill is now primarily a hedger's tool, but was generally used in woodland crafts. An example of a socketed bill was found in the Flixborough hoard (**4A**). A tool resembling a broad chisel was found at Coppergate and inter-preted as a 'slice' (see below; **4B**), but it is also possible that this tool was used to remove the bark (itself a valuable commodity) from felled trees.

Chisels and gouges

Anglo-Saxon chisels and gouges are not common. The surviving examples were made in a number of forms with socketed, tanged and solid handles (**5**). Socketed chisels are known from the Anglo-Saxon period: examples have been found at Coppergate, Skerne, East Yorkshire and Stidriggs, Dumfries. The Coppergate chisel had an open socket and a 70mm-wide cutting edge, making it unsuitable for fine work; indeed, this object may not be a chisel and could be an example of a tool known as a 'slice'. These large chisel-like blades were fitted on long handles and used with a planing action, to remove wood from areas that an adze could not reach. A socketed gouge with a 24mm-wide blade found in the Crayke, Yorkshire hoard would have been used for heavy work, as would the *c.*200mm-long Stidriggs socketed gouge. The small iron-paring chisel, 'V' gouge and crank gouge from Coppergate are all fitted with tangs for insertion into wooden handles; the crank gouge has a double 90° bend in its tang to keep the user's hand clear of the work piece (**5**). A different form of handle was used on the chisel and a gouge found in the eleventh-century

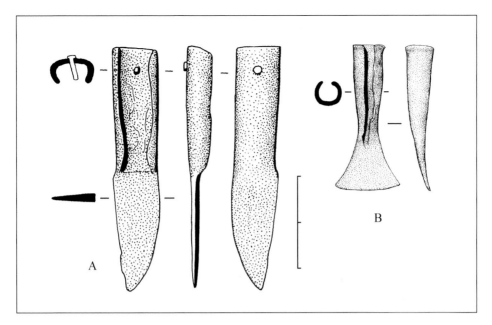

4 *Bill and slice.*

*The bill, **A**, is from the Flixborough hoard, eighth- to ninth-century. **B** is from Coppergate, Anglo-Scandinavian; it is possibly a slice for cutting wood in areas where an axe or adze could not reach, or could have been used for stripping bark from felled trees.*

Drawing **A**, by author; **B**, by author after Ottaway 1992

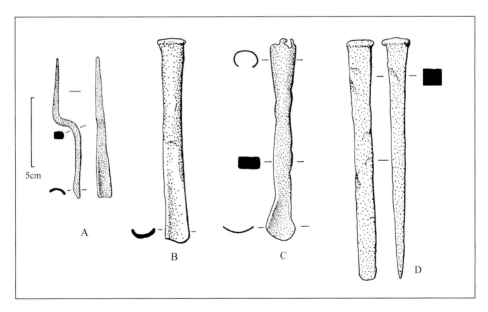

5 *Gouges and chisel.*

A *Tanged gouge from Coppergate, Anglo-Scandinavian;* **B** *Solid gouge from the Nazeing hoard, eleventh-century;* **C** *Socketed gouge from Crayke, York, possibly ninth-century;* **D** *Solid gouge from the Nazeing hoard, eleventh-century.* Drawings by author, **A** after Ottaway, 1992; **C** after Wilson 1976; **B** and **D** after Morris 1983

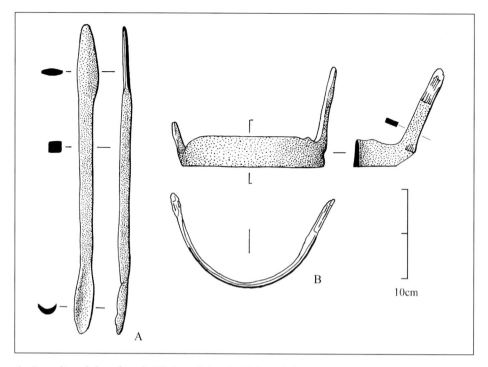

6 *Spoon bit and shave from the Flixborough hoard, eighth to ninth century.*
The spoon bit was set in a 'T'-bar handle for making holes and the shave used for shaping rounded sections.
Drawing by the author

Nazeing hoard. These lacked either a socket or a tang, having instead well hammered, solid iron handles.

Spoon bits

Wooden structures can be secured together by means of wooden pegs driven through the joints or by 'trenails' as used in shipbuilding. These holes were made using spoon, shell or boring bits (**6A**). As the name suggests, the end of these tools consisted of a spoon-shaped blade, the edges and end of which were sharpened. A metallographic section of an auger from Coppergate showed it to have been made as a layer of steel between two layers of phosphoric iron: unfortunately the steel was out of line and not exposed at the cutting edge. At the other end of an auger was a coffin-shaped tang which was set within a wooden crossbar for use. Spoon bits were used in Roman times and remained in use over the whole of the Anglo-Saxon period undergoing little or no development. Towards the end of the period, the 'breast auger' appeared. These were fitted with a freely rotating disc on the top of the cross bar which would be braced against the user's chest so that increased pressure could be

applied. A 'breast auger' is shown being used by a shipwright on the Bayeux Tapestry (**7**). Twist-drill bits, of the sort used today, are known from Viking age Scandinavia but the only possible English example, from Shakenoak, Oxfordshire fails to convince me any more than it convinced the excavators.

Planes

Only one Anglo-Saxon plane is known, a tiny example found in a seventh-century grave at Sarre, Kent. This is 150mm long and 32mm wide and is made from antler and fitted with a copper alloy sole-plate, attached by three iron rivets. The blade of the Sarre plane would have given a 19mm cut, but unfortunately it is missing, as is the wedge that would have secured it. It is possible that this plane was of Romano-British origin, but similar planes have been found on Dutch *terpen* or village mounds. A larger example, in wood, from a terp at Aalsum, Holland, was decorated with an interlace design suggestive of an eighth-century date. Most of these planes are only suitable for very fine work, something that otherwise appears to be absent from the record.

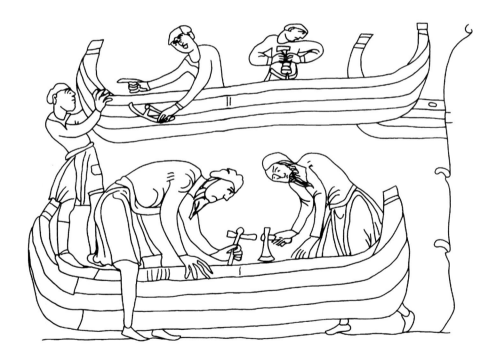

7 *Shipbuilding scene from the Bayeux Tapestry.*
The man working on the top left is using a 'T'-shaped dressing axe, while the man to his right is using a breast drill, a development from the simple cross-handled drill. On the bottom right, a man is shown using an axe with a fan-shaped blade. Drawing courtesy of Michael Lewis

Draw-knives and round-shaves

These simple but useful tools were drawn over the surface of the work-piece removing shavings. They are capable of quickly removing large quantities of shavings but it is also possible to exercise a high level of control. A draw-knife has a straight blade and a round-shave has a curved blade and was used for working curved surfaces. The Stidriggs hoard contained the remains of a draw-knife with a blade length of about 250mm. An example of a round-shave from Coppergate was interpreted as being a cooper's tool but, while accepting that these tools were used by coopers, I would not want to exclude their use by other woodworking trades. Two round-shaves were found in the fill of an Early Anglo-Saxon *Grubenhaus* at Mucking, Essex and two examples of round-shaves were found in the Middle Saxon Flixborough hoard. These both had asymmetric tangs for the handles suggesting that there was a vertical handle on one side of the blade and a knob on the other (**6B**).

Saws

There is good evidence for the use of saws in the working of bone and antler but their use in woodworking is more doubtful, although they may have been used for some light tasks. The grooves in the ends of St Cuthbert's coffin reliquary were made using a saw. Anglo-Saxon saws are known from Icklingham, Suffolk and Thetford, Norfolk (**8**). The example from Thetford was found in a pit which contained early twelfth-century pottery. It has teeth on both sides of its blade, with pitches of around 3.7 teeth/cm and 6.1 teeth/cm (a modern tenon saw has a tooth pitch of 5.5 teeth/cm). The Icklingham saw was found on the site of the Mitchell's Hill cemetery, but we cannot be certain that it is Early Anglo-Saxon. This saw has a single row of teeth with a pitch of 4.6 teeth/cm, and was found with a folded iron channel,

8 *Anglo-Saxon saws.*
A *Mitchell's Hill, Icklingham,* **B** *Thetford, Suffolk.* Drawings by author after Wilson, 1976

which could have been a case to protect the teeth or support for the blade when it was in use. Find 2983 at Coppergate has been described as a fine-toothed saw with a tooth pitch of 13 teeth/cm but its blade has a wedge-shaped section which would not have formed a slot. It is better described (as in the Coppergate ironwork report) as a serrated edge knife. Early saws suffered the disadvantage that the soft iron or poor steel from which they were made was likely to buckle if used for the pushing cut used on a modern saw. This problem could be overcome if the saw was used with a pulling cut (as in an oriental saw) to keep the blade under tension. In the recent past, this was done by the use of a bow saw in which the blade was secured between two uprights and tensioned with a twisted cord. What has been interpreted as the antler frame for a hand-saw was found at Coppergate where it appears that the blade was tensioned with a wedge (**9**). The two saws from the Late Viking period Mästermyr hoard resemble modern pruning saws in shape. The teeth appear to have been designed to cut on the push stroke, the problem of the blade buckling being overcome by their having a relatively thick section (4mm). It is notable that the teeth on the Mästermyr saws both have considerable 'set', being bent alternately to the left and right to ensure that the cut was wider than the blade width to prevent the blade binding.

Nails and pegs
Excavations at Coppergate produced large numbers of iron nails which were seen as being used in furniture making. They were not used in the construction of the Coppergate buildings but were probably used to secure fittings. Some nailed coffins were made. Most nails were flat headed (the most common form in the ninth to eleventh centuries) with a square section shaft. It was found that the majority had lengths of between 30 and 65mm which must reflect their function. The sound board of the Sutton Hoo lyre was secured using 9mm-long pins cut from a strip of sheet copper alloy (**10**).

Some items of furniture and buildings were held together by the use of an extended tenon which was passed through the mortise and then secured by a peg or wedge driven through a transverse hole. This technique was used in the assembly of the Tamworth mill and the furniture found in the Oseberg, Norway ship burial, dating to *c*.AD 800.

Anglo-Saxon ships were secured together using two methods: trenails (wooden pegs) or iron clench bolts. The trenails used on the Viking Gokstad ship were driven in from the outside of the hull. They had conical heads and were driven in slightly below the level of the outer planking. Once driven home they were locked with small wooden wedges knocked into their inner ends. A clench bolt consists of two parts, the iron bolt itself, which has a square or round section and a flattened mushroom-shaped head at one end, and the

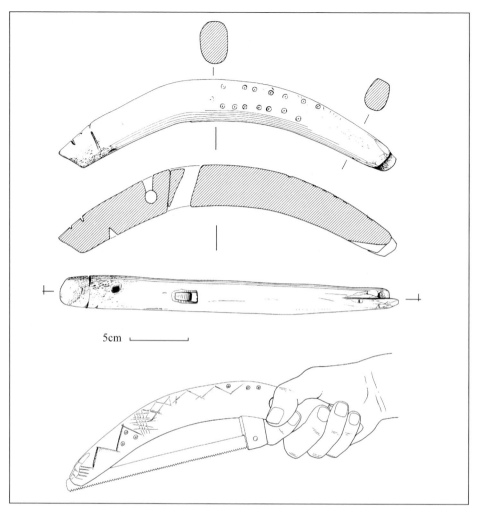

9 *Anglo-Scandinavian saw-frame from Coppergate.*
This object is probably the antler frame for a small saw, late ninth- to early tenth-century. Drawing from
MacGregor, Mainman and Rogers, 1999, courtesy of the York Archaeological Trust

rove, a diamond-shaped iron washer. The timbers were clamped together and
a hole drilled through them; in recent Scandinavian boat building, timbers
were clamped using forked branches secured by wedges. A clench bolt was
passed through the hole and a rove put over its protruding end which was
hammered to expand it and lock it into place. Clench bolts were also used on
land: a line of them was found across the line of one of the Flixborough
buildings. It has been suggested that the perforated iron bars found in the
Tattershall Thorpe grave (**73A**), the late Viking Swedish Mästermyr hoard and
the mid-tenth-century Bygland grave from Norway were used to hold nails
while their heads were being forged. The groove down one face of the bar
might be in keeping with this as it would allow a 'T'-shaped head to be

formed. Another possible interpretation is that they were dowel plates. These are discussed by Salaman in his book on woodworking tools who describes them being used to make wooden dowels by hammering lengths of split wood through the holes.

Wood and timber products

Our best insight into Anglo-Saxon (or, to be more precise, Anglo-Scandinavian) woodwork and woodworking comes from later ninth- to eleventh-century deposits at Coppergate, York, which were the subject of a masterly analysis by Carole Morris. At Coppergate, the excavators were fortunate to find the workshops used by woodworkers, in particular turners, whose activities may have given the street its name, from the Old Norse *koppr*, meaning cup, 'cuppers' street. In addition to well-preserved wooden objects, the Coppergate excavation also produced manufacturing waste, something that is of great interest when trying to understand how something was made.

Most of the wooden objects found at Coppergate were made from split-wood, that is logs that had been cleaved down their length. Two methods of splitting were used – radial and tangential. Most of the logs were split radially, that is on lines that went from the outside of the log towards its centre, giving planks with a slightly wedge-shaped section. In tangential splitting, all of the splits run parallel to each other across the log, giving flat planks. As radial splitting follows the tree's natural grain it produces timbers that are stronger than those which have been tangentially split or sawn: they are also more stable and less likely to warp. Anglo-Saxon wood was worked green – that is unseasoned. Oak is easier to work in this condition as seasoning reduces the

10 *Making copper alloy nails. This method was used to make the tacks which secured the sounding board on the Sutton Hoo lyre.* Drawing by the author after Evans 1983

10 mm

effectiveness of tools by more than 50 per cent. Unseasoned wood was also turned on the lathe and it appears that deliberate steps were taken to ensure that prepared blanks did not dry out and crack. Blanks ready for turning have been found in bogs and waterlogged pits in both Ireland and the Netherlands.

Some preferences existed in what each type of wood was used for. Oak was the preferred timber for building: it splits well and will stand being buried better than most other woods, an important consideration with wall posts. The turners at Coppergate preferred to use alder for making bowls, with maple as a second choice. Light woods were favoured for shield boards which were made from, amongst other woods, lime, poplar, alder and willow. Trees were felled using an axe. A felling axe would need to be heavy and robust and we have illustrations of trees being felled with axes with broad, fan-shaped blades on Anglo-Saxon calendars (**21**) and on the Bayeux Tapestry (**3**). An example of a felling axe was found at Coppergate and a heavy axe was present in the Flixborough hoard, although its narrow blade does not seem suitable for felling

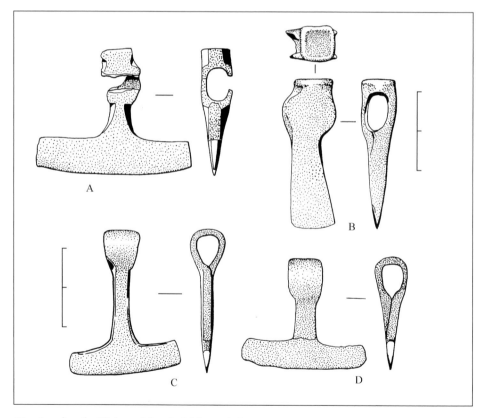

11 *Axes from the Flixborough hoard, eighth- to ninth-century.*
Two forms of axes are shown, the 'T'-shaped dressing axe and a heavier tool. Note the different ways in which the holes for the handles were formed. Drawing by the author

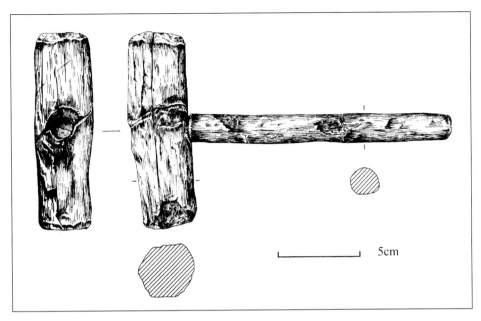

12 *Wooden mallet from Coppergate, York.*
Anglo-Scandinavian mallet with a hazel handle and a willow head, burred-over by use. Illustration from
Morris 2000, Find 8186, courtesy of the York Archaeological Trust

trees (**11B**). The two-man pit saw used in the recent past for cutting large
timbers did not appear until the fifteenth century when we get references to
'saw pits', probably using large frame saws. Prior to this the large timbers used
for the frames of buildings and in shipbuilding would have been cut from the
parent logs using wedges. In experimental work, Richard Darrah was able to
split trees using seasoned oak wedges 130-300mm long with an angle of
between 5° and 15°. Splitting was carried out with the unseasoned tree trunk
lying on bearers so that it could be easily turned. After an examination for
knots that would cause the split to run off-line, the oak wedges were driven
into the side of the trunk along the line of the desired split, starting near one
end. As the crack advanced, more wedges were driven in along the line, and
eventually wedges were also inserted on the opposite side of the trunk to
complete the split. In this way it is possible to produce planks and timbers
without the use of a saw, final finishing being done with the axe and adze.
Thirteen radially split oak wedges were found at Coppergate: the larger
examples were suitable for splitting logs but the smaller ones may have had
other uses such as for securing clamps. A few iron wedges have also been
found: a well used sixth-century example was found in grave 233 at Sarre, Kent
and they seem to span the Anglo-Saxon period. All of the surviving examples
are too small to have been used for splitting timber. In experiments the
wooden wedges were driven into the timber using a 'beetle', a 4kg iron bound

elm mallet. A wooden mallet (**12**) found at Coppergate had a willow head and a hazel handle but lacked the mass to be used in splitting. Anglo-Saxon axes were occasionally combined with a hammer, and it has been suggested that they were used to drive the wedges used in splitting timber. They are, however, too light for this purpose and were probably used for driving in pegs and nails.

Joinery

Little in the way of fine woodwork has come down to us and, indeed, it might be wondered how accomplished the Anglo-Saxons were in the making of small wooden objects. The oak coffin-reliquary in which the remains of St Cuthbert were placed in AD 698 is more remarkable for the quality of its decoration than the elegance of its joinery (**13**). The coffin consists of seven radially split oak boards including an inner lid supported on three cross battens. The base was housed into the two ends and the sides rebated and secured to both with pegs. The slots along the ends were formed by two cuts with a stiff handsaw and the waste removed from between them. It is not known how the slots along the

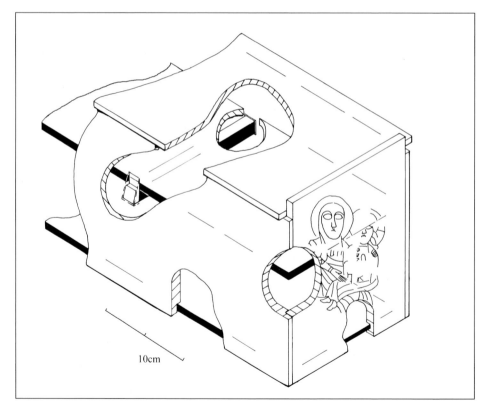

10cm

13 *St Cuthbert's coffin/reliquary.*
Reconstruction of the wooden coffin in which the remains of St Cuthbert were placed in AD 698. Drawing by the author

sides were made. Incised lines were used to decorate St Cuthbert's coffin, figures were incised on the lid, ends and sides in two ways, either using a 3mm-wide 'U'-shaped gouge or by a 'V'-section groove made by two converging knife cuts. These two methods never appear on the same panel.

It is notable that the only piece of Anglo-Saxon wood-carving in deep relief to have survived, the tenth century box-wood casket from Uttoxeter, Staffordshire, is cut from a solid block of wood, with a second block forming the gabled roof. In the surviving metal-covered box-shrines, such as the example from Winchester, the sheet metal plates are laid over a wood block, not a box. While it is made from whale's bone, the way in which the eighth-century Franks Casket was fabricated is instructive. There are four corner pieces into which the sides are simply secured by pegs. The base is fitted into a groove cut along the inside of the four sides. This is all cleverly done, but is hardly great joinery. A small long brooch found in a grave at Fonaby, Lincolnshire was in a wooden box, its lid secured by two small pegs. The joints used on the chest that contained the Mästermyr hoard were formed by cutting steps into the ends, into which corresponding steps on the sides could be located. Two tenons on the ends of the base were fitted into mortises in the ends, the sides being butted against the base. Finally the chest was fixed together with wooden pegs. The Saxo-Norman wooden coffins found at St Peter's church, Barton on Humber were similarly unsophisticated, the sides, ends and bases all being made from single planks, butt-jointed and secured by pegs and wedges. More elaborate joinery was used to make some of the wooden objects found in the Oseberg ship burial. The wooden bed was fixed together using a system of mortise and tenon joints in which the tenon extended through the mortise and was secured by a peg.

Other than chests, the only items of Anglo-Saxon furniture for which we have evidence are beds, which were sometimes used as biers for burial. The most informative bed burial we have is the seventh-century example from Swallowcliffe Down, Wiltshire. Very little of the wooden framework survived but around 50 iron fittings gave some indication of how the bed was constructed. The frame of the bed was made from ash planks, secured together with pairs of iron plates, each pair fixed together with two rivets. Variations in the distance between the pairs of plates showed that the planks were not of even thickness, which would be a result of them being radially split timber. It is not known how the corners of the bed were jointed. Around the inside edge of the frame were 14 large eyelets, and 32 small eyelets were found within the frame, all of which bore traces of mineralised ash wood. The base of the bed was reconstructed as having a lattice of ash laths, secured at their crossing points by nails and suspended by cords or thongs linking the smaller eyelets to those in the frame. These would have been much more flexible and comfortable than leather strapping.

Shield boards

Anglo-Saxon literature leaves us in little doubt about what type of wood was used to make shield boards, they are always referred to as *linden* ('lime', *Tilia*). However, an examination of Anglo-Saxon shield boards showed that lime was only one of the woods used; alder and willow/poplar were the most common, followed by maple and birch, with lime, ash and oak being the least popular. It may be that the literature reflects a later time when lime was the most frequently used timber. The choice of timbers used reflects practicality: the woods most commonly used are light in weight, and resistant to splitting. Oak, on the other hand, is heavy and splits easily, although this could be limited by the cross-battens. While laminated shields were known in Roman Britain there is no archaeological evidence for this method of construction in Anglo-Saxon England, and it seems that all Anglo-Saxon shield boards were made up of a single layer of wood.

Continental evidence and practicality suggests that shields were made up of a number of planks, laid edge to edge and joined by transverse battens. The thickness of shield boards varied, the average being around 7.5mm at the boss, but they may have tapered towards their edges. There has been some discussion of whether the wooden boards of Anglo-Saxon shields were ever dished, i.e. plano-convex. There is some pictorial evidence for dished shields: the shields shown in use on the Franks Casket appear dished, as do some of the round shields carried by the Anglo-Saxons on the Bayeux Tapestry. The flanges seen on many iron shield bosses are angled suggesting that they were designed to lie against a curved surface and the mounts from a shield from the Lyminge II cemetery come from a shield that must have been curved. The great shield from Sutton Hoo has been interpreted as having a curved edge. This curving of the wood could have been achieved by softening the wood by steaming and clamping it into the desired shape. It is unlikely that the majority of shield boards were curved. Many were too small to make this a worthwhile exercise and shields have been found with long iron handles leaving no doubt that their boards were flat. It is perhaps more likely that the angled flanges on shield bosses were designed to allow them to bite into the wooden board.

Lathes and wood turning

While the evidence for Later Anglo-Saxon and Anglo-Scandinavian wood turning is good, our evidence for the use of this technique at an earlier date is limited. Six turned, maple wood bottles and eight turned, walnut burr-wood cups were found in Mound 1 at Sutton Hoo. Poor preservation made it difficult to determine the dimensions of the bottles, but they probably had a diameter of around 140mm and a height of *c.*140-160mm. Their walls were about 5.5mm thick, but this may have increased towards the bases. Even so,

turning these bottles would have called for great skill. More common evidence for the use of lathes comes from the turned antler spindle whorls that are common in Early Anglo-Saxon burials.

Metal clips are often found in Early Anglo-Saxon graves and have been described as being repairs from wooden vessels. Their position in the graves, usually up at the shoulder, is in keeping with fittings from vessels, as this is where pots are usually found. I would hesitate to ascribe all of these clips to turned vessels or to suggest that they were repairs. It is possible that they formed part of vessels made from some other materials such as leather or bark, or possibly a lath-walled box where it was necessary to reinforce the vertical joint.

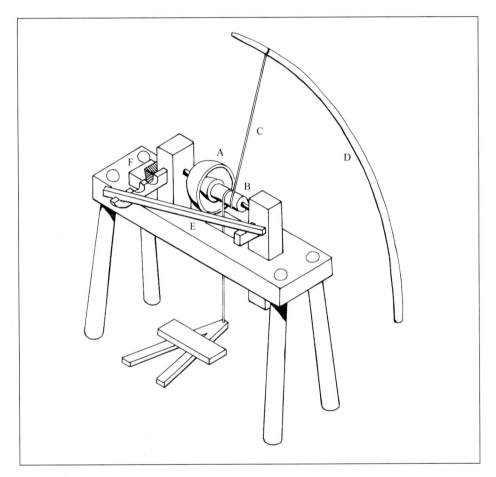

14 *Pole lathe.*
*On a pole lathe the work piece (**A**) was attached to a mandrel (**B**) around which went a cord (**C**) which was tied to a springy pole (**D**). The operator depressed the treadle with his foot, pulling down on the cord and causing the mandrel and work piece to rotate. As the bowl revolved, a cut was made using a turning tool resting on **E**. When the treadle was released, the pole pulled on the cord, returning the lathe to its start position ready for the next cut. The tailstock (**F**) is in a slot so that its spacing can be adjusted to insert work pieces and to allow different-sized work pieces to be turned.* Drawing by the author

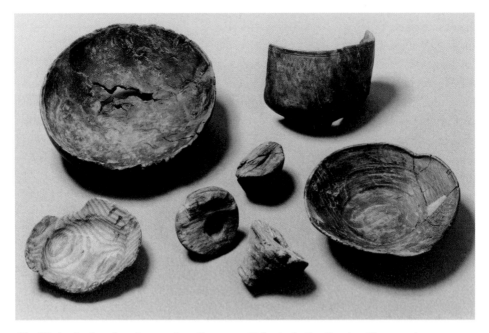

15 *Wooden bowls and turning cores from Coppergate, York, Anglo-Scandinavian.* Photograph courtesy of the York Archaeological Trust

Two forms of lathe were used by the Anglo-Saxons, the pole lathe and the bow lathe. The pole lathe was operated through a cord or thong which encircled the spindle, one of its ends being attached to a foot treadle and the other to a springy pole (**14**). Pushing the treadle down pulled the cord causing the spindle and the work piece to revolve, allowing a cut to be made and pulling down the pole. When the treadle was released the pole sprang back, pulling the cord and returning the treadle to the start position. The cutting tool was withdrawn and the work piece revolved in the opposite direction to which the cut was made. This leaves highly characteristic, discontinuous spiral tooling marks on the work piece. Pole lathes remained in use until recent times, being used by the 'bodgers' to make the legs for Windsor chairs.

Like all machine tools, a pole lathe must have a substantial bed to keep it stable. It stood on legs to raise it to a convenient working height. At each end of the bed was an upright stock containing a metal spike on which the work piece revolved. One of these (the tail stock) needed to be adjustable for work pieces of different sizes and to allow objects to be removed from the lathe. There are two ways in which a lathe is used – spindle turning and face turning. In spindle turning, the work piece was placed between the head and tail stock and was itself encircled by the drive cord. This method was used to turn long, small diameter objects, but could also be used for a stick of conjoined cups. With face turning the drive cord went, not around the object, but a wooden mandrel

placed between the work piece and the head stock. This method was used to turn large objects such as bowls and, by varying the diameter of the mandrel, it was possible to change the cutting speed when turning a large diameter bowl. When turning a bowl it was necessary to leave its centre in place to engage with the mandrel. When turning was complete, this conical 'core' was cut out of the base of the bowl with a chisel (**15**). The spikes at the head and tail stock are smooth to allow the work piece to revolve freely, but a positive link is needed between the mandrel and the work piece to transmit the drive. Various types of link were used, but scars left on the ends of cores at Coppergate show that the most common type consisted of two small plates, set side by side and hammered into both the mandrel and the work piece.

A lathe must be fitted with a tool rest on which the cutting tool is placed, a mid-tenth-century example of which was found at Coppergate. This represents the only Anglo-Saxon lathe fragment to have survived. The turning tools used on a pole lathe were unlike those employed on a modern lathe. They had very long handles to cope with the repeated kicks caused by the lathe's reciprocating action. A 290mm-long socketed turning tool with a hooked cutter was found at Coppergate in 1906 (**16**), and a similar tool was found in a ninth-century pit at Portchester Castle, Hampshire with four wooden turning cores. These can both be paralleled by tools used by pole lathe turners in the early twentieth century. An eighth- or ninth-century chisel-like turning tool found at Southampton had a 110mm long blade with a 6mm wide cutting edge. This was tanged with a circular stop between the blade and tang, but does not look strong enough for use on a pole lathe and it may have been used on a bow lathe.

The bow lathe also had a reciprocating action, but in this case the motion was imparted through a cord attached to a bow which was worked back and forth turning the work piece (**17**). These lathes lacked the power of the pole lathe but could turn at high speeds. They were used for turning small objects such as cups,

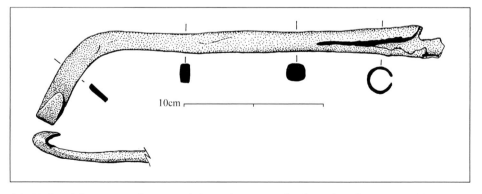

10cm

16 *Hook-ended cutting iron for use on a lathe, York.* Drawing by the author, from Morris 2000

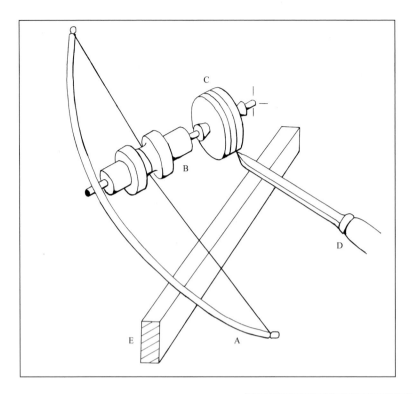

17 (Above) *Bow lathe.*
*These lathes were used for turning small objects such as spindle whorls and beads. The bow (**A**) had a cord or strap that encircled a mandrel (**B**) and by pushing the bow forward the mandrel and the work piece (**C**) revolved. As with the pole lathe there was a non-cutting return stroke. A cutting tool (**D**) was placed on the rest (**E**).*
Drawing by the author

18 (Right) *Lyre from Sutton Hoo.*
*The main body of the instrument, containing the sound box (**A**) was carved from a single block of wood. Over the sound box was a 3mm-thick sound board secured with nails (**B**). The yoke (**E**) which contained the pegs for tensioning the strings was attached to the body by housed joints.*
Drawing by the author after Bruce-Mitford, 1983

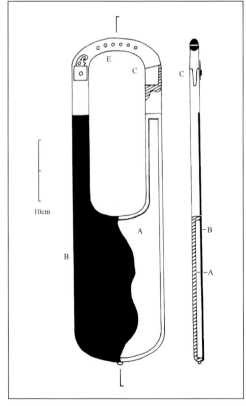

10cm

beads, counters and spindle whorls in materials such as antler, stone and amber. Two bows were found with cores and a turning tool in the ninth-century pit at Portchester Castle, Hampshire, referred to above. It is possible that the bow-drive was sometimes attached to what was otherwise a pole lathe.

Musical instruments

Musical instruments represent the highest level of woodworking as, in order to work, the sound-box must be thin and tightly jointed. The remains of the Sutton Hoo lyre have been subjected to exhaustive analysis and we have some idea of how this instrument was made (**18**). A lyre consists of two main elements, the sound-box and the yoke into which the pegs for the strings were seated. The Sutton Hoo lyre's 16mm-deep sound-box was carved out of a single piece of maple over which was nailed the 3mm-thick sound board. The joints used to fix the yoke to the arms of the sound-box on the Sutton Hoo and Taplow lyres have been described as being 'mortise and tenons'. This is not the case: a housed joint was used on the Sutton Hoo and Bergh Apton lyres and that on the Taplow lyre is a bridle joint, both of which, having open sides, are much simpler to make than a mortise and tenon. These joints were secured by rivets. One must wonder if the Anglo-Saxons had access to any adhesive suitable for gluing wood.

Anglo-Saxon ships

Five Anglo-Saxon ships or boats have been found although only two of them are well enough preserved to be informative. These are the ship from Mound 1 at Sutton Hoo and the remains of the vessel found, in 1970, in marshes around a tributary of the Thames at Graveney, Kent.

The Sutton Hoo boat was buried around AD 625, but repairs to her hull show that she was old when placed in the grave (**19**). Little survived of the ship's timbers, but the highly acid sand had preserved a cast of the hull, along which ran the lines of iron clench bolts. The ship had a clinker-built hull which consists of a series of planks or 'strakes' overlapping each other and riveted together using iron clench bolts. The hull of the Sutton Hoo ship was made of nine, 25mm-thick strakes either side of the keel, sweeping gracefully up to the bow and stern. As the ship was 27m long with a maximum width of 4.5m, it was impossible to make the strakes from single pieces of wood, and they had to be jointed. The clench bolts used to do this show that the edges of the two planks were angled to make a sloping scarf joint.

The difference between a clinker-built vessel and one built using carvel construction is that in the latter method the main strength is in the frames, onto which the planks are laid, edge to edge, not overlapping. In a clinker-built hull, the strength is in the strakes forming the skin of the hull: the frames are only put in to improve the vessel's rigidity. When the hull of the Sutton

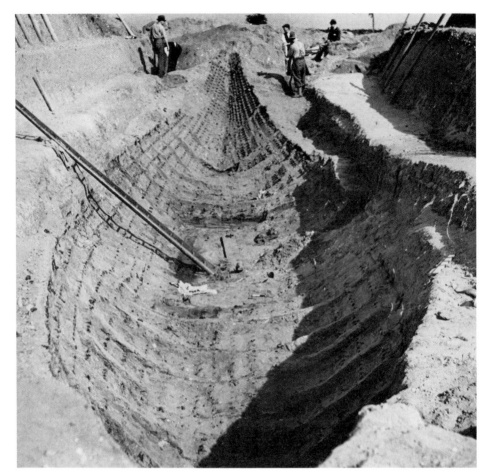

19 *Ship from Sutton Hoo, Mound 1, during the course of its excavation.*
This 1939 photograph shows almost the full 27m of the ship's length. The rows of rivets which fixed the
overlapping planks can be seen, together with the ribs which were fixed inside the planks.
Photograph courtesy of the British Museum

Hoo ship had been completed and the strakes fixed with clench bolts, the 26
frames were inserted. These were fixed to the top strake by a single heavy bolt,
but elsewhere along the frames, stains were found suggesting that these bolts
had been supplemented by wooden pegs – 'trenails'. It appears that the frames
were shaped to follow the profiles of the overlapping strakes. High in the stern,
on the starboard side, two frames had expanded heads and were secured by five
and three rivets to accommodate the massive steering oar.

On the gunwales were the traces of claw-tholes, the rowlocks used by the
40 rowers. For strength the tholes were carved from naturally forked timbers.
The Sutton Hoo boat had a stubby, square keel that would have been of limited
use in sailing across the wind; indeed there was no sign that the boat had ever
been fitted with a sail.

The Graveney ship is unlike the Sutton Hoo vessel both in date and function. She was built around AD 900, not as a warship or state barge, but as a wide hulled cargo carrier. Like the Sutton Hoo ship, the Graveney vessel was clinker-built, but massive frames were used, fixed to the strakes with trenails. Unlike Viking ships of the period, the Graveney boat lacked a 'T'-shaped keel and had a plank or 'hog'. She seems to have had been fitted with a *barde*, a board-like projection from the bow and stern which is shown in some contemporary illustrations and would have improved the vessel's directional stability. Analysis of the Graveney boat's hull form showed that she would have been a reasonably fast merchant ship, able to transport six or seven tonnes of high density cargo.

In addition to plank-built boats, some use was also made of logboats, an example of which was found in one of the graves at Snape, Suffolk. This logboat was 3m long and had a beam of 0.7m. A logboat from the River Calder at Stanley Ferry, Wakefield, Yorkshire has been radiocarbon dated to the early eleventh century.

Coopering

The skill in coopering lay in ensuring that the staves of the barrel met to form a tight joint. Three products were made by coopers: wet casks for fermented liquids; casks made to contain dry goods or unfermented liquids, which have straighter sides and required less skill to make than the 'wet' casks; and buckets, which were straight-sided and open-topped. The craft of coopering was known in the Early Anglo-Saxon period as is shown by the stave-built wooden tubs and buckets found in early graves. Often only the bindings and mounts survive, but where wood has been preserved, the staves have been found to have been made of oak, yew or pine. Tubs have been found in rich seventh-century graves at Sutton Hoo, Taplow and Morning Thorpe. These were fitted with iron hoops and suspension rings through which a pole was threaded for carrying. At Sutton Hoo they were found with the cauldrons in the 'domestic' end of the grave suggesting that they played a part in hospitality.

Bucket bindings have been found made from both iron and copper alloy. Iron would allow the use of the important cooper's technique of shrink-fitting the heated rings to lock the staves together, but it is unlikely that this was done. The size of the buckets varied between 400mm in diameter to thimble-sized miniatures. The Anglo-Scandinavian buckets from Coppergate were made from radially split oak so that the medullary rays would provide a layer impervious to liquids. They were generally of constant thickness, although the width of staves often varied on a single barrel. The edges of the staves were angled with an axe so that they fitted together forming a watertight joint. Around the inside of the staves a 'V'- or 'U'-shaped groove was cut, into which the base board was seated. The evenness with which these grooves were cut suggests the

8906

0 5cm

8908

20 *Basket bases, Coppergate, York.*
These perforated wooden plates held the uprights around which the basket was woven. Circular base, second half of the ninth century, fragment tenth century. Drawings from Morris 2000, courtesy of the York Archaeological Trust

use of something like a cooper's croze, a tool that cuts a groove at a set distance from the edge of a board or stave.

Unlike Early Anglo-Saxon buckets with their metal bindings, the Anglo-Scandinavian buckets from Coppergate all had wooden hoops suggesting that they were utilitarian rather than social objects. These hoops were usually made from split ash, which is strong and flexible and could be easily bent around the vessel. The surviving ends of some of the hoops were stepped so that they could be clipped together and they were also secured to the casks by means of wooden pegs. Wooden hoops do not give as tight a fix as iron hoops and it is necessary to use more of them on each cask. There are references to iron bound casks in the twelfth century, but we have no evidence for them in the Anglo-Saxon period. An eighth-century oak cask bound with hazel or willow hoops was found at Chapel Road, Southampton. This was made up from 17 staves and appears to have been straight sided. Fragments of casks were found in tenth- and eleventh-century contexts at York, Durham and Winchester and

the remains of a stave-built barrel were found in an early Norman pit at Pevensey Castle. This has an oval cross-section which is considered to have been an original feature. Illustrations of casks on the Bayeux Tapestry show that they were being made in the familiar 'bellied' shape by the eleventh century, but it is not known when they first appeared.

Basketry and lath-walled vessels

It is probable that basketry was considerably more important than the evidence would suggest. Two baskets were found used as well liners at Odell, Bedfordshire. One was made from osier (willow) rods and gave a radiocarbon date of AD 520 ± 40. This seems to have been woven on a solid base, perforated for the 49 uprights, but the base had been knocked out. The other basket used willow uprights with dogwood as the weave. It gave a radiocarbon date of AD 551 ± 40. A ninth-century oval basket base was found at Westgate Street, Gloucester and the perforated wooden bases for baskets were found in Anglo-Scandinavian contexts at Coppergate (20). These deposits also contained fragments of hazel roundwood which may have been used to make baskets.

Lath-walled vessels were made from a strip of split wood thinned by shaving to around 4mm and bent around to form a cylindrical box. Ash was used at Coppergate, but other woods have been employed elsewhere. Once the lath

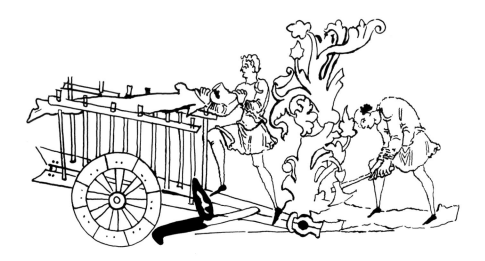

21 *Anglo-Saxon wood-cutters.*
Detail from an early eleventh-century calendar showing each month's tasks. Wood is being cut with a fan-shaped axe and loaded onto a cart. This appears to have a triangular chassis made from two beams joined at the towing point. The wheels are wooden, with spokes secured by pegs or rivets. What may be an ox-yoke lies against the side of the cart. Drawing by author after British Library manuscript Cotton Julius A.vi, fol. 5v

was cut, it was softened by soaking, or perhaps steaming, to make it pliable enough for bending. When bent, the overlapping ends of the cylinder were secured by sewing or pegging. The flat base was held in position by pegs which went into its edges. A feature of the base was a notch that accommodated one of the overlapping ends of the lath. Boxes of this type were made over a long period of time and are difficult to date. An example was found in a late ninth-century context at Coppergate, but the technique was still used to make sieve hoops in the twentieth century.

The wheelwright

Unfortunately, we have no surviving example of an Anglo-Saxon wheelwright's work. The craft is an old one with examples of spoked wheels being found in Iron Age contexts at Glastonbury and Mere. Spoked wheels are shown on the Bayeux Tapestry, although the detail is insufficient to be useful, but a wheeled plough and a cart depicted on British Museum Cotton Julius A VI, a calendar of early eleventh-century date, are more informative (**21**). Both vehicles have spoked wheels, the rims of which are built up out of curved felloes, but where these wheels differ from modern practice is in the presence of a rivet or peg set either side of each spoke. These would be unnecessary on a wheel fitted with an iron tyre, as the contraction of the tyre locks the wheel together. The use of iron tyres is known from the Iron Age, but it may not have been employed by the Anglo-Saxons, at least not on these agricultural wheels. It is notable that the wheels on the wagon found in the Oseberg ship burial lacked tyres. A further possibility is that the wheel was fitted with strakes, curved metal plates nailed to the rim, which would protect but not secure the felloes. The cart shown in the wood cutting scene is interesting in its own right. It appears that its main frame consisted of two beams, tied together where the animals were attached. These then diverged towards the back of the cart where they were linked together by a pole so forming a triangular chassis. The object apparently lying against the side of the cart may be the yoke for attaching the oxen.

2

TIMBER BUILDINGS

Stone was little used by the Anglo-Saxons for secular buildings, and the use of stone, even for churches, only became relatively common in the Late Anglo-Saxon period. In most cases, all that remains of timber buildings are the traces of the holes into which the wall posts were set. Most Anglo-Saxon timber buildings would have been relatively simple structures, but there are some exceptions: the ninth-century palace at Cheddar contained large, fine buildings and the structures at Cowdery's Down appear to have been remarkable (**23**). Occasionally some wood survives, and we can see remains like the timbers from the watermill found at Tamworth, Staffordshire, and an arcade post from a late Anglo-Saxon hall incorporated in a later harbour frontage at Vintner's Place, London. We also have the walls and basements of Anglo-Scandinavian buildings preserved at Coppergate, York.

Grubenhäuser

The Anglo-Saxons used two basic forms of timber building, post-built 'halls' and *Grubenhäuser* – smaller buildings which consisted of a pit containing two or more post holes which supported a ridge pole. There has been a move away from the term *Grubenhäuser* to calling these structures 'sunken-featured buildings', a term which manages to combine opacity with inelegance. *Grubenhäuser* pits generally measured around 2m by 3m. At West Stow (**colour plate 12**), 70 *Grubenhäuser* were found, covered by blown sand which preserved evidence that does not usually survive. Of the 70, 32 had two posts and 38 had six posts. They were set in pits which ranged in shape from oval to rectangular, with a round-cornered rectangle being the most common. Most of the pits had sloping sides and, on average, the pits for the two-post *Grubenhäuser* had been cut to a total depth of around 760mm; six-post *Grubenhäuser* were deeper, ranging between 800-1100mm.

There has been some discussion as to whether *Grubenhaus* pits were planked over, or if the bottom of the pit represented the living surface. At West Stow, it was noted how clean the interface was between the fill of the pit and the sand into which it was cut. No trampling had occurred suggesting that the pits had been planked over. It was also noted that there were no signs of a step into the pit or a hollow where people had stepped down. Two of the West Stow *Grubenhäuser* (SFB3, SFB15) had burnt down and the fill of their pits contained large amounts of burnt timber and hazel withies, which are likely to represent the substructure of the roof. Some caution should be exercised in interpreting these timbers as floors. Stake holes around the edge of SFB3 suggest that it was revetted, which would make little sense if the pit was floored over. Stake holes were also found around a *Grubenhaus* pit at Colchester and could be seen around the edge of Building 13 at Catholme, Staffordshire where a possible entrance could also be seen. It is notable that charred planks in both West Stow SFB3 and SFB15 overlie one of the two main post holes, which could not have occurred if the posts were in situ when the building collapsed. Ten of the *Grubenhäuser* at West Stow contained clay hearths and it was suggested that the hearths in SFB44 and SFB49 had been on a floor overlying the pit. Hearths were found actually on the earth floors of *Grubenhäuser* pits at Bourton on the Water, Gloucestershire and Puddlehill, Bedfordshire. A Middle Saxon *Grubenhaus* excavated at Belton, Lincolnshire was found to have a cobbled floor. It appears that, while planked flooring may have been used on some *Grubenhäuser*, in other cases the occupation was on the earth floor.

We can only guess at the form of the roofs used on *Grubenhäuser*. Two-post buildings are best interpreted as having a simple ridged structure supported by the posts. In the case of six-post *Grubenhäuser*, I believe that the lateral posts supported two purlins to allow the roof height to be maintained in a way impossible with the ridge pole only. These purlins would have been linked by ties to prevent the thrust of the roof pushing them apart. The problem of the walls might be explained by what is, admittedly, special pleading: the existence of light screen walls made of turf or with some other structure that did not penetrate the subsoil. Experimental work carried out at West Stow has shown that it is inadvisable to extend the thatched roof down to ground level: rain water not only rotted the thatch, but was able to run under the thatch into the building.

Hall-type buildings

Anglo-Saxon hall-type buildings seem to have been built using earth-fast posts set directly in the ground, either in individual post holes or in a continuous wall trench. The posts may be in the centre of the trench or along one side so that

they can be braced against the undisturbed soil, as was found at Cheddar. With a good level of survival and careful excavation, it is possible to define the actual shapes of the posts as stains in the ground. It seems that most of the posts were split timbers and not round wood. On less well-preserved sites, the locations of the posts may be marked by pad-stones on which the posts were sited. In sill beam construction, the uprights were mortised into a horizontal beam set in the ground. This is primarily a later Anglo-Saxon technique which is found in urban contexts, but a variant was used on the ninth-century Tamworth mill, the machinery installed in the mill perhaps calling for greater structural rigidity (**24**, **colour plate 13**). A feature of many Anglo-Saxon halls is what has been described as 'weak corners', as can be seen at Catholme (**22**). The corners, where one would expect to find large structural posts, contained lighter timbers than that of the walls. This is not easy to understand in structural terms.

Experiments have been carried out in which Anglo-Saxon buildings have been reconstructed. These have produced some useful evidence, but reconstructions can only give negative evidence – if it falls down we got it wrong. Philip Dixon, however, pointed out that, using good sized posts to construct a relatively small building, it is all but impossible to get one that will fall down. He also discussed the essential nature of buildings constructed with earth-fast posts. They are quite different from a framed building, and a combination of the two techniques is difficult to achieve. It was found impossible to line up the pre-cut joints of a frame in earth-fast posts. This means that in a post-build structure, the joints must be cut when the posts have been erected, which, in turn, means that these joints must be simple, as it is more difficult to make a joint in a standing post than one lying on the ground. Making the joints on a standing post means that there is no need for the posts to line up as it is easy to compensate for any irregularity; variations in a line of posts may have been to allow a bent wall plate to be used. On many of these small, Anglo-Saxon 'halls,' the post holes are not paired across the width of the building, which would be the case if framing was used. It is wrong to equate the depth of the post holes needed for a building with that called for with a single, freestanding post. They do not need to be as deep as, once the building is erected, structural integrity will make it self-supporting.

In order to understand Anglo-Saxon timber building, it is necessary to look at the few cases where structural timbers have been preserved by waterlogging or have left such good traces that we can start to understand the way in which they were constructed. Two of the best examples of Anglo-Saxon building come from Cowdery's Down, Hampshire and what was a highly usual building, the watermill at Tamworth.

At Cowdery's Down, Basingstoke, Hampshire, the details of the sub-surface structure of the buildings were preserved in remarkable detail in the chalk soil

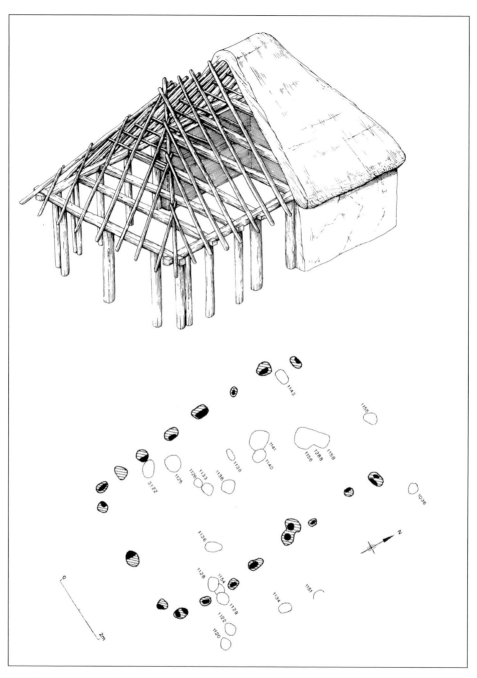

22 *Plan and reconstruction of hall building AS29 at Catholme, Staffordshire.*
The plan of this building shows the 'weak' corners often found on Anglo-Saxon buildings. In this
reconstruction the unevenness of the wall posts has been overcome by using a large number of linking tie beams
on which the wall-plate rests. This would also have given the advantage of additional storage space in the roof.
Illustration courtesy of the Trent and Peak Archaeological Trust

and it was possible to suggest an elegant reconstruction for one of them, Structure C12 (**23**). As this reconstruction has appeared in the archaeological literature on a number of occasions, it is worth briefly reviewing the evidence for this brilliant piece of archaeological deduction.

Structure C12 was a substantial hall measuring 22.1m long, 8.5m wide at its ends, expanding to 8.8m in the middle of its sides, where there were gaps for 950mm-wide doors. There was a gap for a third door, 1.15m wide in the eastern end of the building. The posts forming the walls were set in continuous trenches, cut into the chalk with a sharp-pointed tool. In the fill of the trenches it was possible to see the ghosts of the wall posts which had been rectangular timbers measuring 360-400mm wide by 80mm thick. These were set in two rows along the trenches, staggered so that the posts in one row were opposite the gaps in the other row. Between the rows of posts was a line of stake holes, each *c*.20mm in diameter, which were likely to have held the uprights for wattle-work. Outside the line of the walls was a row of post holes that must have accommodated buttress-like timbers. There was no sign of any internal aisle posts to support the roof of Structure C12, but it was divided into three parts by two cross walls, each with a central door.

Any reconstruction of a building from sub-surface remains is highly conjectural, and it must be emphasised that the reconstruction described here is only one of a range of possibilities suggested by the excavators. It does, however, use the evidence in an elegant way and serves to show what Anglo-Saxon builders could have achieved. The basic wall structure consisted of double rows of posts, between which were panels of wattle and daub. For structural integrity, there must have been horizontal timbers at intervals between the upright posts. It seems that Structure C12 was eventually burnt down so that charcoal and burnt daub were deposited in part of the wall trench that had not been fully back-filled. That this wall trench had remained unfilled is important, showing that it must have been covered in some way, and, as it was on the inside of the building, it is likely that it was beneath a wooden floor. The absence of occupation debris within the walls also suggests the presence of a raised floor. In the suggested reconstruction, the bottom of the lowest horizontal timber is raised 300-500mm above the ground – if it was any less, there would have been no need for the wattling that was present below it. An examination of the plan shows that the alternating wall posts are, in this case, aligned in pairs across the building, a feature that would allow the ends of the floor joists to rest on the top of horizontal timbers running along the wall. These joists would have also helped tie the building together.

As we move up to the roof of a building, things get still more uncertain. The presence of large posts either side of the doors in the two cross-walls strongly points to Structure C12 having a hipped gable roof, in which the

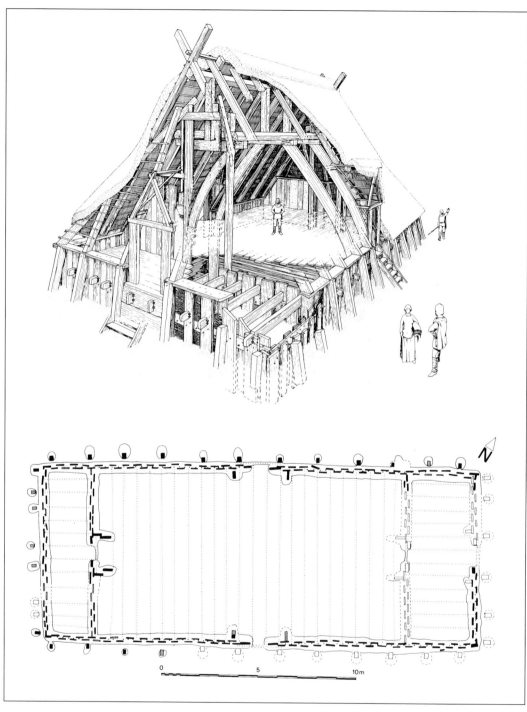

23 *Cowdery's Down, Hampshire, plan and reconstruction of building C12.*
The skilful excavation of this site allowed the traces of its sub-surface structure to be recorded in great detail.
A number of possible reconstructions were suggested, one of which is illustrated. While reconstructions must
always remain hypothetical, most of the features shown here are based on what was found in the ground.
Illustrations from Millet and James, 1983, reconstruction drawing by Simon James, courtesy of the
Royal Archaeological Institute

upper part of the gable end was angled back to shorten the ridge. This is unusual and it is likely that most Anglo-Saxon buildings had simple vertical gables. A thatched roof needs to have an angle of between 45° and 55° — any less than this and the thatch will leak, while a greater angle increases the weight of the roof to an unacceptable level and increases the chances of the thatch slipping. The roof of Structure C12 would have been 6m high at 45° and 8m high at 55°. It is likely that various roof coverings were used in the Anglo-Saxon period, but that thatch was the most common. A group of objects known as 'censer covers' are representations of church towers and their roofs are decorated with a scaled pattern suggesting the use of wooden shingles (**colour plate 25**).

In the absence of aisle posts, the weight of the roof of Structure C12 would have been carried on the walls. The buttress-like raking timbers against the walls were found to be at the wrong angle to counteract the thrust of the roof which, in any event, the walls were capable of supporting. It was thought that the raking timbers were intended to stop the wall-plate, which runs along the top of the wall, twisting under the thrust from the roof. It was thought that a ridge pole was used which was supported on the posts either side of the cross-wall doors. This still left the problem of supporting the main span of the roof and it was suggested that this was done through crucks, naturally curved timbers set in the post holes found either side of the side doors. It has been estimated that the material used in the construction of Building C12 would have weighed 70 tonnes.

It would be wrong to think that Anglo-Saxon buildings were constructed entirely from mature oaks. Looking at a large fifteenth-century farmhouse, Oliver Rackham found that it was made out of 330 trees of which only three were more than 450mm in diameter, half were less than 225mm in diameter, and 10 per cent were less that 150mm. While this is a much later structure, practicalities must always play a part — small oaks are much faster grown than the large ones and it is easier to shape them by simply flattening off four faces. It is unlikely that these had a long life — a buried oak post would have probably lasted, on average, about 25 years.

Very little metalwork of any kind was found at Cowdery's Down, but there is some literary evidence for the use of iron bindings in the construction of buildings, as in 'Beowulf' where the hall, Heorot, was described as '*innan ond utan irenbendum*'. As well as being used in shipbuilding, clench bolts are found on land where they have been used to secure timbers and fittings, like doors. A line of clench bolts was found across one of the buildings at Flixborough, Lincolnshire and they were associated with a building at Yeavering.

The Tamworth Mill (24, colour plate 13)

The Anglo-Saxon watermill found at Tamworth is remarkable both for the surviving timber work and the technological information provided by its structure. Dendrochronology gave a felling date of AD 855 \pm 9 for the mill timbers, but they may have been used in an earlier mill before being reused later in the ninth century. The mill ended its working life by being burnt down, but its waterlogged lower timbers survived. These consisted of the base of the wheel house through which the water was channelled to turn the waterwheel. The massive timbers were framed together using mortise and tenon and half-lap joints, with some use of square pegs. These did not go through the joints, but were passed through holes in the extended ends of the tenons preventing them from being withdrawn.

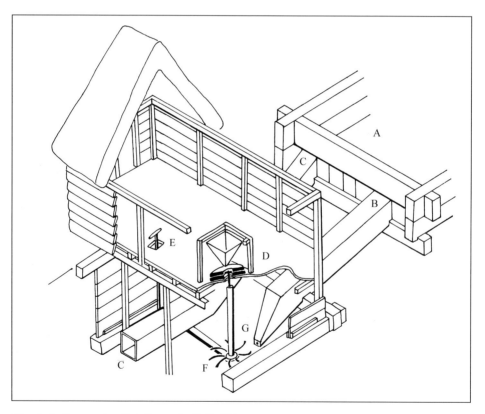

24 *Anglo-Saxon watermill at Tamworth, Staffordshire.*
*Possible reconstruction of the Tamworth Mill. The water from the river was retained in the pond by a revetment (**A**). From here it could either go down the chute (**B**) to emerge from the jet (**G**) and drive the horizontal water wheel (**F**). If the wheel was not in use, the water could be diverted down the relief chute (**C-C**). The power from the waterwheel was transmitted to the mill stones (**D**) by a vertical shaft. By raising and lowering the 'lightening bar' through the lever (**E**) it was possible to adjust the distance between the mill stones.* Reconstruction by the author after F.W.B. Charles in Rahtz and Meeson, 1992

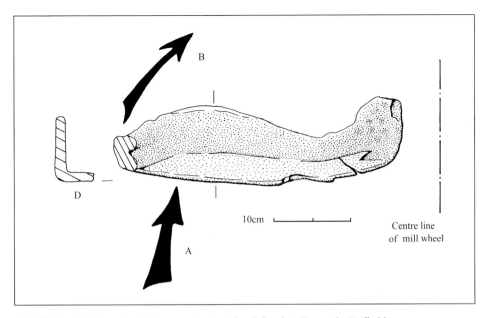

25 *Wooden blade from the ninth-century horizontal mill found at Tamworth, Staffordshire. The arrows show the direction in which the water jet was hitting the blade (**A**) and the direction in which it was revolving (**B**).* Drawing by the author after Rahtz and Meeson, 1992

Water was supplied to the Tamworth mill from a timber-revetted pond linked to the River Anker. It ran down a closed chute which would have been tapered, increasing the water's velocity to form a jet. This was most important, as, unlike most modern waterwheels, which are turned by the weight of the descending water, the Tamworth mill employed a horizontal wheel which was turned by the pressure of a water jet hitting wooden paddles. This acted directly through a vertical shaft to turn the millstones on a floor above. One of the wooden paddles from the wheel survived and, while not well preserved, was clearly of sophisticated design, with a shelf below the blade to hold the water long enough for its impact to be transmitted to the wheel (**25**). Three oak paddles from a horizontal mill were found at Nailsworth, Gloucestershire, but these lack the elegance of the Tamworth find. The Tamworth millwheel would have probably been around 1.22m in diameter, and had around 12 paddles. To one side of the chute supplying the waterwheel was a second chute which would have diverted the water away from the mechanism when the mill was not in use. This, like the water used by the wheel, would have flowed away through an outfall channel.

Horizontal watermills survived into recent times in Ireland, Scandinavia and the Atlantic islands and give us some idea of how they worked. The Tamworth mill's wheel revolved on a square block of carbon steel set into the end of the 'sole tree', a wooden plank that allowed the space between the millwheels to

be regulated. By lifting the sole tree, the millwheel was raised and with it the vertical drive shaft, to which was attached the upper millstone on the floor above. The carbon steel bearing had a recess at its centre in which ran the millwheel's central spindle. This had seen some use as it had been turned over to allow its reverse side to be used. The fire that had destroyed the mill had preserved lumps of clay on which the lower millstone was seated. Contained in this material were traces of the cereal showing that the Tamworth mill was mainly grinding oats and possibly barley.

Fragments of millstones were found on the site of the Tamworth mill. These were 650-800mm in diameter and most were of local origin, being Coal Measures, sandstone and Sherwood sandstone, but fragments were also found of Mayen lava millstones from the Eifel in Germany. Those identified were all upper stones with a lip around their lower, cutting face, suggesting that they were used in conjunction with a smaller bottom stone. Mayen lava made the perfect material from which to make millstones, it being both hard and light. Lava mill and quern stones are not uncommon on Middle and Late Anglo-Saxon sites; two unfinished Mayen querns were found with the early tenth-century Graveney boat. Mayen lava querns and millstones may have been referred to in correspondence between Offa of Mercia and Charlemagne in which there is a mention of the supply of 'black stones' (petra nigra). Much more common than powered mills like Tamworth would have been hand querns, which were usually made from local materials. The typical Middle/Late Anglo-Saxon quern stone was flat with a vertical handle in the upper face. What may have been an iron pick from a bill used to dress mill-stones was found at Coppergate but, as no metallographic work was carried out, this identification remains uncertain.

Anglo-Scandinavian buildings at Coppergate, York

Excavations at York resulted in the discovery of a succession of Anglo-Scandinavian buildings of tenth-century date. These fronted onto the street and were between 3.5m and 4.0m wide and must have been in excess of 8.2m long. The earliest buildings were constructed of wattles, worked around stakes and posts but, oddly, little trace of daub was found (26). Later in the tenth century, these were replaced by planked buildings (27) which measured 3.0m by 7.0m and had 1.5m-deep semi-basements fitted with plank linings. These were constructed without the use of nails, pegs or joints, the planks held in place against the vertical posts by earth pressure. Some of the surviving posts had a half-lap joint and a peg hole at a height of 1.8m above the basement floor suggesting that the upper parts of the buildings were framed.

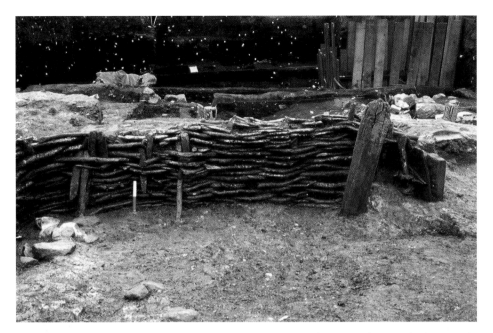

26 *Wicker-work walling at Coppergate, York, late ninth- or early tenth-century.* Photograph courtesy of the York Archaeological Trust

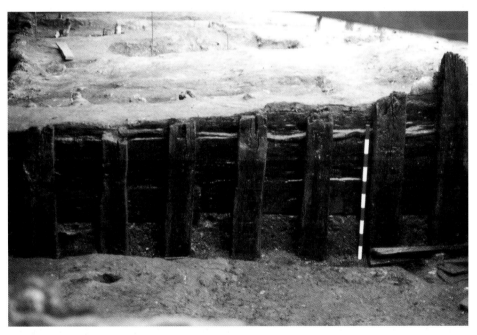

27 *Anglo-Scandinavian building at Coppergate, York.*
The timbered sub-basement of a tenth-century building at Coppergate. No joints were used at this level, the vertical posts secured the horizontal timbers against the sides of the pit in which it had been built.
Photograph courtesy of the York Archaeological Trust

A structure that often appears in the literature as our only surviving 'Anglo-Saxon timber church' is St Andrew's, Greensted juxta Ongar, Essex. However, dendrochronology has shown that the timbers forming the nave of this building only just belong in our period, with felling dates of AD 1063–1103. In spite of its late date, this building may represent the sole survivor of a building tradition that was once more common. Greensted church was built using stave construction which consists of a row of vertical tree trunks, the backs of which have been flattened with an adze to give a flat inner surface. Slots cut down each side of the staves held oak laths that would act as draught excluders. Tenons were cut into the ends of the staves and originally engaged into a wooden sill-beam (bottom) and wall plate (top) and were fixed with pegs.

Charcoal

Not a glamorous material, but charcoal was a mainstay of Anglo-Saxon industry, being required for smelting and metalworking. It would have been produced using the same methods as were employed in the recent past, carefully constructing a dome-like pile of small logs (probably coppiced) which would be covered with earth. The pile was then ignited, but combustion was carefully controlled, with only the minimum amount of air allowed, the wood being roasted, not burnt. In some cases a drain was provided beneath the pile, so that distillation products from the wood, mainly wood-tar, could be collected.

3

ANIMAL SKELETAL MATERIALS

Bone and antler

In the Anglo-Saxon world, bone and antler were used for many of the purposes for which we now use plastics, such as combs, handles, counters and other small objects. Bone is made up of both organic and inorganic materials. The organic component is mainly the fibrous protein collagen, and the inorganic consists of crystals of the mineral hydroxy-apatite. The collagen gives bone its tensile strength while the mineral component gives compressive strength. As bones represent the skeletal framework of animals, they have different structures depending on their place and function. Axial bones such as the vertebrae and ribs support and protect the animal's body while the appendicular bones form the legs and the girdles through which they operate. It is the appendicular bones which are the most useful to the bone worker as their long shafts provide a source of tough, solid material. Some bones from the axial skeleton were sometimes employed for special purposes such as thin casket mounts where their 'cancellous' (cellular) interior could be hidden.

As a product of butchery, bones would have been readily available in the Anglo-Saxon period, but, as the strength and possibly the working properties of bone may be reduced by cooking, it is unlikely that bone workers would have used cooked bones. It is fortunate that the most useful part of the skeleton, the lower leg bones, are poorly covered with meat and are likely to have been removed with the hide during primary butchery.

A far more useful and commonly used material in the manufacture of 'bone' objects was antler. Antlers are made up of coarse bone, produced very quickly over a period of months. Like bone, antler has a cellular 'cancellous' interior, although the ends of the tines are solid. Where it can be determined,

it has been found that most of the antlers used had been naturally shed and were not from animals killed in the chase. The native species available to the Anglo-Saxons were the roe and red deer, both of which were widespread. The date of the introduction of the fallow deer is contentious – Arthur McGregor reviewed the evidence and suggested that fallow deer were introduced towards the end of our period. Red deer shed their antlers in the late winter to early spring and roe shed between October and November. If they are not collected quickly, antlers may be gnawed by the deer to regain their lost minerals and weathering causes them to deteriorate. Antlers are not easily found and the collection of them would call for a detailed knowledge of the forest and the ways of deer. Obtaining antlers could cause problems and it is likely that some system of supply would have existed.

Bone and antler working

The first step involved in working antler was to separate the tines from the beam using a saw. While saws are otherwise rare in Anglo-Saxon contexts, bone and antler objects and working waste often show signs of the use of saws, and saws were used to cut the teeth on antler combs. The detached burrs from antlers (the bosses where they joined the skull) bear saw marks and it can be seen that the antler beam was being turned so that the saw blade did not bind. The beam was then divided into sections by quartering it with a saw, or by cutting grooves down its length and splitting it with wedges. A version of this technique was used on a Viking age antler from Haithabu which had been grooved and a bone wedge hammered into its cancellous interior to split it. Once split, the grooved surface of the beam and its cancellous interior were removed, leaving the solid material ready for working.

Bone, antler and ivory are tough materials and there has been some discussion of possible methods that could have been used to soften them prior to working. It has been suggested that antler could be softened by soaking it in an acid solution, a process carried out by modern Russian craft workers using vinegar (acetic acid). Experimental work has shown that antler can indeed be softened by the use of acids, including the leaves of sorrel (*Rumex* sp.), sauerkraut and soured milk which would soften antler to the extent that it would cut like wood in two or three days. Experiments carried out by Currey and MacGregor confirmed the softening of antler, but it was found that this was not fully reversible. The acid removed some of the mineral component of the antler and once this was gone it did not fully recover its strength. For purely decorative applications, this would not matter, but it would be unacceptable for thin objects like comb teeth. It was found that simply soaking the antler in water for

48 hours resulted in an improvement to its working properties. Fifteen minutes of boiling after soaking led to a further improvement in workability.

Decoration was usually executed with a sharp knife – the flat-bottomed cut produced by a graver has not been recorded. Arthur MacGregor found that some parallel lines appear to have been cut with a double saw, suggesting the presence of this tool amongst the bone worker's equipment. Some dressing of bone objects would have been carried out with a knife. A file found at Coppergate had widely-spaced teeth and it has been suggested that it would best be employed in the working of bone or antler rather than metal. A common feature on Anglo-Saxon bone objects is the 'ringed-dot' motif which sometimes appears in profusion. These are neatly and symmetrically cut and a tool with a rotary cutter turning around a central bit must have been used. There are indications that some bone objects had been coloured, which would have been important if the antler 'counters' had been used as playing pieces. A highly polished, Viking period buckle from York, had been dyed green and it has been suggested that this buckle was coloured to look like bronze. This seems unlikely as green is the colour of patinated copper alloy, and is not how it would have appeared when in use.

Some Anglo-Saxon antler objects were turned on a lathe – antler spindle whorls often bear concentric decoration which is easily executed on a lathe but difficult to achieve by hand (**33**). It is probable that these were turned using a small bow lathe. The other objects that may have been turned are the antler or bone counters found in early graves and urns. These are plano-convex, some having ring-dot decoration on their rounded upper surface and others having crude notches cut into their flat undersides. It is possible that these were turned in sticks on a lathe, and when turning had gone as far as possible, the sticks were removed from the lathe and sawn up to separate the counters. MacGregor suggested that they could have been made by roughly shaping them and then revolving them in a suitably shaped hollow in a block of abrasive stone, the notches on the flat faces acting as keys for the tool used to turn them. These notches are, however, not found on all counters, being common in some sets and absent in others.

Comb making

The most complex antler objects made by the Anglo-Saxons were composite combs. These were common objects and are frequently found on settlement sites and with cremation burials, as at Cleatham, where 30.6 per cent of the 960 urns contained comb fragments. Rough-outs for the making of tooth- and side-plates were found on the Early Anglo-Saxon settlement site at West Stow, Suffolk and in eighth- or ninth-century contexts at Fishergate, York. Further evidence comes from Haithabu, Ribe and Lund, where large-scale comb

making was being carried out. The evidence from these sites, together with a study of English combs, gives a good idea of the processes involved in the manufacture of combs (**28**). Although usually described as 'bone', most combs are made out of red deer antler. They consist of two main elements: the two side-plates, between which were riveted a row of thin antler strips into which the teeth were cut with a saw. Care was taken to use the antlers in the most economical and efficient way. The side plates were generally made from the lower parts of the antler beam and the tooth plates cut from its more solid upper sections. These were cut into short lengths and either sawn or split to form the flat tooth-plates. Sometimes bone was used for the side-plates as they did not need to be as strong as the tooth-plates. Tests on the mechanical properties of antler have shown how the comb makers maximised the strength of their raw material. A piece of antler is around three times stronger when bent along the length of the beam than when bent across it. This is important when making comb tooth-plates and it was found that they were all cut with their length parallel to the axis of the antler, even though the plates could have been made broader by cutting them across the axis.

Once the tooth-plates were cut from the antler, they were thinned down to around 2-3mm, probably using a chisel cutting down on to the end of the plate, followed by final finishing with a file or a stone. It was important that all tooth-plates on a comb had the same thickness as any variation would allow the thinner plates to slip out of position. This could be done by putting the tooth-plates in a wooden jig and filing them to the required thickness. The widths of the plates were also a consideration as the ends of the plates must coincide with gaps between the teeth. It is likely that this was achieved by the use of templates. The side-plates were decorated with knife- or saw-cut lines and ring-dot, but elaborate terminals appear on some early combs. Decoration was carried out prior to assembly as rivets often cut the lines.

Once the component parts of a comb were made, they were clamped together and holes drilled through the sides and tooth-plates with a bow drill. The iron bit was placed in a stock around which was wound a cord or thong attached to the ends of a bow. By working the bow back and forth, the bit was made to reciprocate rapidly and the hole drilled. Rivets were placed in the holes and then tapped to expand their ends and lock them into place. Comb rivets were usually made from iron, but copper alloy was occasionally used. The most common practice was for the rivets to pass through every second joint between the tooth-plates. The plates were not perforated and each bears half of the drilled hole on one edge. There were, however, rivets through the end-plates, as these were needed to lock the comb together. Once the comb was assembled it was trimmed to shape, and on single-sided combs, the tops of the tooth-plates cut level with the side-plates. The teeth were then cut with a

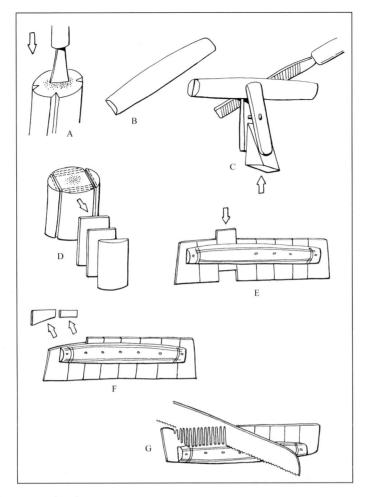

28 *Anglo-Saxon comb making.*
This shows the stages in the process of making a comb from antler: **A** *The antler is grooved and split into sections;* **B** *These sections are roughly shaped to make the side plates of the comb;* **C** *The pairs of side-plates are clamped together using a two-leaf clamp secured by a wedge. They are then dressed to shape;* **D** *The tooth blades are cut from a section of antler;* **E** *The side and tooth plates are assembled and fixed together with iron rivets;* **F** *The tops of the tooth plates are trimmed off, level with the top of the side plates. In the case of a double sided comb, these would be left, ready to have teeth cut into them.* **G** *The teeth are cut using a saw and are then trimmed to shape using a knife, file and possibly a stone.* Drawing by the author

saw which, oddly, was generally allowed to cut into the edges of the side-plates. In recent times, the makers of bone combs have used a double saw or *stadda* on which two blades were separated by a spacer. This allowed two teeth to be cut at once or each tooth to act as a guide for the cutting of its neighbour. The antler frame from a small bow saw was found at Coppergate and would have been ideal for the cutting of comb teeth (**9**). Once cut, the teeth would have been finished by knife-trimming and/or grinding.

Perforated antler strips occur that have been interpreted as clamps used to hold objects together during working (**28**). These consisted of two pieces of antler fixed together with a central rivet so that they resemble a two-part clothes-peg. A wedge was hammered into one side of the clamp which caused the jaws on the opposite side to close, pinching the work piece. An example of a clamp of this type was found at Coppergate, York and there is a possible example found in a sixth-century *Grubenhaus* at Puddlehill, Dunstable, Bedfordshire.

Motif pieces (**29**)

These are bones which have had one or more designs cut on them. Motif pieces are a well known but poorly understood phenomenon – it appears that they were being used by craftsmen to work out a design. Some, however, are so well finished that it has been suggested that they were used as dies for making *Pressblech* foils.

Some finely-decorated bone objects survive from the Anglo-Saxon period – the Franks casket is made from whale's bone, which is usefully confirmed by an inscription. The casket dates from the first half of the eighth century and is decorated with an eclectic mixture of images drawn from Christian and Jewish sources together with classical and Germanic mythology. It bears inscriptions using both Latin and Old English, written in Roman-based and runic lettering, all carved in low relief. The Gandersheim casket dates from the late eighth century and is also carved from whale's bone held together with metal strips. Its decoration consists of animals and birds surrounded by interlace, all executed in exquisite style.

Ivory

Ivory comes from the dentine tusks of elephants and the teeth of some sea mammals such as the walrus. Elephant ivory contains up to twice the amount of organic material as is found in teeth, allowing it to be carved with ease. The early Anglo-Saxon period saw a remarkable level of ivory use, the burnt remains of which is often found in cremation urns. Of the 960 urns at Cleatham that retained their contents, ivory was found in 168. While the frequency is high, the amount of ivory found is low, some urns containing only a scrap weighing less than 0.1g. These fragments come from ivory rings from the mouths of bags or purses, and their diameters suggest that they came from elephant tusks. There has been some discussion of the source of this material. It is probable that it was being imported from East Africa and India through Byzantium but, interestingly, ivory is not found in contemporary Frankish graves. Ivory was not the only exotic material found with early Anglo-Saxon

29 *Anglo-Saxon bone 'motif piece' from Coppergate.*
Cut into the surface of this bone are a number of animals executed in the ninth-century Trewhiddle style,
together with sketches of similar animals and a small panel of interlace. Drawing from MacGregor,
Mainman and Rogers, 1999, courtesy of the York Archaeological Trust

burials – coral and cowrie shells from the Red Sea also occur. There has been
some discussion of the possible use of ivory from sub-fossil mammoth tusks
and, while the tusks found in gravels are notoriously friable, tusks found in
waterlogged peat deposits might still be workable.

Arthur McGregor gives examples of British finds of mammoth ivory being
utilised in recent times. He also suggests that the metal bindings found on some
rings in graves may have been used to prevent a fossil ivory ring delaminating.
A further possible source of ivory was Siberia where mammoth tusks were
collected in the nineteenth century and used for the manufacture of billiard balls
and piano keys. Ivory becomes rare in England after the seventh century, its use
being restricted to a few ecclesiastic objects of eighth- and early ninth-century
date – its scarcity may have been a result of the Arab expansion around the
Mediterranean. In the Later Anglo-Saxon period, it seems that elephant ivory
was no longer available and walrus ivory was used. The surviving examples of
the Late Anglo-Saxon ivory carvings show something of the skill and vigour of
the people working in this medium. Objects were carved both in the round and
in low relief. Secular carvings from this period are rare, although we have some
seal matrices and a pen-case carved in walrus ivory (**colour plates 24**).

Horn

Horn consists mainly of keratin, a fibrous, sulphur-containing protein which also forms skin, claws, hooves and feathers. On animals like cattle and sheep, the keratin forms a sheath covering bony projections on the skulls, the 'horn core'. As horn is more prone to decay than bone it is likely that it is under-represented in the archaeological record, but traces of horn are commonly found on the tangs of Anglo-Saxon knives representing horn tips used as knife handles. The discovery of more than 2,000 fragments of sheep and goat horn cores in tenth- to twelfth-century contexts at the Lower Brook Street site in Winchester shows the importance of the industry in the city.

To prepare the horn, it first had to be removed from the bone cores which were attached to the skull. This was achieved either by soaking the skull for some weeks and cutting around the base of the horn, which allowed the keratinous sheath to be removed from the core, or by cutting away the sheath from the core in cylindrical sections. Fragments of cut horn-core from Fishergate, York, suggest that the latter method was used. Softening was achieved by boiling the horn for 60 or 90 minutes before removing its tip and then cutting down its length. After carefully holding the horn over a fire to soften it still further, it was then possible to open it out to flatten it or shape it.

In addition to its common use on knife handles, the hilt of a sword found in Cumberland was made from horn. This was also inlaid with gold and *cloisonné* garnet. Horn was also used on the seventh-century helmet found in a grave at Benty Grange in Derbyshire. This consisted of an iron band encircling the wearer's head and two strips of iron crossing over the top of the head. One strip extended in front of the wearer's face forming a nasal bar, and also behind the head to guard the neck; the transverse strip extended down over the ears to provide further guards. This framework was supplemented by additional strips in each of the quadrants. The frame was filled with horn plates, now decayed but represented by the characteristic pattern of fine lines on the corroded iron. Further strips of horn covered the junctions between these plates and were held in place by silvered rivets. The horn plates had been heated and moulded to fit the curving shape of the helmet.

The most prestigious use of horn in Anglo-Saxon England was as drinking horns. Most of these are represented only by their metal mounts, although we have an example without mounts from Broomfield, Essex. Drinking horn mounts were found in Mound 1, Sutton Hoo and in the aristocratic Taplow burial mound. The silver gilt mounts from the mouths of the Sutton Hoo drinking horns show that they had a diameter of 100mm which, together with their length (900mm), suggests that they came from aurochs, the great oxen that survived in Europe until the seventeenth century.

4

TEXTILES

The manufacture of textiles was a common, one might even say ubiquitous, practice during the Anglo-Saxon period. Most settlement sites produce evidence for the making of cloth – this usually consists of loom-weights or spindle whorls, but other textile-related finds may also occur. The practice of burying the dead fully clothed has provided valuable information about the textiles used in the early Anglo-Saxon period. Fragments of cloth and mineralised traces are preserved on metal objects, the corrosion products of which acted as a fungicide (**colour plate 14**). Due to the absence of brooches, much less is known about male costume than that of women. With the end of pagan burial in the seventh century, this source of information ceases, and we know much less about Middle Saxon textiles and dress. In the Late Saxon period, finds of textile equipment from urban excavations and manuscript illustrations provide information about textiles and clothing.

Anglo-Saxon textiles had a reputation for quality on the continent which may have been linked to the large numbers of eighth-century Frisian coins found in England. We also have the evidence provided by the exchange of letters between Offa, king of Mercia, and the Emperor Charlemagne in which Charlemagne complains that English merchants are entering his lands disguised as pilgrims to avoid tolls. He also comments on the miserable little cloaks that the English were now supplying, which, although not as long as before, cost the same. In another letter he wrote, 'What is the use of these little cloaks: I cannot cover myself up with them in bed, when riding I cannot protect myself from the wind and rain'. He also complained that he got cold when answering the 'call of nature' (*ad necessaria naturae tibiarum congelatione dificio*). Charlemagne was known to have conservative tastes, and may not have welcomed a new fashion, but this exchange of letters points to a trade in textiles.

Fibres used

Wool

Cloth is made up from fibres from plants and animals which can be spun and then woven. The most common animal fibre used by the Anglo-Saxons was wool. The sheep were sheared, or plucked, in June, each animal probably producing less than a kilogramme of wool. This must be washed or 'scoured' to remove dirt and some of the oil (lanolin) contained in the fleece. It is likely that stale urine, which contains ammonia, was used to loosen the lanolin so that it could be washed out. Before spinning, the wool fibres need to be aligned. This can be done with the fingers, but wool combs are more effective. These were used in pairs, the wool being picked up on one comb and pulled off it with the other, aligning the fibres. Two rows of iron teeth were set in an iron bound block of wood and attached to a wooden handle. This type was in use from at least as early as the seventh century, as is shown by finds from Lechlade, Gloucestershire and perhaps Shakenoak, Oxfordshire. Wool-combs are known from Middle Saxon Flixborough and Anglo-Scandinavian Coppergate, where the comb contained two rows of 93mm-long, iron teeth. The comb from Coppergate (**30**) was found to retain wool fibres around the base of its teeth. There is a reference to a '*wulcamb*' in *Gerefa*, an early eleventh-century account of estate management.

Silk

The cultivation of the silk moth, *Bombyx mori*, and the manufacture of cloth from the cocoons of its pupae originated in China, but by the tenth century, the practice had spread west into the eastern Arab Emirate, the Byzantine Empire and North Africa. Silk was found in a reliquary discovered in a seventh-century child's grave at Updown, Kent and also in the seventh-century smith's grave at Tattershall Thorpe, Lincolnshire. Imported silk ribbons are not uncommon on late Saxon and Anglo-Scandinavian sites and silk head-dresses have been found at Lincoln, Dublin and York, where there was evidence for them being made. Penelope Walton Rogers has pointed out that silk textiles are more common in areas that were under Viking control and suggested that it was being traded from Byzantium via the Russian rivers. Silk was used by English embroiderers, as on the textiles found in St Cuthbert's coffin.

Plant stem fibres

The best known plant fibre used in the Anglo-Saxon period is flax which comes from the stem of the linseed (*Linum*) plant. Other stem fibres available were hemp and nettle. Plant fibres consist of long, cylindrical cells which carried the water and food up the stem of the plant. They were usually harvested by pulling

2273

5cm

30 *Wool comb, Coppergate, York.*
The iron teeth were set in an iron-covered wooden block to which a handle was attached. Wool fibres were found around the teeth on this Anglo-Scandinavian comb. Drawing from Ottaway 1992, courtesy of the York Archaeological Trust

up whole plants, which were then dried. After drying, the seed pods were removed by pulling the stems through a toothed wooden 'rippler' and the stems were then placed in water for some weeks, a process known as 'retting'. During retting, the stems were broken down by partial decomposition so that the fibres could be removed from the tough outer surface. This was done after drying, by pounding them with heavy wooden mallets and then removing the tough outer covering from the fibres using a scutching knife which had a heavy paddle-like blade and was worked up and down the flax against a vertical wooden board. Coppergate produced two Anglo-Scandinavian wooden flax pounders, made from willow and alder, and an oak scutching knife (**31**). The fibres were then 'heckled' using long iron teeth which clean and separate the fibres ready for spinning. In contrast to the two rows of teeth on a wool comb, the rows of teeth on a heckle were grouped in thick blocks of wood. When dealing with the finds from the Flixborough settlement, Penelope Walton Rogers noted that the heckle teeth and wool-comb teeth were found separately, following the traditional practice of flax processing being done out of doors and wool dressing indoors. Excavations at St Aldates, Oxford, produced enormous quantities of

31 *Wooden tools for preparing flax from Coppergate, York, Anglo-Scandinavian.*
After 'retting' the flax stems were beaten with wooden pounders to break down the fibres. The fibres were then scraped with the paddle-like wooden 'scutching knife' to separate the useful material from the barky exterior of the stem. Illustrations from Morris, 2000, courtesy of the York Archaeological Trust

flax seeds in a gully between two wattle fences, which is likely to have been a retting pit. Pottery and radiocarbon dating showed this deposit to have been of eighth- or ninth-century date.

Textile production methods

Spinning

In spinning, the fibres are twisted together to form the yarn ready for weaving. If the fibres to be spun were long, as in the case of flax or long stapled wool, they were attached to a distaff that could be held in the hand or pushed

through the spinner's belt. Short stapled wools were made up into rolls or *rolags*, which rested on the spinner's arm. The surface of the individual hairs in wool and other animal fibres is covered with small scales or 'bracts' which interlock during spinning, preventing the thread from unwinding. The spinning wheel was not known in Anglo-Saxon England, probably only appearing in the thirteenth century, and all spinning was carried out using a drop-spindle. This consisted of the spindle, a short wooden rod which tapered towards its ends, the widest point being towards one end. Around this was the spindle whorl which acted as a fly-wheel (**32**). The end of the thread was attached to the top of the spindle, either by a notch or simple hitch. As the spindle descended to the ground, the strands of fibre were pulled from the distaff with one hand and fed into the spinning thread with the other. Once the spindle had reached the ground the spun thread was wound around the

32 *Anglo-Saxon spindle whorls.*
A & **B** *pottery whorls,* **C** *antler spindle whorl, all from West Stow, Early Anglo-Saxon;* **D** *whorl made from the end of a bone;* **E** & **F** *lathe-turned antler whorls, all Anglo-Scandinavian from Coppergate.* Drawings **A**-**C** by the author after West 1985; drawings **D**-**F** from MacGregor *et al.* 1999, courtesy of the York Archaeological Trust

spindle and the process repeated to form a long thread. Depending on the direction in which the thread was spun it can be described as Z- or S-spun. When viewed from above, a Z-spun thread was twisted in a clockwise direction – the twist, when viewed from the side, looks like the bar on a letter 'Z': '/'. S-spun thread was twisted anti-clockwise or '\'.

Spindle whorls are common finds with early Anglo-Saxon cremation burials and are also found on settlement sites. They were made of a number of materials including antler, ceramic, stone, lead and bone. Many whorls were turned to shape on a lathe, although cut, and in the case of pottery, modelled whorls, are also known. Most stone whorls were made of stone from the area where they were found, suggesting local manufacture. Large faceted beads made from glass and, in some cases, quartz, are found in sixth-century graves. These may have been spindle whorls; certainly the flashing of the revolving crystal would have been appealing.

Warping

Before weaving can begin, it is necessary to set up the vertical threads forming the 'warp'. These are very important as they impart most of the strength of the fabric – in some cases the horizontal 'weft' threads are only loosely spun fillers. The yarn would have been removed from the spindle and either made into skeins or wound into balls. The difficulties of setting up the warp should not be underestimated – dealing with a large number of threads which must be kept untangled and prepared for the loom takes some care. Penelope Walton Rogers has found that this is best done by following the recent Lappish practice which involves using a warping frame consisting of two beams of wood laid on the floor at 90° to each other. At the end of one beam, and at the angle where they join, two 700mm-long vertical pegs are set. A short peg is set at the end of the other beam. To set up the warp, around 24 threads are run from the angle peg to the small peg. These form a warp, on which the starting border is woven. A weft is woven through this, with a very long loop left on one side. These loops are taken back and forth between the two long pegs to keep them from tangling and, when removed from the warping frame, are mounted on the loom as the warp.

Weaving, the warp-weighted loom

Most weaving during the Early and Middle Anglo-Saxon periods was carried out on the vertical 'warp-weighted loom' (**33**). While little survives of the wooden frames, the clay loom weights that were used to keep the vertical warp threads under tension are common finds on settlement sites. To see the way in which these looms were used, it is helpful to consider the evidence from Norway, where warp-weighted looms remained in use into the 1950s. While

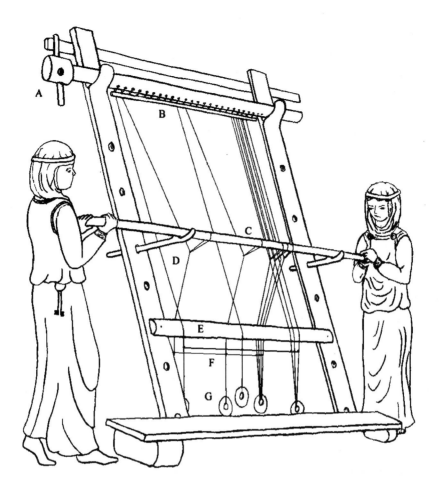

33 *Warp-weighted loom.*
Reconstruction of a loom in use, for clarity most of the warp threads have not been shown: **A** *Top roller with spokes for taking up the cloth as it is woven;* **B** *Starting braid stitched to top roller;* **C** *Heddle bar connected to alternate warp threads by leashes. By raising this, a second shed is formed through which the weft is passed;* **D** *The shed, through which the weft thread is passed;* **E** *The shed bar which forms the natural shed though which the weft is passed;* **F** *The warp threads are linked together to keep them in line;* **G** *The clay loom weights which keep the vertical warp threads under tension.* Drawing by Dianne Leahy

the parallels look convincing, caution is needed in using this evidence – as well as the long separation in time, the Norwegian looms come from the edge of this weaving tradition and may not reflect it as it was at its height. However, the technical difficulties faced by the weavers remain the same, and it is useful to see how they were overcome in recent times.

A warp-weighted loom consisted of two wooden uprights which were leant against a wall. Across the top of them was a roller resting on two crooked brackets. The upper ends of the vertical 'warp' threads were attached to this

roller through a heading cord or woven starting braid. This was sewn to the top roller through a series of holes, at 20-30mm intervals, drilled though a carved rib or step which ran along the length of the roller. The ends of the roller were also fitted with holes for spokes to help wind up the cloth during weaving. On recent warp-weighted looms, the height of the uprights varied between 1.96m to around 2.40m, but the length of the cloth can be increased by chaining up an additional length of warp below the loom and releasing it as weaving progresses. The width of the cloth woven on a warp-weighted loom is regulated by the length of the top roller, and it seems that widths in excess of 2m could be produced. The lower ends of the warp threads were tied, in groups, to the weights that gave the loom its name. Experiments suggest that 28 loom weights were needed for each metre of loom width. Loom weights found during the excavation of an Anglo-Saxon building at Grimston End, Packenham, Suffolk, lay in a double row of 30 and 32 weights, 2.44m long. Loom weights are often found in the small, sunken-floored, Anglo-Saxon buildings known as *Grubenhäuser*. At West Stow, 22 of the 70 *Grubenhäuser* were found to contain loom weights, but 15 contained fewer than ten weights, which is not sufficient to equip a loom. Two post holes found in the floor of a *Grubenhaus* at Bourton on the Water, Gloucestershire, were interpreted as the settings for a loom with provision for a seat for the weaver. This seems unlikely, as evidence from Scandinavia suggests that warp-weighted looms were not permanent fixtures, but consisted of knock-down frames that were stored when not in use. The weaver also stood up to use one.

In use, alternate threads of the warp pass either side of a pole fixed across the width of the loom, the 'shed bar'. This gave an opening or 'natural shed' through which a skein of thread was passed to form the 'weft' going under and over alternate warp threads. To make the shed for the return pass of the weft, a 'heddle bar' was used. This consists of a rod which is tied to alternate warp threads by loops or 'heddles'. When the heddle bar is raised, it lifts every other thread forming a second shed through the warp. Using the shed bar and heddle it is possible to make alternate openings so that the cloth can be woven. Just beneath the shed bar, two chain-wound cords were worked around the warp threads, one linking the threads behind the shed bar and one linking those in front. These ensured that they stayed in line during weaving.

The shuttle does not seem to have been used by the Anglo-Saxons and instead a skein was passed back and forth between the weavers, each pass of the skein of yarn forming a 'pick' of 'weft'. After five to seven picks, the weft was beaten upwards to consolidate the cloth, using a bone pin-beater followed by a weaving sword. In recent Norwegian practice, the sword beater was made out of iron, wood or whale's bone. Iron weaving swords are known from the graves of women, mainly in Kent and also occur on the continent. They range

in length between 240mm and 590mm and have what looks like a tang at each end (**34**). It is possible that one of the 'tangs' was used as a sort of pin-beater with a wooden handle on the tang proper. Weaving swords are known which have pattern-welded blades, for example Finglesham grave D3. While this could represent a cut down weapon, it is more likely that its aristocratic owner simply wanted the best. A weaving sword found during the excavation of Hall 7 at West Stow was 630mm long and had a squared-off tip at one end and a long tang at the other. Radiography showed that the blade of this was also pattern welded. In addition to the tanged weaving swords, a socketed type exists. In Scandinavia these date to the Viking period and are notable for their length. However, an example of what looks like a socketed weaving sword was found in a seventh-century burial at the Castledyke, in Barton on Humber cemetery. This resembles a weapon but its point and its edges are blunt and, at 350mm long, is short in comparison to the Scandinavian examples. The Castledyke weaving tool closely resembles spearheads of Swanton's type G1, an example of which was found with a woman at the Searby cemetery in Lincolnshire. A 535mm-long socketed weaving sword found in the pit which contained the Coppergate helmet is probably better linked with the later Norwegian tools.

Pin-beaters are pieces of bone or antler which range in length between 80 mm and 160mm and have diameters of between 8mm and 10mm with a point

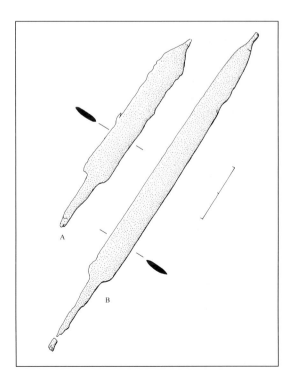

34 *Weaving swords from the Buckland, Dover cemetery.* Drawing by the author after Evison 1987

at one or both ends (**35A** & **B**). Well-preserved examples are highly polished and have grooves worn on their tips suggesting contact with the threads on a loom. It is possible that thin pin-beaters were linked to the weaving of linen. At Flixborough, it was found that phases in which thick pin-beaters were used also saw an increase in the size of the loom-weights, suggesting an increase in the use of wool. Pin-beaters are found on settlement sites, but also occur in graves and with cremation deposits.

As the weaving progressed, it was necessary to take up the woven cloth on the roller to allow weaving to continue at a convenient height. While it was possible for one woman to work a loom by herself, this was hard work. Women worked in pairs, one at each end of the loom, talking as they worked, but never mentioning anyone by name to avoid entangling them in their web. It is not a coincidence that we talk of weaving spells.

LOOM WEIGHTS (**36** & **colour plate 8**)
In the early Anglo-Saxon period, loom weights were annular, resembling ring-doughnuts, with a hole through their centre larger than the thickness of the ring (**36A**). These were replaced by 'intermediate' loom-weights with smaller perforations (**36B**). Eventually, these in turn were replaced by 'bun-shaped' weights which were thick and had a small hole through their centre (**36C**). The sequence seems to hold true for the Early Anglo-Saxon annular weights, but at the Flixborough Middle Anglo-Saxon site, it was found that interme-diate and bun-shaped weights were found in all phases. Many of the annular

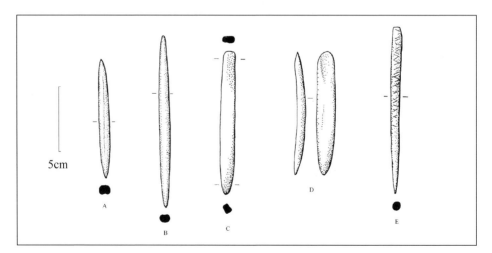

35 *Bone pin beaters, tenth or eleventh century.*
A & **B** *are double-ended antler pin beaters of the type used on a warp-weighted loom, fifth to ninth century.*
C & **D** *are single-ended pin-beaters and* **E** *is a long weaving pin. These are of the types used on a two-beam loom, tenth to eleventh century. Drawings by the author;* **A** & **B** *from West Stow after West, 1985;*
C-E *from Winchester after Biddle, 1990*

36 *Anglo-Saxon loom weights.*
A *is an early Anglo-Saxon period, doughnut-shaped loom weight;* **B** *shows later 'intermediate' weights which had smaller holes, but there was probably some overlap;* **C** *is a typical Middle Saxon loom weight, bun-shaped with a small hole.* Drawings are all by the author: **A** Sutton Courtenay, Berkshire, after Dunning *et al.* 1959; **B** Nettleton Top, Lincolnshire; **C** York, after Mainman and Rogers, 2000

loom-weights found on early settlement sites such as West Stow, Suffolk, Grimston End, Suffolk and Mucking, Essex were not fired and have reverted to clay. At Nettleton Top, Lincolnshire, it was found that clay used for unfired loom-weight contained temper as if prepared for firing. The practice of using dried loom-weights would have caused no difficulties so long as the weights did not get wet. Some unfired, or poorly-fired loom-weights, were found in Middle Saxon contexts at the Flixborough settlement site.

Stamp-marked loom-weights found on Anglo-Saxon settlement sites are difficult to interpret. At Flixborough the marks consisted of large and small circles, groups of four dots and deep stamps around the weight, in addition to which there were a number of stamps which only occurred once. Penelope Walton Rogers has noted that on the continent stamps are most commonly found at trading centres such as Haithabu and Ribe. While this might be equated with the Flixborough site which is situated on the River Trent, it cannot be true of Nettleton Top, which is in the middle of nowhere. These stamp marks could be the trade marks of particular makers (unlikely, as they don't appear to be much to boast about) or some system of recording the masses of weights, as was used in Norway. Some Anglo-Saxon loom weights had a radial groove cut across them prior to firing. On recent Norwegian looms, the warps were not threaded directly through the holes in the weights, but were attached by looped cords, which would fit into the grooves. This would also make it easier to move the weights down when weaving a cloth that was longer than the loom's height.

The two beam and horizontal looms (**37** & **38**)

Loom weights are rare on later Saxon sites, and it appears that the warp-weighted loom went out of use, at least on urban sites, during the late ninth century. What then replaced it? Other changes were taking place, it is notable that in the tenth century there was an increasing use of 2/1 twill for wool textiles, a weave not natural to the warp-weighted loom. Double-ended pin-beaters were replaced by a short, single-ended form, known as a weaver's pick-up (**35C** & **D**). These are nowadays used with the two-beam vertical or tapestry loom (**37**). Penelope Walton Rogers has speculated that the two-beam vertical loom arrived in England from France, where it had survived from Gallo-Roman times, in the tenth century, and was used for wool 2/1 twill in urban centres such as York and Winchester. It was probably joined by the sophisticated treadle-operated horizontal loom (**38**) in the later eleventh century, although this may have been used for linen plain weaves when it first arrived and only later developed into a wool cloth loom. The warp-weighted loom did not die out completely, a row of loom weights was found between two post holes at Sparkford, just outside Winchester, and dated to the eleventh century. At Rochester two clamp kilns, also dated to the eleventh century, were thought to have been used for firing loom weights. Thus, in the eleventh century there were three looms in use: the warp-weighted which was rapidly going out of use even in rural areas, the two-beam vertical loom which was temporarily used for 2/1 twill but which was eventually to become a tapestry loom, and the horizontal loom which was to develop into the main cloth loom of the late medieval period.

The two-beam loom (**37**) consists of a vertical frame across which are two cylindrical cross-beams both fitted with handles so that they can be revolved. Only one example has survived, this was found in the early ninth-century Oseberg, Norway ship burial. The warp is wound around the upper beam and the woven cloth is taken up on the lower beam; unlike the warp-weighted loom, therefore, the weft threads are pushed down. Two forms of beater are used for this, a single-ended type, sometimes with a chisel end opposite the point, and long narrow form which was held and used like a pencil (**35C, D & E**). Unlike the warp-weighted loom, it was possible to sit down to use a two-beam loom.

On a horizontal loom (**38**), treadles, operating through pulleys, pulled the multiple heddles, quickly producing the different sheds through which the shuttle was passed. These looms were more efficient than warp-weighted looms and cloth could be made six times faster. The work of compacting the weft was done by using a 'reed', two rods linked by threads that ran between the warp threads – a single pull on the reed was all that was needed. In contrast to the warp-weighted looms, it seems that horizontal looms were usually

37 (Right) *Two-beam loom, tenth century. The two-beam loom replaced the warp-weighted loom at the end of the ninth century. At this time, it was probably still used by women.* Reconstruction by Simon Chew, courtesy of Penelope Walton Rogers and the York Archaeological Trust

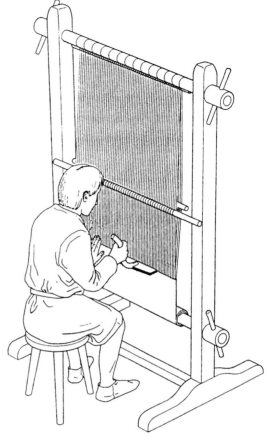

38 (Below) *Horizontal loom, eleventh century. This type of loom replaced the vertical, two-beam loom during the eleventh century. The weaver was able to move the heddle bars (**E-F**) by pressing the treadles (**A-B**). These operated through one or more pulleys (**C**). Once the weft threads had been woven they were pulled into place using the reed (**D**). As weaving progressed, the cloth was wound onto a roller in front of the operator. The shuttle seems to have come into use by this time. The number of warp threads has been reduced for clarity.* Drawing by Dianne Leahy based on technical details from Walton Rogers 1989

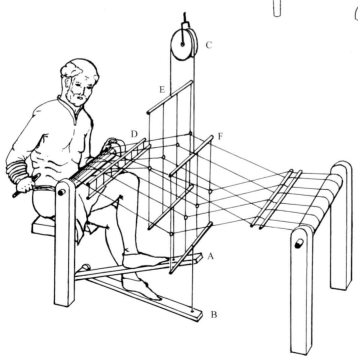

operated by men. The Jewish scholar, Rashi (AD 1040-1105), writing in Troyes in France, describes how men wove with their feet while women had a cane that they moved up and down, a distinction between a warp-weighted and a horizontal loom and the sex discrimination that went with it. As with pottery, it seems that once a craft becomes specialised and it becomes possible to support a family by its practice, it moves from being a feminine to a masculine activity, or from domestic to specialised.

Textile products

In its simplest form, woven cloth consists of the horizontal, weft threads being passed over and under alternate warp threads to form what is known as 'plain' or 'tabby' weave. In addition to tabby weave, the Anglo-Saxons also produced twills, in which the weft threads passed over two or more warp threads. As on each pass the weft stepped over one warp, it was possible to produce a cloth patterned with diagonal lines or diamonds. These more complex weaves called for additional heddle bars to allow for the different passes of the weft. Fabrics are described in terms of the relationship between the warp and the weft threads and the number of threads per centimetre. A tabby weave is 1/1 with one weft thread crossing each warp. In a 1/2 twill, each weft thread will cross two warps before going under the third. In a 2/2 twill, two weft threads cross two warp threads. Weaves ranged between a coarse 5 x 5 threads per centimetre and a very fine 30 x 28 threads/cm, but most textiles made by Anglo-Saxon weavers had more than 8 threads/cm. It is common for there to be more threads per centimetre in the warp than in the weft. Some evidence exists for the use of 'piled' fabrics in the Anglo-Saxon period. These had tufts of fibre woven into them to give a 'hairy' fabric used to make cloaks. Examples have been found in seventh- to eighth-century contexts at Gally Hills, Surrey and in an early seventh-century context in the great Sutton Hoo ship burial.

It has been suggested that, in addition to the warp-weighted loom, another loom was in use in Early Anglo-Saxon England. Marta Hoffmann argued that 2/1 twills from Sutton Hoo, Broomfield and Eriswell could not be made on an angled warp-weighted loom. The warp-weighted loom could only be used to produce an even numbers of sheds (from the shed and heddle bars) and three shed fabrics may suggest the survival of the Roman two-beam loom. In view of the increasing evidence for sub-Roman survival in the Anglo-Saxon period, the use of the Roman-type two-beam loom need not be excluded. It has, however, been pointed out that the problems involved in using a warp-weighted loom could be overcome by setting the loom vertically, effectively doing away with the shed bar.

Dyeing cloth

One of the many things that we now take for granted is access to a limitless range of permanent colours for our clothing. It is known that the Anglo-Saxons enjoyed the use of brightly-coloured fabrics. In AD 798, Alcuin saw fit to warn any English clerics visiting the continent not to wear their usual gaudy dress, and the Council of Clofeshoe in AD 747 had to explicitly ban clerics from wearing ostentatious clothing. If this was how priests, monks and nuns dressed, one can only wonder what the rest of the population looked like. The only limiting factor was their lack of dyes, but analysis has shown that naturally coloured wools were being separated in the Early Anglo-Saxon period, so that they could be used to produce patterned cloth.

The best dye available to the Anglo-Saxons was woad (*Isatis tinctoria L.*), which was cultivated and would give a strong and permanent blue. The young leaves were picked and reduced to a pulp, which was fermented in water until it turned into a dark sludge which was packed into barrels for sale or storage. To use woad it was fermented again in a heated vat, and wood ash added to the preparation to make the dye (*indigotin*) soluble. On being removed from the dyeing vat, the cloth or yarn develops its blue colour through oxidation. By repeated use of woad, it was possible to get a black cloth.

Yellow can be produced using dyer's broom or green weed (*Genista tinctoria L.*) or weld, (*Reseda luteola L.*), but this colour calls for the use of a mordant. A mordant is a substance, usually a metallic salt, in which the cloth is boiled (or soaked in the case of silk) prior to dyeing. It is then washed and boiled in a solution of the dye-stuff with the result that an unstable colour becomes fast. The most common mordant is alum, crystalline potassium aluminium sulphate $(K_2SO_4.Al_2(SO_4)_3.24H_2O)$ although in early times other astringent metal salts were known as 'alum' and could also be used to fix dyes. The extraction of alum from the Whitby shales did not start until the seventeenth century. Alum was extracted in Egypt and on the Mediterranean islands of Melos and Stromboli. At what stage it started to reach Anglo-Saxon England is not known, but if it was considered worthwhile importing mercury to gild objects in the sixth century, the importation of this other important aid to personal adornment might be expected. The clubmoss, *Diphasium complanatum*, was found at Coppergate and can be used as a mordant, as can iron, and possibly tannin. A green dye could be obtained by a combination of the blue woad and the yellow weld. Cloth could be dyed red by the use of madder which could be obtained from the roots of one of several species of *Rubia* with an accompanying mordant. This is not a native plant but it appears that it was being cultivated in England in the medieval period and may have been introduced into England at an earlier date. It has been identified at Coppergate. A good red could be obtained by the use of the lower stem of ladies' bedstraw (*Galium*

sp.), which does not require a mordant. The lichen, *Xanthoria sp.*, fermented with stale urine, will give an orange-brown and it is possible that a lichen such as *Ochrolechia tartarea* was used to give a purple; neither requires a mordant. While wool will readily take up dyes, linen is much less easy to dye. Linen will take up woad to some extent, but it is likely that it was usually left as its natural colour or bleached in sunlight.

The making of garments

The Anglo-Saxons used sprung iron shears in which the two knife-like blades were attached together by a long bar (**39**). In the early part of the period, it appears that the blades on most shears were joined by a 'U'-shaped return; later more open, round loops were used. At Flixborough it was found that the shears ranged in length between 100mm and 205mm. Small shears are found with burials, particularly cremations, but both their small size and the objects found with them (tweezers and sometimes razors) suggest that they were used in toiletry. Needles occur in the cylindrical, copper alloy, work boxes that are found in the graves of seventh-century women (**40**). These boxes were worn at the waist and have been found to contain needles, thread and sometimes scraps of cloth. Needles were made from iron, copper alloy and bone, although some of the bone needles may have been dress pins. At Flixborough it was found that iron needles were most common, representing 68 of the 81 found. This pattern was also found at Winchester and York, where iron needles predominated until the Norman Conquest, when copper alloy started to become more common. It was found that the iron needles at Flixborough ranged in length between 25mm and 47mm and were between 1.3mm and 3.8mm thick, while at Anglo-Scandinavian Coppergate, York they ranged between 23mm and 73mm or 1mm and 5mm in diameter. It is likely that needles were being manufactured at Coppergate (**41**). The eyes of copper alloy needles were usually made by putting long narrow grooves down each side of the head and punching through an oval eye. Most of the Flixborough iron needles were made using this method, but on occasion the end of the needle was split to form a 'Y', the two open arms of which were then re-united by hammer welding to form the eye.

The work of Penelope Walton Rogers on the textile finds from Coppergate has revealed some of the techniques used in the making up of clothing. Various methods were used to form the hems on Anglo-Scandinavian garments – when silk was being used, a simple rolled hem was employed, which used less of the valuable cloth and formed a tight hem. With other textiles, a hem could be formed by folding the cut edge in twice before sewing although, because of their greater bulk, the coarse wool cloths were often only turned once. In some cases a cut edge was covered with a fold of finer material to stop it

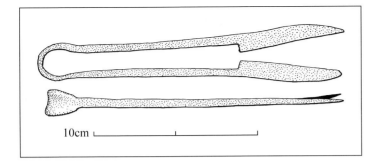

39 (Above) *Iron shears from Flixborough, eighth to ninth century.* Drawing by the author

40 (Right) *Work-box from Grave 183, Castledyke South, Barton on Humber.*
These *copper alloy boxes are found in the graves of seventh-century women and occasionally contain needles and scraps of cloth.* Drawing by the author after Drinkall and Foreman 1998

41 (Below) *Anglo-Scandinavian iron needles from Coppergate.*
*These show the three methods of forming an eye. In the case of **A** the end of the needle was simply flattened and a hole punched through. **B** was grooved on both sides prior to perforation and **C** was made by splitting the ends of the needle to form a 'Y' and rejoining the ends to form an eye.* Drawing by the author after Ottaway 1992

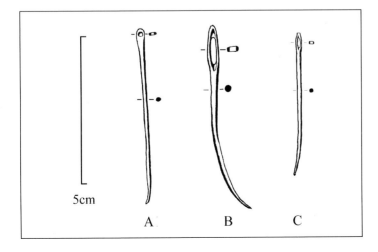

fraying. The Anglo-Saxon needle women were using all of the techniques used by the modern sewer, plus a few of their own.

Tablet weaving (42)

This technique was used to make decorative braids primarily for edging garments, but sometimes for use as girdles or to make the starting bands for attaching the warp threads to the upper part of a vertical loom. Weaving is done using a number of bone or wooden tablets with holes drilled through their corners. The warp threads are passed through these holes and by rotating them half a turn clockwise and then half a turn anti-clockwise, it is possible to offer alternative sheds to the weft thread which is being passed back and forth. Variations in the turning of the plates could be used to make complex weaves. A weaving tablet was found in grave 299, at the Kingston Down cemetery, Kent and consisted of a 'square flat piece of ivory with a hole in each corner'. This object no longer survives and it is not possible to confirm that it is made from ivory or if it exhibits the wear marks characteristic of a weaving tablet. A

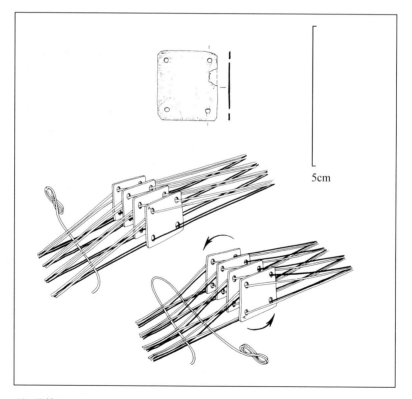

5cm

42 *Tablet weaving.*
An antler weaving tablet from Coppergate and an illustration of the process of tablet weaving. By revolving the tablets it was possible to change the shed and weave elaborate braids. Illustrations from Hall 1984, courtesy of the York Archaeological Trust

later, Anglo-Scandinavian, antler weaving tablet found at Coppergate measured 27mm by 35mm and, like the Kingston Down find, had a hole through each of its four corners.

Even the limited evidence available to us shows that braids were made in bright colours – a 20mm wide braid from Fonaby, Lincolnshire was blue or green with a red border and a braid from Mucking, Essex used blue, and possibly, yellow threads bounded by red. In some cases, the tablet woven band was further decorated with the addition of surface-brocading. In this process, a fine strip of gold or silver was threaded across the face of the braid to form a supplementary decoration, usually consisting of simple geometric patterns. While the cloth braid has long since decayed, traces of these gold strips have been found in more that 20 sixth-century Anglo-Saxon graves, mostly in Kent. It is usually found in the graves of women and lies across the skull showing that it came from a headband or the edging of a veil. In these Early Anglo-Saxon graves, the metal thread was in the form of strips of metal, which varied in width between less than 0.5mm at Taplow and 2.0mm at Faversham.

Embroidery

Anglo-Saxon embroidery was famous, with *opus anglicanum* being admired on the continent in the years following the Norman Conquest. Other finds show this work to have had a long ancestry stretching back to the eighth century and earlier. A few fragments survive to show that this reputation was fully deserved. The so-called *casula* of SS Harlinde and Relinde at Maeseyck in Belgium is a composite of textiles made in England in the late eighth or early ninth century. These fragments are decorated with roundels and arcading, both containing birds and animals. The best known examples of Anglo-Saxon embroidery are the stole, maniple and girdle found in St Cuthbert's coffin-reliquary at Durham (**colour plate 6**). These textiles were not linked to the Saint, who died in AD 687, but were placed with his remains after *c.*AD 934, when they were presented to the community of St Cuthbert by King Athelstan. An inscription records that the stole and maniple were made by command of Queen Ælfflæd for Frithestan, bishop of Winchester between AD 909 and AD 916. These textiles are decorated with a central panel depicting the *Agnus Dei*, either side of which are the figures of prophets, each identified by an inscription. The field around the figures contains a graceful composition of Winchester-style acanthus leaves, executed to the highest standard. If all 16 of the Prophets had been present, the stole would have been about 3m long with a width of 60mm. Each of the figures is about 125mm tall.

The stole was worked in coloured silks of dark blue, brown, dark green, brownish-red, and red together with gold thread, all laid onto an off-white ground with a red couching thread. The gold thread embroidery was made by

cutting thin gold sheet into narrow strips and then twisting them around a core of red silk to give a 0.78mm diameter thread. Two embroidery stitches were employed in the manufacture of the St Cuthbert stole – stem stitch which was used for outlines and some details, and split stitch which was employed for the fillings of the figures and foliage. The gold thread was couched, that is sewn down to the surface, and was then hammered to increase its apparent thickness. Spun gold thread was also used in the decoration of the Maaseik embroideries. These were worked on a linen base in silk threads of beige, green, red, yellow as well as light and dark blue.

The Bayeux Tapestry is, without doubt, the most important piece of Anglo-Saxon embroidery to have survived. While it takes its name from the town in Normandy, where it has been housed for 900 years, there is no doubt that it was made in England, justifying its inclusion here. The 'Bayeux Tapestry' is not a tapestry, but a piece of embroidery, made from dyed wools laid on a bleached linen ground. It is around 500mm wide and its surviving 70.34m length is made up of eight sections sewn together. Eight colours were used, with five predominating: terracotta red, blue-green, sage green, buff and blue. There is some variation in the hue of these colours which must, in part, be due to the use of different batches of dye. The embroidery was done by laid and couched work, supplemented by the use of stem and outline stitch. In laid and couched work, parallel woollen threads are laid close-packed over the area to be covered. A second series of threads usually, but not always, of the same colour were then laid at right angles to these. These were spaced at about 3mm and were, in turn, couched down to firmly secure the whole block of thread in position. Details were then added using stem or outline stitch. The whole effect is of raised figures standing in low relief against the flat linen. The Bayeux tapestry is perhaps unusual only in that it has survived to represent what must have been a common art form, these hangings being used to decorate walls throughout northern Europe. In the epic poem *Beowulf*, halls are said to have rich hangings and it is known that the minster at Ely once contained a '*cortina*' or curtain on which were recorded events in the life of the Ealdorman Byrhtnoð who was killed fighting the Danes in AD 991. While this tapestry does not survive, Byrhtnoð's final fight is described in the Old English epic poem, *The Battle of Maldon*.

Soaps and detergents

Despite the popular belief that no one took a bath between AD 400 and AD 1900, it is doubtful that the people of the past were quite as filthy as we have been led to believe. It is interesting to note that in medieval hagiography,

extreme filth was seen as a sign of holiness, suggesting that the less pious were trying to keep themselves clean. Little is known about Anglo-Saxon cleaning materials, but we can consider what was available to them. Cleansing was also important in some manufacturing processes – it is impossible to dye a wool cloth unless the natural oils are removed.

Alkalis can be used as detergents – the one most easily available to the Anglo-Saxons was wood ash, which contains potassium carbonate (K_2CO_3). This can be washed out of the wood ash and concentrated by evaporation, or used as a 'lye', a solution of alkali in water. An alkali which was very important in the past was stale urine which contains ammonium carbonate, distasteful as it might seem, this substance was much used and works well. It is also possible that use was made of soapwort, *Saponaria officinalis*, the boiled leaves and roots of which contain saponins which will form a lather and are still used in the cleaning of delicate fabrics.

Soap is mentioned in a Carolingian document, *De Villis et Curtis*, which dates from *c*.AD 800, which recommends that some of the workers on an estate should be versed in the boiling of soap. A tenth-century Anglo-Saxon magical ritual contains a reference to 'hallowed soap' and soap is mentioned in Anglo-Saxon *leechdoms* or medical books. From a little later than our period (*c*.AD 1175), we have a reference to soap in a homily, 'She smeareth herself with face-powder, which is the devil's soap'. Soap making is also suggested by the place-name, Sapperton, Lincolnshire. This appears in Domesday and comes from the Old English 'sāpere tūn' or 'the soap maker's village'. The soap that the Anglo-Saxons would have been able to make would have been

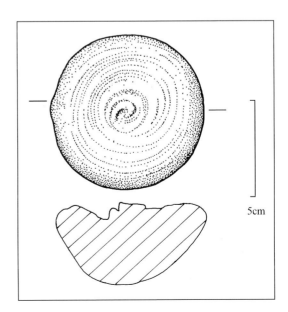

43 *Glass linen smoother from London. These objects were probably heated and used to 'iron' linen after laundering. They were known in the Roman period, but become more common in the Late Saxon/Anglo-Scandinavian period. Drawing by the author after Vince (ed.) 1991*

5cm

a soft soap, produced by boiling wood-ash lye with quick-lime to 'sharpen' it, taking off the clear liquor and boiling this with fat or oil. In order to make the more desirable hard soaps, it was necessary to use a sodium carbonate lye, made from natron or the ashes of marine plants. These soaps were mainly products of southern Europe.

An object that may relate to the cleaning of cloth are the so-called 'linen smoothers' or 'slick stones' which occur on a number of sites with examples from London (**43**), York, Winchester, Thetford and elsewhere. They are bun-shaped and made from 'black' (usually very dark green) glass, which is often in poor condition suggesting that it was made using potash as an alkali. It is probable that linen smoothers were heated and used, like an iron, to press linen after washing. Microscopic examination of some well-preserved examples has shown fine scratch marks that are in keeping with this use.

5

LEATHER

Leather was of great importance in the Anglo-Saxon period as its toughness and flexibility could not be provided by other materials. It was used for footwear, clothing, straps and belts, harnesses, sheaths and scabbards, and many other purposes that have not survived in the archaeological record. In Ælfric's *Colloquy* which was written around AD 1000, the Anglo-Saxon leather worker says:

> I buy hides and skins and prepare them by my skill, and make of them boots of various kinds, ankle-leathers, shoes, leather breeches, bottles, bridle-thongs, flasks and budgets (containers), leather neck pieces, spur-leathers, halters, bags and pouches, and nobody could wish to go through winter without my craft.

Leather is made from the skins of animals – therein lies a problem, as the natural fate of a skin is rapid and smelly decomposition. The craft of the tanner involves stopping this decomposition and making the skin stable and flexible. Skin or hide consists of three layers: the *epidermis*, the *dermis* and the *subcutaneous tissue*. The epidermis is the outer layer containing the hair and hair roots. Below this is the fibrous dermis or 'corium', the main part of the skin which will form leather. This in turn covers a layer of fleshy fat, the subcutaneous tissue. When a hide is removed from a carcass, it must first be washed to remove blood and filth, which could be done by placing it in a river or stream. To remove the outer layer of skin (the epidermis) it was necessary to loosen it. This could be done by 'sweating', which involved folding the hides, hair side, in and putting them in a warm place, where bacterial action will begin to rot the hair roots so allowing the epidermis to be scraped away from the corium. Alternatively, the epidermis could be loosened by soaking the hides in alkaline liquors of lime or wood ash of

increasing strength, or by sprinkling the hair side of the skin with urine. This would also have the effect of plumping the hide, opening it up to allow a better penetration of the tanning agent.

When the epidermis was loosened, the skin and hair could be removed, a process called 'scudding'. In more recent times, this was carried out using a blunt-edged, two-handled tool rather like a concave draw-knife. A similar tool was used to remove the subcutaneous flesh, but this had a sharp edge. No examples of these two-handled knives have been identified on Anglo-Saxon sites although they are known from a tannery found at Pompeii. It is possible that simpler tools, a long bone for scudding and a knife for removing the flesh, were used in the Anglo-Saxon period. Two iron 'slickers' of tenth- and eleventh-century date were found at Winchester. These tools look like blunt draw-knives and were used to force dirt out of the hide and to rub grease into it. To make a soft leather, it was necessary to treat the hide to remove the lime and some of the organic (*albuminous*) matter. This was done by soaking it in an infusion of poultry droppings or dog faeces which promoted bacteriological action leaving the hide soft and flabby.

Having prepared the hide, it was treated to prevent decay. A number of processes exist – a hide can be preserved by salting or smoking, although the product would have been stiff and unsuitable for most purposes. Fats, brains and egg white can be worked into a hide to prevent decay, the oxidation products of these fats acting as preservatives and giving a flexible, tough, leather. Dubbin can be used, made from tallow and fish oil, which gives a good, stable product. Hides can be preserved using alum in a process known as 'tawing'. The alum was usually mixed with common salt, but as this gives a poor leather, it was customary to supplement these ingredients with egg yolk, flour and oil. This process was known in antiquity and used in the medieval period, but it is not known if alum was available to the Anglo-Saxons in suffi-cient quantities to allow them to use it in tawing leather.

In the preparation of furs, it was essential that the epidermis be preserved. Fortunately the most suitable fur-bearing animals have thin skins which allow the rapid penetration of the preservative. The skins were stretched over a frame and the preservatives applied to the flesh-side only. In the Anglo-Saxon period, it is likely that furs were preserved using fats and egg whites. Furs are likely to have been extensively used and traded in the Anglo-Saxon period – an otter-skin cap was found in the Sutton Hoo ship burial and the lyre had been buried in a beaver-skin bag. Sword blades have been found bearing traces of the wool lining from their scabbards; the lanolin in the wool would have helped protect the blade from rust.

Until the invention of the 'chrome leather' process in the middle of the twentieth century, vegetable tanning was the most commonly used process.

This involved the use of tannic acid, usually from oak bark or oak galls to preserve the skins. The hides were first soaked in pits containing a weak liquor of oak bark and moved daily until they had achieved a uniform colour. They were then placed in a second pit, the hides being separated by layers of macerated oak bark and the pit filled with water or a mixture of water and weak tanning liquor. As the process continued, the concentration of tannin was increased ensuring that the tannic acid fully penetrated the hide and was not restricted to the surface. Vegetable tanning was a slow process and medieval guild regulations specified that the hides should spend 12 months in the tanning pit. Once tanned, the hides were washed and slowly dried ready for use.

Tanning pits have been found in Anglo-Scandinavian York. While there were major concentrations of tanneries around towns and cities in the medieval period, rural tanneries were still very common and persisted into recent times. As the distribution of tanneries is likely to have been due to the local availability of hides, a similar dispersal probably existed in the Anglo-Saxon period.

Vegetable tanned leather can be moulded using a technique know as *cuir bouilli*. This involves soaking the leather in cold water until it is saturated and flexible. It is then laid or beaten over a former made from wood, hardened clay or wet sand and moderately heated, the degree of heating affecting the final rigidity of the leather. On drying, the leather retains the shape of the former. This method can be used to make armour and vessels. The shoulder clasps found in Grave 1 at Sutton Hoo may have come from a two-part *cuir bouilli* corselet.

Most leather objects were assembled by sewing, a technique very suited to its fibrous nature which allows stitches to be placed close to cut edges. Sewing can be done with sinew or thongs, but it is likely that most Anglo-Saxon leather objects were sewn with waxed thread. This holds leather very well, will not unravel and continues to hold even if broken. Animal-based glues can be used to fix leather to a rigid surface, such as the face of a shield or a leather-covered box. A number of the needles found at Flixborough had the triangular cross section characteristic of leather working needles. Leather workers' awls had diamond-shaped points allowing a clean hole to be made (**44**). Awls were fitted with wooden handles, some of the Coppergate awls having a shoulder to prevent the iron point splitting the handle.

Another leather working tool identified at Coppergate was a 'creaser' (**44A**), which was a two-armed device looking like a pair of tweezers, the nips of which were turned sideways. A creaser was heated and run down the edges of leather, one arm sealing the moistened cut edge of the leather, the other impressing a decorative line parallel to the edge. Leather can also be decorated by the use of heated metal dies, which are pressed into its surface (**47**).

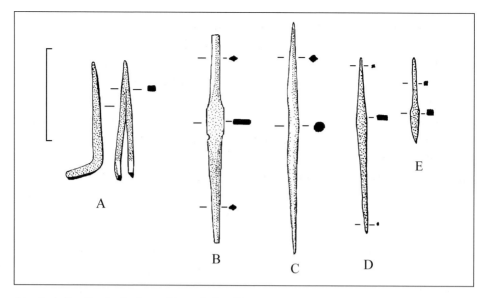

44 *Anglo-Scandinavian leather-working tools from Coppergate.*
A *Creaser for decorating the edge of leather;* **B-E** *Awls.* Drawings by the author after Ottaway 1992

Shoes

These were the most important leather product, but unfortunately have a low survival rate. Four early seventh-century shoes were found beneath the great silver dish in the Sutton Hoo ship burial. These were made by the 'turn-shoe' method which seems to have been introduced into England by the Anglo-Saxons (**45**). This involved the shoe being sewn together with the hair 'grain' side of the skin on the inside. When sewing was complete, the shoe was turned inside out, putting the tougher hair side outside and shielding the stitching within the shoe. The Sutton Hoo shoes were made from either cattle or deer hide, with the leather soles being no thicker than the uppers. In modern terms, they are size 7 (UK) or 40 (Continental). None of the buckles found around the Sutton Hoo shoes could be linked to them with any confidence, but strips of leather may represent thong-straps. One of the Sutton Hoo shoe fragments comes to a triangular point, which can be paralleled on a ninth or tenth-century ankle-boot from York where it ended in a toggle which engaged in a

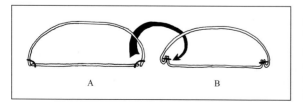

45 *Making a turn-shoe.*
*The sole and the upper are sewn together (**A**). Once this is done the shoe is turned inside out (**B**) so that the stitching is on the inside.*
Drawing by the author

loop around the ankle (**46**). A surprising feature of one of the Sutton Hoo shoes was a small strip of triangular sectioned leather with a line of holes down its centre. This could be interpreted as a 'rand', a precursor of the welt, a strip of leather sewn between the sole to the upper to help make it watertight. A piece of sole was found that lacked any sign of stitching and may have been part of an inner sole used to make the shoe more comfortable. While the Sutton Hoo shoes are very important, they may, with their fine stitching and thin leather, represent the footwear of only the upper tier of society, most people wearing something more robust. Surprisingly, in view of the riches in Mound 1, shoe 1 at Sutton Hoo was worn out, with holes in the heel and the end of the big toe. Perhaps worn shoes were already starting to take on a value as votive objects. Shoe 4 was, however, apparently unworn when buried.

Anglo-Scandinavian and Late Anglo-Saxon shoes and shoe fragments were recovered at Coppergate (**colour plate 21**) and Winchester. These were made by the turn-shoe method and have thin leather uppers, often made from a single piece of leather wrapped around the foot. Onto this was stitched a single piece flat sole, often with a triangular extension that went up the back of the heel. At Winchester a progression was noted in the way shoes were sewn together from the use of coarse thonging in the tenth century, through fine thongs, to the use of thread in the eleventh century. It was found that rands were sometimes used along the sole/upper joints.

Buckles are commonly found in Anglo-Saxon contexts, but it is rare for any evidence for a leather belt to survive. All that may be said is that leather belts were commonly used.

46 *Ankle boot from 5 Coppergate, York.*
This tenth-century boot was made by the turn-shoe method, the sole and the upper were both made from single pieces of leather. Stitching was at 8mm intervals using a wool thread. There is an opening in the front of the boot that was closed by a toggle. Illustration from McGregor 1982, courtesy of the York Archaeological Trust

Sheaths and scabbards

The mineralised remains of leather sheaths have been found on Early Anglo-Saxon iron knife blades and it is sometimes possible to see traces of decoration on the surface of the leather. Better preserved scabbards from water-logged deposits show the remarkable decoration borne by some of the later sheaths (**47**). This was impressed into the surface of the leather using metal tools. Anglo-Saxon sword scabbards were made from two strips of wood covered with leather. There is evidence that many scabbards were lined with sheep fleece, with the wool on the inside. This would have cushioned the blade, preventing it from rattling, and the lanolin in the wool would have helped inhibit rusting.

47 *Tooled leather knife sheaths from York.*
These show the skill of the Anglo-Scandinavian leather worker. Sheath 753 (left) can be dated to the second half of the eleventh century by its decoration. It probably originally had metal fittings. The other two sheaths date from the tenth to eleventh century. Illustrations from Tweddle, 1986, courtesy of the York Archaeological Trust

Cups and vessels

The remains of a silver-mounted leather cup, 75mm in diameter, were found with the helmet in the seventh-century Benty Grange, Derbyshire, barrow. Excavations carried out by the writer at the Sheffield's Hill, Lincolnshire cemeteries revealed the traces of organic vessels near the shoulders of a number of the burials. While these may represent the remains of wooden vessels, it is possible that leather was used and that the folded metal clips found in many Anglo-Saxon graves could represent, not repairs to wooden vessels, but the clips from rolled leather vessels. Riddle 12 in the Late Saxon *Exeter Book* refers to leather bottles.

Shield facings

One area where evidence for the use of leather does survive is the facings on wooden shields where the remains have been preserved by contact with the iron boss. A leather facing would prevent the shield board from splitting when the wood grain was struck end on. It may have been applied wet and allowed to shrink, tightening it around the board. The leather cover of the Sutton Hoo shield appears to have been made from vegetable-tanned ox hide, a very tough material. Ox hide seems to have been the preferred material for facing shields; the Laws of King Athelstan (AD 926-30) order that 'no shield-maker is to put any sheepskin on a shield'.

Parchment and vellum

While it is perhaps odd to add this sublime subject onto the end of leather working, it does perhaps naturally follow on from leather. Parchment is a special type of skin product. It is made from the skins of calves, sheep and goats and differs from leather in that it is dried, not tanned. In leather, the collagen fibres are interwoven, but the fibres in parchment are in lamellae, lying parallel to the surface. To prepare parchment, the skin of the animal was washed and soaked for 24 hours before being placed in a 30 per cent slaked lime solution. It was left in the solution for about eight days, depending upon the temperature. As with leather, the epidermis and hair were then scraped off, and the skin put into a fresh lime solution and soaked again. These soakings in lime were needed to remove the fat from the skin so that it would take ink. After re-liming, the skin was washed and stretched on a frame. In its weakened state it could not be nailed to the frame, and was attached by folding small pebbles

into its edges and tying a cord around them. These cords were attached to pegs around the edges of the frame and, by turning the pegs, the tension could be adjusted. Drying took place at around 20°C and at intervals cold water was poured over the skin until a smooth, sticky surface was obtained. At this stage it was thinned by shaving with a half-moon knife. Such knives are shown in use on a number of medieval manuscripts and an example was found on the Anglo-Saxon settlement site at Flixborough, Lincolnshire (**48**). This is an elegantly shaped tool with a sharpened edge and swept back wings. As the Flixborough excavation also produced evidence for literacy, this tool could plausibly be linked to the preparation of parchment. After scraping, the parchment could be removed from the frame and, following polishing and buffing with chalk, was ready for use.

The finest parchment was vellum which, as the name suggests, was made from calf skin, vellum and veal having the same origin. Sheepskins, and probably the skins of other animals, were also used, but the terms parchment and vellum are now interchangeable. Calfskin was thin, and was not yet damaged by the warble fly burrowing through the beast's hide. The two sides of a sheet of parchment have different colours, the grain side, on which the hair grew is darker, being creamy or yellow.

Manuscripts

Throughout the Anglo-Saxon period most, if not all, manuscripts were written by monks and, it must be emphasised, nuns. They were preserved in monastic libraries where they were seen as treasured possessions. In antiquity a book, *liber*, was written on a scroll of parchment, made up of squares sewn together to make a long strip. The book, as we know it, appeared in the second century AD, and was known as a *codex*. Such a book was made up from groups of eight or ten pages known as quires, gatherings or signatures, which were

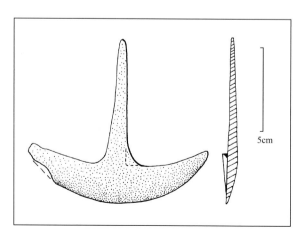

5cm

48 *Half-moon knife, Flixborough. This ancient form of knife has long been associated with leather working. The Flixborough knife is carefully made, with an angled cutting edge and probably dates from the eighth or ninth century.* Drawing by the author

sewn together to make the volume. This made the book easier both to bind and open. An Anglo-Saxon book could be impressive by its sheer mass – the one surviving great Northumbrian Bible, a manuscript now known as the *Codex Amiatinus*, is 10½in thick, contains 2,060 pages, each 27½in high and 20½in wide, and weighs 75lb. The skins of an amazing 1,550 calves were used in its production. It is understandable that the books of the Bible were usually bound as separate volumes.

In order to keep the lines of text straight, the pages had to be marked out. This was done by drypoint, using a stylus or the back of a knife to score the lines across the pages. The pages forming each quire of the Stonyhurst Gospel were marked out together, considerable pressure being used to press the line through all eight leaves. The decorated carpet pages of the great books were also marked out using drypoint, and the setting out lines can be seen on the backs of the pages. Writing was, of course, carried out using a quill pen. Pens were made from the flight feathers of geese and swans, the quills from the left wing being better, as their curve suits a right-handed user. Before a quill could be used it was left to dry for a few months to harden. The fletchings are then removed together with the outer skin and the inner pith leaving just the barrel of the quill. Using a short, sharp knife (the eponymous 'penknife'), the nib is then made, trimming down the sides of the quill to give the nib shape. A slit is made up the middle of the nib and a square cut made across the point which will actually be in contact with the parchment. Most depictions of Anglo-Saxon scribes show them to be holding a quill in their right hand and a knife in the other. As it is likely that a quill would need to be sharpened 60 or more times in a day's work, the knife would have been an essential part of the scribe's equipment. It would also have been useful for quickly erasing small errors and ink-spots. Depictions of Anglo-Saxon scribes show them to be working on very steeply angled boards and holding their quill lightly between the thumb and the first two fingers – their action would have come from the wrist, not the hand and would have been rather like that of a painter.

Two types of black ink were in use in the Anglo-Saxon period – one was made of carbon (charcoal or lampblack) mixed with a gum. The second was made from tannic acid from oak galls mixed with *copperas*, ferrous sulphate ($FeSO_4.7H_2O$, also known as green vitriol). This, too, was mixed with a gum to thicken it. *Copperas* occurs naturally in Spain and may have been imported. The making of tannic acid/*copperas* ink using hawthorn bark was described by Theophilus in the early twelfth century and both inks were known to the Anglo-Saxons. Coloured inks were employed on some manuscripts – red was made up of vermilion (mercuric sulphide, HgS) mixed with egg white and gum.

Wax tablets were used to keep notes, prepare drafts and practise writing. One half of a whale's bone writing tablet was found at Blythburgh, Suffolk.

One face of this is hollowed out to hold the wax and the other bears interlace decoration allowing it to be dated to the eighth century. Styli, of the sort that would have been used with the Blythburgh tablet, are becoming increasingly well known. One end bears a point for writing, the other being squared off for use as an eraser.

Book binding

While we have a reasonable number of Anglo-Saxon books, few survive in their original bindings. The best known is the Stonyhurst Gospel, which was found in the coffin of Saint Cuthbert (obit. AD 687) and almost certainly belonged to him (**49**). This tiny book measures only 134mm by 91mm and contains, on its 92 leaves, the Latin St John's Gospel, its plain text written with superb precision and accuracy. The binding consists of two quarter cut birch wood boards, each about 2.8mm thick. Four holes were drilled through the boards and two needles, each carrying eight strands of fine flax thread, were used to sew the quires between the boards. The threads were placed in narrow grooves so that they would lie below the faces of the boards. After sewing, the outer leaves were stuck to the inside of the boards. These were covered with

10cm

49 *The Stonyhurst Gospel. This copy of St John's Gospel was deposited in St Cuthbert's coffin in AD 687. It is one of the few Anglo-Saxon books to survive in its original binding.* Drawing by the author

red, vegetable tanned goat skin which was highly decorated. To achieve the raised decoration on the front cover the leather was laid, damp, over a pattern of cords fixed through holes in the board. Impressed lines were added to both the back and front covers and filled with coloured pigments. To join the leather to the leaves, head bands were sewn at the top and bottom of the book.

It has been argued that the binding of the *Victor Codex* at Fulda in Germany was executed in England during the late seventh or eighth century and that this book was once owned by St Boniface (obit. AD 754). The manuscript contained within the binding measures 137mm wide by 286mm high and is 86mm thick at the spine. Both its style and an inscription show that it was written in Italy in the sixth century. The original binding is obscured by later work, but careful observation by Sir David Wilson has made it possible to understand its form. Like the Stonyhurst Gospel, the *Victor Codex* is within leather-covered wooden boards. These boards are made of oak and are around 6mm thick. They are covered with red-dyed leather decorated with stamp impressions forming simple floral motifs. As with the Stonyhurst Gospel, the leaves were secured by cords which passed through holes drilled through the wood and were concealed in grooves. The two covers of the *Victor Codex* bear a series of metal mounts, some of which are decorated with interlace designs made using the pressblech technique. These designs allowed Wilson to suggest an Anglo-Saxon, specifically Northumbrian, origin for the binding. A series of gilt copper alloy plates bearing eighth-century style decoration are usually described as 'book mounts'. In the case of the gold mount found at Brandon, Suffolk which depicts St John the Evangelist as the eagle-headed man of Revelations, this may be the case, but other mounts could have come from boxes or crucifixes and some may have been secular. In the archaeological literature, a series of decorated lipped plates are often described as 'book mounts'. It is now clear that these are actually eleventh-century stirrup mounts and must be discounted.

6

POTTERY

Unlike most of the crafts described in this book, Anglo-Saxon pottery undergoes a technological development. Elsewhere, we see developments in the types of objects made and the way in which they were decorated, but little in the way of technological innovation. In pottery we have the reappearance of the slow potter's wheel in the seventh century and the fast wheel at the end of the ninth century, together with improvements in kiln design and the reappearance of glazed pottery.

Pottery is made from clay, a substance that is both common and widespread. Most clay is hydrated silicate of aluminium, kaolinite ($Al_2O_3.2SiO_2.2H_2O$), formed from the decomposition of rocks containing feldspar. This was distributed by water and glacial action and became the commonly found 'secondary clays'. In clay, the fine platelets of kaolinite are separated by water, which allows them to slide over each other, giving clay its plasticity. On drying, this water is lost and the clay loses its plasticity, shrinking by about 10 per cent; a pot will also shrink by this amount.

In addition to the clay that forms the basis of a ceramic, other materials were added as a 'temper' or 'filler'. This was sometimes added in large quantities and can make up to 30 per cent of the clay's volume. Fillers were added for a number of reasons:

They reduce clay's plasticity making it less sticky and easier to model or throw. They reduce the amount of shrinkage that occurs on drying and firing the pot. They give better resistance to thermal shock when a pot is placed over a fire. Grass filler absorbs moisture and makes a sticky clay easier to work.

As it is often impossible to say where a secondary clay came from, fillers are important, as they provide a guide to where a pot was made. The most commonly used filler was sand or quartz, but many other materials were used, including calcareous rocks such as limestone and chalk, crushed sea-shell, grass, straw and dung, fragments of fired clay or broken pots (grog). At Cleatham it

was found that many of the early urns contained crushed iron-ore and slag as fillers, which is probably related to the Anglo-Saxon slag-heaps that exist around the cemetery. A group of pots found in the English East Midlands are linked by the use of acid igneous rock as a filler. Petrological work on thin sections has allowed Alan Vince to confirm the source of the igneous rock as the Mountsorrel Granodiorite of the Charnwood Forest in Leicestershire. It has been suggested that this pottery was being made in the area to the south-east of Charnwood Forest and 'traded' throughout the region. So far this fascinating observation has been treated with caution.

Early Anglo-Saxon pottery (colour plate 22)

When Britain ceased to be part of the Roman Empire, the pottery industry collapsed. The fine, wheel-thrown, well-fired pots that characterised Roman Britain ceased to be made and were replaced by handmade pottery, sometimes of dubious quality. Early Anglo-Saxon pottery can be divided into two basic classes: plain domestic pots (**50**) and funerary urns, which were often highly decorated (**51**). While domestic pots were sometimes used as urns, sherds from decorated vessels are not common on settlement sites, suggesting that the decorated urns were purpose made. The cremation cemeteries contain large numbers of urns, there being about 2,700 at Spong Hill, Norfolk. Some settle-ment sites can also produce prodigious quantities of pottery – 53,570 sherds were found at West Stow.

Two sites have produced possible evidence for the preparation of potter's clay in the Early Anglo-Saxon period. House 21 at Sutton Courtenay, Berkshire was described as a potter's workshop. This 'building' consisted of a pit, measuring 6m by 5m with a maximum depth of 2.3m. In one corner was a wattle-lined hole, 600mm by 900mm, containing a dirty mixture of clay, gravel and charcoal. This was thought to be a 'puddling pit' in which clay was mixed with a filler before use, but in view of the mixed nature of the material in the pit and its odd location at the bottom of a deep hole, this identification seems unsafe. In the recent past, filler was introduced into the clay by spreading it over a floor and treading it in with bare feet. A better argument could be made for a deposit of clay found within a 7.6m by 8.5m oval enclosure at the West Stow, Suffolk settlement. The clay was in a layer 50-100mm thick and is thought to have been exposed for weathering, the ditch being used to keep out animals. Two antler dies for stamp decorating pots were also found at West Stow, which again suggest that potting was taking place. Weathering is important as clay, when dug out of the ground, is difficult to work – the kaolinite particles need to be broken down by frost, although clay collected from a river or lake bed can be used immediately.

1 *The Fuller brooch, silver with niello inlay, late ninth century.*
This remarkable object is decorated with figures representing the five senses. It has no known provenance and at one time was considered to be a fake, but analysis of the niello confirmed its date. Diameter 114mm. Photograph courtesy of the British Museum

2 *The Witham pins, late eighth century.*
The silver-gilt pin-set found in the River Witham at Fiskerton, Lincolnshire is a masterpiece of metal working. The discs are decorated with a complex pattern of animals surrounded by interlace. The animals' eyes contain small blue glass balls. These discs may not have originally been part of the same set, the central and left hand discs are similar, but the lozenge-shaped openings on the other disc suggest that it came from another source. It is also notable that the linking bars are crudely made in comparison with the discs. Diameter of central disc, 48mm. Photograph courtesy of the British Museum

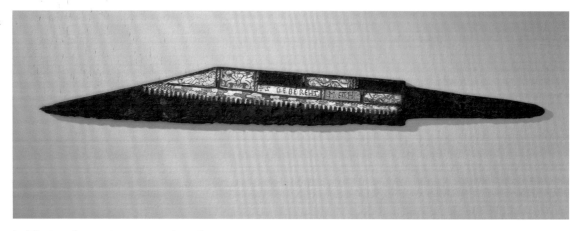

3 *The Sittingbourne, Kent, seax, early tenth century.*
Most iron objects are plain, but we have a small number of seaxes (single-edged knife/short sword) which are magnificent exceptions. Both sides of the Sittingbourne seax's blade are inlaid with silver, copper, brass and niello to give a startling polychrome effect. The side of the blade shown bears animals of 'Trewhiddle' origins together with acanthus leaves, a motif that became very popular in the tenth century. This face also bears an inscription reading +S[I]GEBEREHT ME AH 'Sigebereht owns me'. The other side of the blade is also decorated and bears the inscription +BIORHTELM ME ÞORTE *'Biorhtelm made me'. Length 322mm.* Photograph courtesy of the British Museum

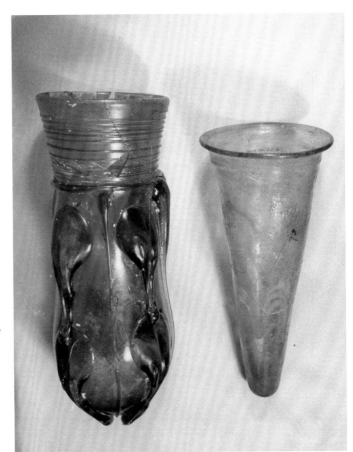

4 *Early Anglo-Saxon glass vessels: claw beaker from Sarre, and cone beaker from Bifrons.* Maidstone Museum, photograph courtesy of Brian Philp

5 *Bag beakers, Guilton, Kent, late sixth or seventh century.* Canterbury Museum, photograph courtesy of Brian Philp

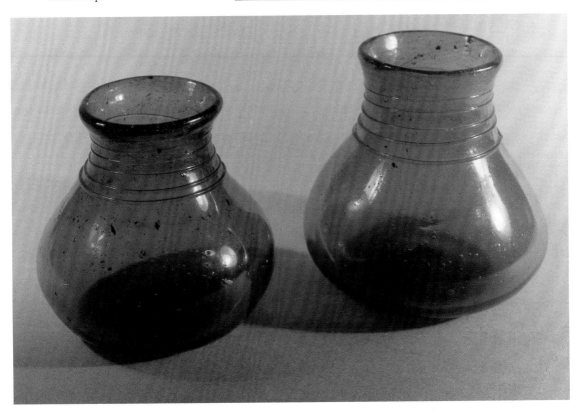

6 *'St Cuthbert's stole'.*
Figure of the Prophet Jonah from the silk stole placed with St Cuthbert's remains after c.AD 934. The stole is embroidered in coloured silks and enriched with gold thread. The figure is about 125mm tall. Photograph courtesy of the Chapter Library, Durham

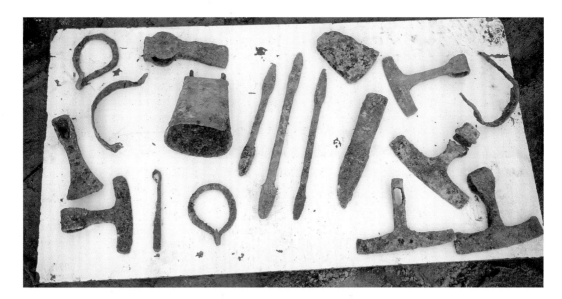

7a (Above) *The Flixborough tool hoard on the day of its discovery. The hoard was found within the two lead tanks, one of which was inside the other. It contained axes, adzes, spoon bits, shaves and an iron bell. An eight to ninth century date is likely.* Photograph courtesy of North Lincolnshire Museums

7b (Left) *The lead tanks in which the Flixborough hoard was found.* Photograph courtesy of North Lincolnshire Museums

8 (Below) *Loom weights found on the floor of a burnt building in Dover, seventh century.* Photograph courtesy of Brian Philp, Kent Archaeological Rescue Unit

9 (Above) *Torksey-type ware vessel from York, tenth century.* Photograph courtesy of the York Archaeological Trust

10 (Opposite, above) *Middle Saxon Ipswich ware.*
Ipswich ware was made using a slow wheel or turn-table and produced in a strong, well-fired fabric. It was used in East Anglia during the seventh to ninth centuries, but is sometimes found on sites elsewhere in England. Ipswich Museum, photograph courtesy of Brian Philp

11 (Opposite, below) *Stamford ware pitcher from Leicester.*
This finely made pottery appears in the late ninth century, but continues through the eleventh and twelfth centuries. It is finely made, glazed and was widely distributed. Photograph courtesy of John Lucas, Leicester Museums

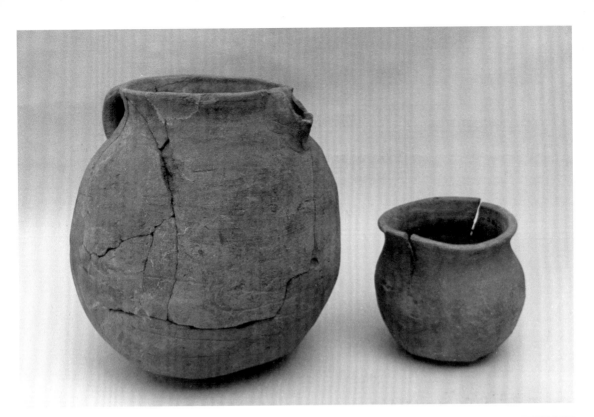

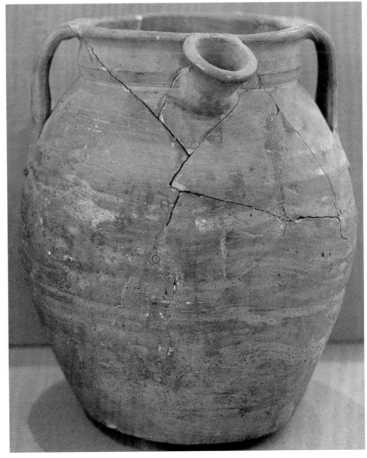

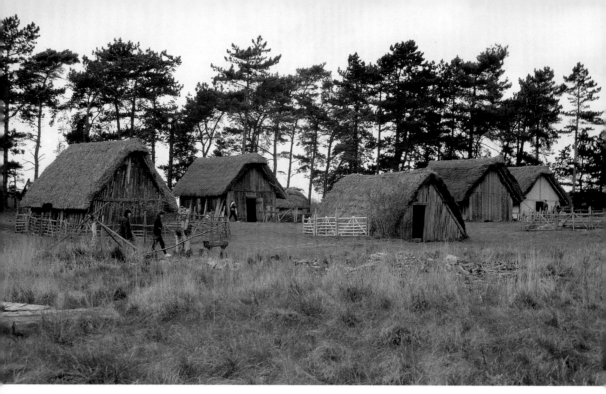

12 *West Stow Anglo-Saxon settlement.*
Reconstructed buildings at West Stow, Suffolk. Photograph by the author

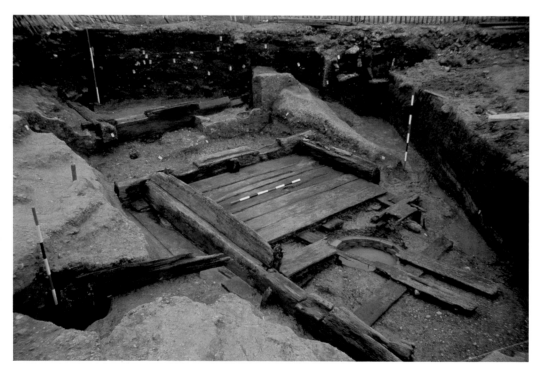

13 *Tamworth Anglo-Saxon water mill during excavation in 1971.*
The water was carried in conduits located in recesses cut into the two cross beams in the background. Water from the right-hand conduit turned a horizontal water wheel, set on the planked floor in the foreground. When the wheel was not in use, water was diverted though the left-hand conduit and ran to waste. Photograph courtesy of Professor Philip Rahtz

14 *Textiles and beads on the back of a sixth-century, cruciform brooch from the Cleatham cemetery, Lincolnshire.* Photograph by Mike Hemblade, North Lincolnshire Museum

15 *Cruciform brooch from Broughton Lodge, Leicestershire.*
Florid brooch decorated with gilding and white metal appliqué, *second half of the sixth century.* Nottingham Castle
Museum, photograph courtesy of Brian Philp

16 *Gilt copper alloy brooches from Billesdon, Saxby and Rothley, Leicestershire.*
These 'florid' brooches are gilded with some use of white metal appliqué. *The example from Saxby (centre) shows the work*
of someone whose ambitions exceeded their competence. They date from the second half of the sixth century. Leicester
Museums, photograph courtesy of Brian Philp

17 *Ingot mould, Stamford ware crucible and casting waste from Lincoln, tenth century.* Photograph supplied by
permission of Lincolnshire County Council Heritage Service (City & County Museum, Lincoln). Image
generated by Lincolnshire County Council Heritage Service

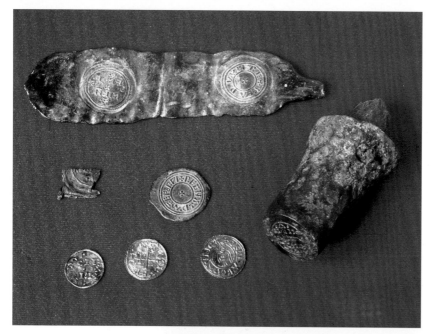

18 Coiner's die and lead trial piece from Coppergate.
One half of a pair of iron dies for striking silver pennies of the St Peter's type, AD 920-27, and a lead trial piece struck from dies made for pennies of King Eadwig, AD 955-59. Photograph courtesy of the York Archaeological Trust

19 Cloisonné *enamel brooches from Swallow and Horkstow, Lincolnshire, tenth century.*
It is only recently that the use of enamel was recognised in the late Anglo-Saxon period. The brooch on the left (from Swallow) has projections around its edge which contain blue glass balls. The Horkstow brooch bears traces of gilding. The Swallow brooch measures 25mm overall.
Photograph by Mike Hemblade, North Lincolnshire Museum

20 *Polychrome beads from Tallington, Lincolnshire.*
Photograph courtesy of Birte Brugmann

21 *Tenth-century Anglo-Scandinavian footware from Coppergate.* Photograph courtesy of the York Archaeological Trust

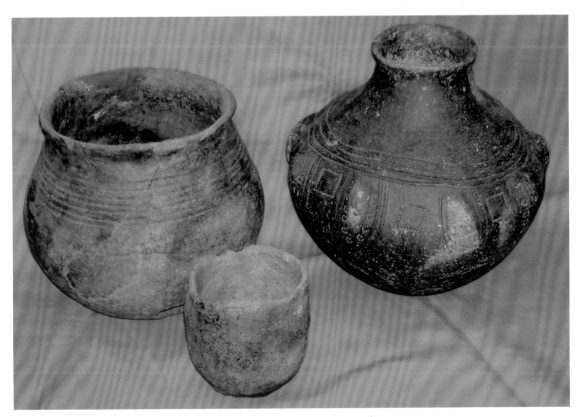

22 *Early Anglo-Saxon pottery from Cleatham, fifth to seventh century.* Photograph by Mike Hemblade, North Lincolnshire Museum

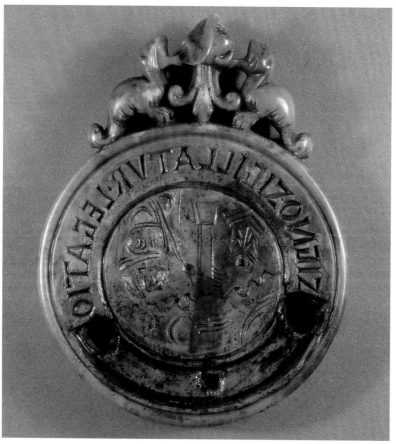

23 (Opposite and above) *The cloisonné garnet brooch from Kingston, Kent, early seventh century.*
This magnificent brooch shows most features of cloisonné *work, the cut garnets are set in cells lined with*
corrugated gold foil. Some use was also made of filigree. Diameter: 85.5mm. Photographs courtesy of
Liverpool Museums

24 (Opposite and above) *Walrus ivory seal matrix from Lincoln, eleventh century.*
The inscription SIGNO.SIGILLATVR.LEGATIO is incomplete, originally being continued on a metal strip,
inlaid into the lower part of the seal. On the top of the seal are two stylised animals and, in its centre, is the
figure of a priest gazing up at the Hand of God (Manus Dei). LEGATIO may have referred to a Papal legate.
Photograph courtesy of Heritage Service (City & County Museum, Lincoln); image generated by
Lincolnshire County Council Heritage Service

25 *The Pershore 'censer cover', late tenth or early eleventh century.*
Cast copper alloy censer cover in the form of a church tower. It is decorated in the late Anglo-Saxon 'Winchester style'.
It bears the inscription +GODRIC ME ÞVORH/T *'Godric made me'. Height 97mm.* Photograph courtesy of the
British Museum

50 *Early Anglo-Saxon undecorated 'domestic' pottery, from the Cleatham cemetery in Lincolnshire. Typical forms of Anglo-Saxon 'domestic' pottery. While these vessels either came from graves or had been used as urns, some bear traces of soot showing that they had been used for cooking.* Drawing by the author

 The potter's wheel was not used in the manufacture of Early Anglo-Saxon pottery which was coil-built, modelled or fashioned from a slab of clay. Most pots were made to an adequate standard – a few vessels were highly accomplished with thin, fine, fabrics, but some urns can only be described as shameful, crude and poorly fired. The pottery of the Early Anglo-Saxon period is best known from the urns which include some of the most highly decorated vessels ever made. A wide range of methods were used in the decoration of these urns – incised lines, stamp impressions, modelled and applied bosses and bands were combined in a bewildering profusion of decorative schemes. Stamp decoration was applied after the pot had dried to 'leather hardness' and it would also have been possible to cut incised decoration at this stage. Examples of antler dies used to stamp Anglo-Saxon pots have been found at West Stow, Little Eriswell and Lakenheath, Suffolk and Shakenoak, Oxfordshire (**52**).

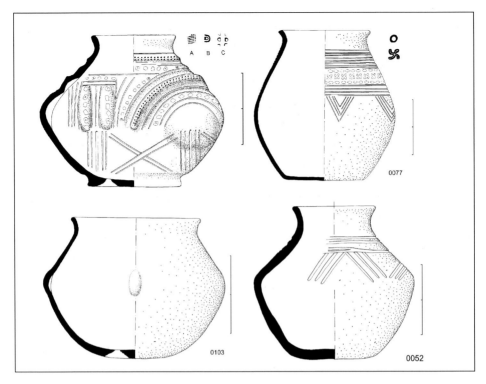

51 *Early Anglo-Saxon decorated urns from the Cleatham cemetery in Lincolnshire.*
Like the domestic pots, urns were handmade in a wide range of fabrics, but were often highly decorated. The
urn at the top left was made by someone whose work is also found at Spong Hill, Norfolk, more than 130km
away. Drawing by the author

Once the decoration was complete, a pot must be thoroughly dried before
it can be fired. If this is not done, the moisture will turn to steam during firing
and may shatter the pot. Drying should be done slowly, to prevent the pot from
splitting as moisture is lost, with parts of the pot shrinking at different rates.
Anglo-Saxon pottery was fired, using wood as fuel, to a fairly low tempera-
ture, certainly below 850°C and in some cases as low as 500°C. As the temper-
ature rises during firing, the last of the moisture is steamed off, followed by the
water of crystallisation (chemically combined in the kaolinite), which is lost
between 500°C and 700°C. Once this has occurred, the structure of the clay
is permanently changed and it becomes water resistant. As the temperature is
increased, the clay particles begin to melt and fuse. Pure kaolinite melts at
1770°C, a temperature that no early kiln could achieve. However, impurities
in the clay act as fluxes reducing this 'maturing point' to something that the
Anglo-Saxons might reach.

The only known Early Anglo-Saxon kilns are two single-flue, updraft kilns
at Cassington, Oxfordshire and it has been suggested that much of this pottery
was fired on a bonfire. Most Early Anglo-Saxon pots are black, although some

are red, orange or buff. The colour of pots is due, in the main, to the oxidation state of the iron in the clay. Most clays contain iron and if the clay is fired in an oxidising atmosphere, the iron will be in the form of red iron oxide (Fe_2O_3). If the same clay is fired in a reducing atmosphere, the iron will be reduced to black iron oxide (Fe_3O_4) and the pot will be black. A pot fired on a bonfire should be in an oxidising environment and will come out red, buff or yellow. However, most secondary clays contain carbon and it is possible that many Early Anglo-Saxon pots were not fired for long enough for it to be burnt off.

One of the features of early Anglo-Saxon pottery are groups of linked urns that are usually described as the work of 'potters' and identified by the names of sites on which their work has been identified. Some of these groups contain as few as two pots, but others are more significant. Urns made by the 'Sancton/Baston potter' have been found over a wide area, from Sancton in the East Riding of Yorkshire to Elsham and Cleatham, North Lincolnshire and Baston, in the south of Lincolnshire, 130km to the south. These urns are linked by shared stamp dies, but it was found that they were made in local pot fabrics, suggesting that it was the potters, or the dies, that moved rather than the pots. Vessels from Newark, Illington, Loveden Hill, Spong Hill and Melton Mowbray can also be attributed to the Sancton/Baston group but, while the stamps look the same, different dies were used. The other important group of Anglo-Saxon pots was produced by the 'Illington/Lackford potter' and found in an area around the border between Norfolk and Suffolk, linked by shared stamps. This group contains around 200 urns from 12 locations including the West Stow settlement. Petrological

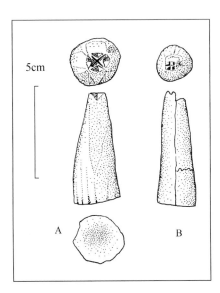

52 *Antler stamps for decorating Early Anglo-Saxon pottery, West Stow, Suffolk.* Drawing by the author after West 1985

examination has shown that Illington/Lackford pots were made using 20 different fabrics, some of which were also being used for domestic pots. Perhaps the most striking example of the long-distance transportation of Anglo-Saxon pots is Cleatham Urn 889 and Spong Hill Urns 1814, 2112 and 3052. These elaborate vessels are identical and were products of the same hand. If, as seems likely, they were all made in East Anglia, the Cleatham urn must have been transported over 140km.

Middle Anglo-Saxon pottery (53)

Cremation disappeared during the late sixth century and the elaborate urns were no longer made. Towards the end of the following century, the pagan cemeteries were abandoned and we no longer find pots in graves, leaving us dependent on finds from settlement sites. Most Middle Saxon pots are plain, although stamp decoration was used on some Ipswich ware vessels. Ipswich ware appeared around AD 625/650 and was coil built on a slow wheel or turntable (**colour plate 10**). The use of a turntable leaves deep, uneven girth grooves around a pot which would not occur if it were wheel thrown. Ipswich ware was fired in single-flue kilns with no internal structures, but they produced a hard, grey fabric which could not be achieved on a bonfire. Experiments suggest that it would take one of these kilns 9-12 hours to reach 800-1,000°C. The large scale of the industry in and around Ipswich points to it being professionally based. Ipswich ware dominated East Anglia but also occurred further afield, following coastal and riverine routes. Large, stamp-decorated, storage jars travelled widely and are found on sites, often with eccle-siastic links, in Kent, Lincolnshire, London and York. Bowls and lamps were also made, but the main product of the Ipswich kilns were small reduced grey jars with sagging, externally convex, bases.

The local pottery in the East Midlands at that time was what is known as Maxey type ware. These are handmade pots which contain large amounts of crushed sea-shell as a filler. Maxey-type ware gets its name from the site in Northamptonshire where it was first identified, although there is no evidence that it was made at Maxey. Initially it was thought that Maxey ware was homemade; these crude flat-bottomed, bucket and barrel-shaped pots, although competently fired, did not look like the work of professional potters. However, when Alan Vince thin-sectioned Maxey ware sherds, he found them to contain, not recent sea shells, but Jurassic fossils. These pots must have been produced at kilns along the Jurassic ridge which runs north-south through eastern England and were distributed throughout the region. It was not homemade and is likely to have been made by specialist potters, although, as is often the case, they may

53 *Middle-Saxon pottery, c.650-850.*
This period saw the appearance of the slow wheel, with some centralised production. **A**, **B** & **D** *Ipswich ware.*
This was made on a slow wheel in a hard-fired, gritty fabric and sometimes bears stamped decoration;
C *Handmade cooking pot from Broomswell, Suffolk;* **E** *Whitby ware from Whitby. A sandy fabric made on a*
slow wheel; **F** *Maxey-type ware, a shell-tempered fabric handmade, but apparently being produced at centres*
along the Jurassic ridge running down the East Midlands; **G** *Pot in a coarse, gritty ware from Southampton.*
Drawing by the author after Hurst, 1976

not have exercised their craft all year. Excavations on Middle Saxon monastic sites in Northumbria have produced sherds of pottery made on both slow and fast wheels suggesting that these techniques were in use in the north prior to the Viking conquest in AD 867.

Late Anglo-Saxon pottery (54)

At some time in the ninth century, the potter's wheel reappeared in England. In East Anglia the well-established Ipswich ware industry adopted the wheel, its new products being referred to as 'Thetford-type ware'. Large pots, however, continued to be made by hand. Thetford ware had a hard, grey sand-filled fabric and was fired in kilns in which the pots were supported over the fire on clay arches, built on a withy framework. Kilns with raised floors are also known at Torksey, Lincolnshire and elsewhere. Some of the Thetford kilns had collapsed during firing and showed that the average load was between 25 and 50 cooking pots. At Lincoln, a fine shell-tempered, wheel-thrown ware was being made by AD 870/80 and was fired in a clamp kiln, producing an oxidised ware, yellow, buff or light red/brown on a grey core. In Northumbria, wheel-thrown, sandy, micaceous 'Whitby ware' pots have been found, in levels pre-dating the Viking destruction of the monasteries. The potter's wheel was introduced into other areas during the tenth century. Oddly, it appears that London and the south-east were slow in adopting the technique.

Little is known of the form of the wheel used by the Anglo-Saxons. A stone-packed hole found at Thetford may have held the pivot for a wheel, but little else survives. The potter's wheel that we now know, in which the wheel-head on which the pot is shaped is connected to the fly-wheel by a long shaft, did not appear until the sixteenth century. Two types of wheel appear in thirteenth-century French manuscripts and may provide a clue to what Anglo-Saxon potters were using. One consists of what looks like a cart wheel, directly on top of which stands the wheel-head. The potter could have kicked the wheel around, pushed it with a stick (tour à bâton) or had an assistant spin it. In the other type of wheel, the fly-wheel and the wheel-head are linked by a number of vertical spokes, which the potters kicked with their feet.

The other innovation appearing around this time was the use of glazed pottery. Lead-based glazes were used, containing either galena (lead sulphide) or a suspension of white lead in water. This could have been made by exposing metallic lead to vinegar. When applied to the surface of a pot, lead acts as a flux, locally reducing the melting point of the clay to between 950°C and 1,030°C to form a glassy coating with a yellow, orange or brown colour. Glazes were usually applied by dipping the pot into a slurry or painting it on to the

54 *Forms of late Anglo-Saxon pottery, c.850-1100.*
The potters' wheel came into extensive use during the late Saxon period and glazing is used at some kilns.
A–B *Thetford-type ware from Norwich, a sandy, hard fired fabric.* **C** *St Neots-type ware from Bedford, a poorly-fired fabric containing crushed shell.* **D** *Winchester ware, from Winchester, a well-fired, sandy fabric with a glaze, the colour of which varies. Applied decorative strips were used on some of these pots.* **E–F** *Stamford ware,* **E** *from Leicester,* **F** *Cambridge. A finely-made fabric with a white or cream colour and with the sparse use of a green/yellow glaze.* Drawings by the author after Hurst, 1976

surface of the pot. Glazed pottery was produced, initially in small quantities, at the Stamford kilns in the late ninth century and at Winchester in the mid- to late tenth century. Some early Stamford pottery was decorated with painted red lines executed in an iron-rich mixture. The products of the Stamford kilns were remarkable for both their quality and quantity (**colour plate 11**). They were thin and finely potted with rims formed using a template. The fabric was made from Upper Estuarine clays which have a low iron content making them white or light coloured. Products of the Stamford kilns were distributed widely, being found throughout England and as far away as Ireland, Norway and Sweden. The most travelled Stamford products were small, heat-resistant crucibles which were found in large numbers at York and Lincoln (**colour plate 17**).

The presence of the kilns at Stamford follows a pattern towards urban pottery production that was appearing in the Late Saxon period with kilns known at Lincoln, Ipswich, Thetford, Torksey (**colour plate 9**) and Stafford. Other towns have produced single kilns or wasters of this date. One would have expected that London and the south-east, being so close to the continent and continental influences, should have been at the leading edge of ceramic development, but this was not the case.

It is not known how these innovations were introduced, or from where they came. The potter's wheel had remained in use in Romanised areas of the continent and the use of glaze and red paint can be paralleled in northern France. There may have been an influx of continental potters or simply the rapid spread of an idea, for which the time was ripe. It may not be coincidental that the Viking conquest of much of England was taking place at this time and that the Vikings had wide-ranging contacts across Europe.

7

GLASS

The material

Glass is a remarkable, almost unearthly material. It can be formed into a wide range of shapes, it can be transparent or translucent and can take brilliant colours giving it a unique fascination. The raw materials from which glass is made are far from exotic, being sand, lime and an alkali, usually soda (NaO_2) or potash (K_2CO_3). The alkali acts as a flux, reducing the melting point of the sand (silica, SiO_2) from around 1700°C to about 1,100-1,400°C – the limestone (calcium oxide, CaO) acts as a stabiliser, making the glass insoluble. Soda could be obtained from the ash of maritime plants, but it is also possible that a mineral source was used. Potash can be made by burning land plants, but does not give such a good glass. Theophilus recommends the use of the ash from beech logs.

The process of making glass starts with the fritting of the ingredients, which are mixed and put into the hearth of the furnace. They are stirred with an iron shovel so that they are fused (fritted) together into granular lumps. In the furnace described by Theophilus, the fire is not in direct contact with the hearth. When fused, the frit is placed into a crucible and melted to form the glass. The making of the crucibles is an important part of the process and Theophilus recommended the use of a white clay (fire clay) which is carefully prepared and fired before use.

When cold, glass is brittle – its homogeneous structure offers no boundaries to running cracks and it will shatter. Once heated, it changes and becomes soft and pliable and can be formed into almost any shape. The working temperature of glass is lower than the temperature needed to make it. When hot it can be stretched and pinched, hot glass can be added to its surface to form trails and blobs and, most remarkably, air can be blown into it forming large bubbles which will retain their shape when the glass cools. Great care is

needed when cooling a newly-made glass object, as a sudden fall in temperature will cause the glass to crystallise and shatter. Cooling is carried out in an annealing furnace or in the top chamber of a three-chamber furnace, the lower part containing the fire, and the middle containing the crucibles of molten glass or 'metal'. In the annealing furnace, the temperature is lowered and the stresses eased by slowly moving the object away from the heat.

The colouring of glass is complex depending on the composition of the glass itself, any additives, and the atmosphere in the furnace. Most ancient glass has a pale green colour due to the presence of iron, which was difficult to avoid. Colorants were sometimes added to the glass in very small quantities – blues could be produced by cupric oxide (CuO), green glass can be produced by the use of iron oxide (FeO) and cuprous oxide (Cu_2O) will give a red. The final colour produced depends not only on the additive, but also on the amount of oxygen present in the furnace.

Glass vessels (**colour plates 4** & **5**)

Glass was not uncommon in Anglo-Saxon England and the remains of burnt vessels have been found with otherwise unexciting cremation burials, suggesting that its use was not restricted to the élite. Glass vessels are also found intact in graves. Many of the glass vessels found with Anglo-Saxon burials are identical to those seen on the continent and it is probable that they were imported from areas where the late Roman glass industry survived.

Some palm cups bear moulded or optic-blown ribbing. This was done by blowing the glass into a ribbed mould; it was then removed and blown further to give a softer profile. The most impressive glass vessels of the period, both from their appearance and the skill that went into their manufacture, were the claw beakers. These were very thin and were decorated with rows of applied claw-like bosses which were hollow and open to the inside of the beaker. These vessels would have been made by blowing, followed by the modelling of the glass and the addition of the claws and, on some vessels, the application of features such as trails of different coloured glass. The distribution of one type of claw beaker suggests that they were being made in England. Other vessels such as squat jars, bag-beakers and pouch bottles are more common in England than on the continent and it has been suggested that these were made here, probably in Kent, during the seventh century. It is also possible that some vessels, found in Norway and Sweden, were the products of English glasshouses. The range of glass vessel shapes being made was gradually reduced after the Early Anglo-Saxon period and, by the ninth century, the simple funnel beaker was the most common type being made. During this time, however, the colours used became stronger and the decoration more elaborate.

Glass working, however, is not the same as glass making and the English makers may have been dependent on imported glass. At this time, glass was being produced at Ravenna, in northern Italy and traded through Europe in the form of small cubes or 'tesserae' to be used in the manufacture of vessels and beads. Glass tesserae were found at Ribe in Denmark where they were being used to make beads during the eighth century. They have been found at Whithorn, and a single, blue glass tessera was found at the middle Saxon site at Flixborough, Lincolnshire. Scrap glass or 'cullet' was collected for re-use, as is illustrated by a pit at the Brooks site in Winchester containing a large amount of glass, mostly from windows, that was intended for recycling.

Window glass

The other important use of glass is for glazing windows. In AD 676, Benedict Biscop sent to Gaul for glass makers to make the windows for the church at his Monkwearmouth monastery. Bede, writing in AD 732 recorded that: 'When the work was drawing to completion he sent messengers to fetch makers of glass, who were at this time unknown in England, to glaze the windows of the church, its side chapels and clerestory'. These were said to have not only done the work required, but also to have taught the English their craft in making both windows and glass vessels. The craft was not well learned, because in AD 758 Abbot Cuthbert of Jarrow was writing to Archbishop Lullus in Mainz telling him that, 'If there is any man in your diocese who can make vessels of glass well, pray send him to me . . . for we are ignorant and helpless in that art'. Excavations at the Monkwearmouth and Jarrow, Tyne and Wear, monastic sites have produced evidence for the manufacture of soda-lime window glass and millefiori during the seventh to eighth centuries. This glass had been cylinder-blown, a method in which a cylinder is blown, its ends removed while it is still hot, and the cylinder then split and opened out to make a small pane, 2-3mm thick. Anglo-Saxon window glass often has a grozed edge, where it was trimmed by nibbling its edges with a pair of pincers. There is also tantalising evidence for the making of glass at Glastonbury, Somerset where two, or perhaps three, furnaces and possibly crucible fragments were found beneath the medieval cloister. It is not easy to interpret this, but what may have been found was a firing furnace with an annealing oven. Associated with these were scraps of coloured window and vessel glass and a fragment of mosaic glass cane. More recently, evidence has been found for Anglo-Saxon glass melting at Barking Abbey, London. Monkwearmouth, Jarrow and Flixborough also produced lead cames, the 'H'-shaped strips of lead used to hold the individual quarries into place in a window.

Most Anglo-Saxon glass was soda-lime-silica glass which is stable and survives well in the ground and has a broadly similar composition to Roman

glass. In the medieval period, the so-called 'forest glass' was used in which the soda was replaced by potash from burnt wood. These glasses are unstable and when found are often in poor condition having become crystalline. Evidence from Winchester has shown that potash was used to make window glass as early as the late ninth to early tenth century.

Glass beads

Glass beads (**colour plates 14** & **20**) are the most common objects found in Early Anglo-Saxon graves, with some burials containing hundreds of them. Evidence for bead making has been found at Garranes, Co. Cork (sixth to seventh century) and Ribe, Denmark (eighth century), but to date the only English sites to have produced evidence of beadmaking are in York, where glass melt has been found on discs cut from pot sherds. Justine Bayley has suggested that glass for beadmaking was being melted on these discs and mis-made beads have also been found in York. It is possible that the Anglo-Saxons were dependent on imports for many of their beads. The process of beadmaking involved the melting of the glass in a crucible (**55**). A gather of glass was then picked up on an iron rod, smoothed out and heated until it started to run. The runs of glass were trickled onto an iron rod which formed the hole through the centre of the bead. To decorate beads, strands of coloured glass were applied to the bead to make bands, spots or waves (**colour plate 20**) – still more elaborate patterns could be made by laying a twisted, multi-coloured strand of glass onto the bead to form reticella beads. The bead was then rolled over a smooth surface to press the decoration into its surface. Most of the decoration added to translucent glass beads was opaque and consisted of a lead glass. This was important as lead glasses have bright colours and low softening points, making it easier to apply them to a translucent bead without melting it.

MILLEFIORI BEADS

Still more elaborate were millefiori beads – these were large globular or cylindrical beads made up from canes of millefiori glass. To make millefiori, a pack of coloured glass rods were fused together so that their ends made up a pattern. The pack was then heated and drawn out to produce thin rods with the same patterned section as the fused pack, but on a greatly reduced scale. Millefiori glass was occasionally used in conjunction with enamel on hanging bowls and some pieces of fine jewellery such as the purse mounts and shoulder clasps from Sutton Hoo. To make millefiori beads, the rods were cut into short lengths and set radially around a core to form a cylinder with their decorated ends showing. They were then encased in a mould to hold the bead in shape while it was heated and fused together. Mosaic beads were made in the same way, but were built up using single-coloured canes.

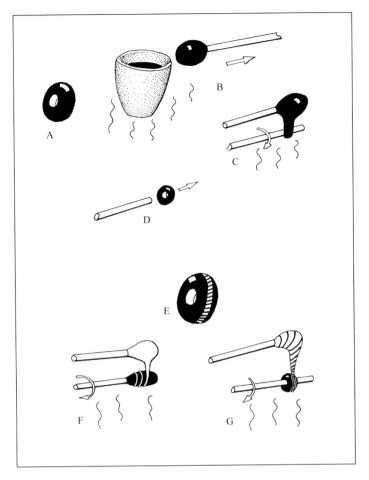

55 *Beadmaking.*
A *Simple monochrome bead, made by getting a blob of molten glass out of the crucible (**B**) and trailing it around a metal rod (**C**). Once complete, it is slipped off (**D**); **E** shows decorated polychrome beads, made by taking a blob of glass from the crucible and **F** trailing a line of different coloured glass around it. This strand of striped glass can then be trailed around a bead made as in **C** above and, while still soft, smoothed off against a flat surface.* Drawing by the author

While these beads were used and appreciated in England, it is doubtful if they were ever made here.

GOLD AND SILVER IN GLASS BEADS

This exotic form of bead is very ancient and in Egypt they date to at least as early as Ptolemaic times. These beads consist of a multi-segmented cylinder made of clear glass often bearing fine groove-like marks on its surface. They were made by covering a fine wire with a thin layer of clear glass. This was then covered with gold or silver foil, which was itself encased in a second layer

of clear glass. At this stage, the bead was pinched at intervals to form the segments. While the silver often does not survive, these beads are not excessively rare, but often only single segments are found.

Decorative studs made from glass were sometimes incorporated into items of seventh- or eighth-century jewellery. Some examples were inlaid with designs in a contrasting coloured glass. These were made by casting the glass stud in a mould which left grooves on its surface, and these were then filled with a contrasting coloured glass. A mould containing an unfinished stud of this type was found during excavations at the eighth-century Irish site of Lagore Crannog. On some eighth-century silver-gilt objects decorated with animal interlace the animals have small, blue glass eyes. These were used, for example, on the Witham pins (**colour plate 2**).

8

IRON METALWORKING

Iron extraction

In contrast to the ores of other metals, iron occurs throughout England and is found in most counties. Carbonate iron ores ($FeCO_3$) occur in the Weald and in Lincolnshire, Northamptonshire and the Cleveland Hills. Haematite (Fe_2O_3) ores are rich in iron, but are less easy to smelt and are found in Cumbria, and limonite ores in the Forest of Dean. In addition to these, deposits of bog iron ($FeO.OH$) occur in places where iron-bearing surface water meets organic materials, causing iron oxide to be precipitated. These are easily smelted and are likely to have been used by the Anglo-Saxons.

Before smelting took place, the iron ore was dressed and washed to remove as much of the non-ore minerals as possible. The ore was then roasted to around 500-800°C. In the case of bog iron, roasting boiled off the water which would cause problems in the furnace. By roasting carbonate ores they are reduced to oxides, which are easier to smelt. Roasting also makes ironstone more permeable, allowing the furnace gases to penetrate during smelting. The roasted ores are also easier to break up, an important consideration as ore must be crushed into small pieces for smelting.

The process of smelting involves the removal of the oxygen from iron oxide to release the metallic iron. This process is based on the principle that, at high temperatures, oxygen has a greater affinity for carbon than for iron. The carbon monoxide in the furnace gasses reacts with the oxygen in the ore, freeing the iron:

$$CO + FeO \longrightarrow Fe + CO_2$$

The fuel used in smelting was hardwood charcoal, which provided both the heat and the reactant in the reduction of the ore. Early smelters would have required prodigious quantities of charcoal – experiments with a 220mm-diameter bowl furnace showed that 7.3kg of charcoal were needed to produce

0.5kg of iron. It is likely that both bowl and shaft furnaces were in use, but from the truncated remains found on excavations, it is often difficult to tell them apart. In a bowl furnace, the ore charge and the charcoal are separate and the air blast operates horizontally through the furnace, carrying the carbon monoxide through the charge. A shaft furnace consists of a low shaft, which is charged with layers of ore and charcoal and blown from the bottom. As the charge descends, a sequence of reactions takes place. In the upper layers, any remaining moisture will be removed; lower down the final carbonates will be converted to oxides. Below this level, reduction starts and the iron oxide begins to be reduced to metal. This starts to occur at 800°C, but a temperature of 1,150°C is needed to melt the slag so that it can be separated from the iron. The slag is fayalite ($2FeO.SiO_2$) formed from silica found with the iron ore. During smelting, the slag would be allowed to run into a pit beside the furnace, or gather below the iron in the base of the furnace. Pure iron melts at 1,536°C, a temperature which was not reached in these furnaces. If the iron absorbed any carbon, its melting point would be reduced and some temporary, localised melting may occur, but most of the iron passed straight from iron oxide to iron metal without becoming liquid. This differs from the process carried out in a modern blast furnace, which produces iron in the form of cast iron containing more than 2.5 per cent carbon, the carbon content later being reduced to make steel. The blast furnace and cast iron were not introduced into England until the later fifteenth century.

There is some evidence for early Anglo-Saxon iron smelting in England – furnaces of north German 'slag pit' type have been found at Aylsham, Norfolk, Little Totham and Mucking in Essex and possibly in North Lincolnshire. A slag pit furnace, as the name suggests, consists of a pit around 800mm deep, over which was constructed, or placed, a shaft. Before firing, the pit was packed with straw to support the charge of ore and charcoal (**56A**). During operation, the lack of oxygen below the tuyères prevented the straw from burning and the slag drained down into the pit, forming a block, on top of which was an iron/slag bloom. At the end of the smelting process, the furnace shaft was moved, or demolished, to allow the iron bloom to be extracted. As the pit was filled with slag, it was easier to dig a new one for each smelting run, and in Jutland, groups containing several thousand slag pits have been found. Nothing on this scale has been found in England.

Evidence for Middle Saxon smelting has been found at Ramsbury, Wiltshire where it was dated to the late eighth to early ninth century. Four smelting furnaces were found, all of which showed signs of intensive use. A possible ore roasting hearth and smithing hearths were also found. Three of the Ramsbury furnaces were of a bowl type, which appear to have had permanent domes with large enough top openings to allow the iron blooms to be removed

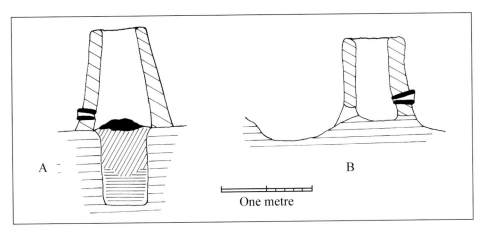

56 *Shaft furnaces.*
A *Reconstruction of an early 'slag pit'-type furnace of the sort used in northern Europe during the Migration period. The shaft was built over a pit packed with straw into which the slag trickled during smelting.* **B** *shaft furnace from Stamford, Lincolnshire, eleventh century.* Drawings by the author, some after Tylecote

and for their linings to be repaired (**57**). The fourth furnace was what the excavators described as a 'developed bowl furnace'. This had a much smaller diameter than the other furnaces, which would have resulted in an improvement in efficiency. There was also provision for tapping off the slag during smelting. These features are interesting as they point to a technological advance during the period that the site was in use. No trace of a tuyère was found on the Ramsbury furnaces and it was assumed that the blast was directed at an angle down into the charge. The smithing hearths consisted of burnt areas containing slag and fine charcoal. A block of sarsen stone, found near one of the hearths, had probably been used as an anvil, and two pairs of smith's tongs were found on the site.

An eleventh-century furnace excavated at West Runton, Norfolk had a 500mm diameter bowl set in the natural clay. This was interpreted as a bowl furnace, although the walls survived to a height of *c.*500mm. The air blast was introduced through two tuyères and slag was tapped from the furnace during smelting. It was thought that the top of the West Runton furnace was partially closed by a low dome. A furnace of similar date was excavated at Stamford, (**56B**). This was 400mm in diameter and was a shaft furnace with metre-high sides. This, too, was fitted with a slag tap-hole and a tuyère slot near the base. Ore roasting furnaces were also found at Stamford, together with large amounts of slag representing relatively large-scale production. At West Runton, the ore pits which supplied the furnace were found nearby. The ore deposits were far from rich and it was calculated that to obtain one cubic metre of ore nodules and about the same quantity of bog-ore, it would have been necessary to move 50 cubic metres of sand. Even if the ore had a high iron content, this would not

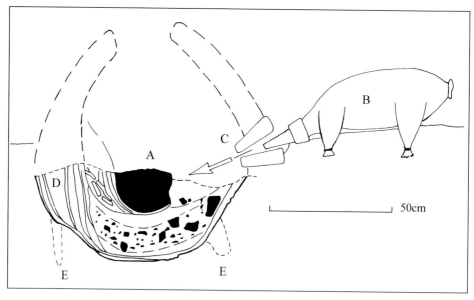

57 *Hypothetical reconstruction of a bowl furnace from Ramsbury, Wiltshire, late eighth to ninth century.*
*A slag block left after smelting; **B** bellows made from a skin; **C** tuyére through which the blast entered the*
*furnace; **D** replacement clay linings; **E** holes left by stakes that supported the dome during construction.*
The iron bloom would have formed in front of, and above, the level of the tuyére. Reconstruction drawing
by the author after Haslam *et al.* 1980

have produced a large amount of iron. An analysis of the smelting slags found
in Anglo-Scandinavian levels at Coppergate showed that they still contained 20-
40 per cent of iron oxide, indicating very inefficient smelting.

To achieve the high temperature needed to smelt iron, it was necessary to
use bellows to get a forced draught. This was hard, hot work and it could take
six to twelve hours to smelt the charge in a furnace. There are references in
Domesday to mills paying their rents in iron blooms, suggesting the use of
watermill-powered bellows in the Late Saxon period. However, the first
concrete evidence for the use of water power in iron working comes as late as
the fourteenth century, when it was used at Chingley, Kent for driving a
hammer, not for blowing. Many smelting sites are located away from any
potential source of water power and, in any event, the quantity of air required
for the small Anglo-Saxon furnaces could easily be supplied by hand bellows.

The production of steel

The product of Anglo-Saxon iron smelting was a porous, poorly consolidated
lump of iron mixed with slag, known as a 'bloom'. Before any further work
could be carried out, it was necessary to re-heat the bloom and hammer it to

express as much of the slag as possible and to consolidate the iron. The bloom could consist of three possible types of iron, pure ferritic iron, phosphoric iron or carbon steel. 'Ferrite' is almost pure iron with less than 0.05 per cent carbon; it is highly malleable, but soft and weak. Phosphoric ores are very common in England and, while phosphorus is unwelcome in most modern iron and steel, it did provide an iron that can be work hardened to 300HV. The third possible product from smelting was steel, with a carbon content of between 0.2 and 1.0 per cent.

Steel is an alloy of iron and carbon, the properties of which can be modified by heat-treatment. At room temperature, carbon is only partially soluble in iron, the excess carbon being deposited as iron carbide (Fe_3C), which is also known as 'cementite'. This is a very hard, brittle compound which is usually deposited in 'pearlite', the microstructure of which consists of laminated layers of cementite and ferrite. The amount of pearlite present depends on the carbon content of the steel; up to 0.76 per cent carbon, the pearlite will be in a ferrite matrix; at 0.76 per cent, the steel will consist entirely of pearlite, and above this percentage (unlikely in the Anglo-Saxon period), the additional carbon will be deposited as massive carbides.

Once carbon has been introduced into iron, it becomes possible to harden it by heat treatment, annealing, quenching and tempering the alloy. Annealing is a process that involves the heating of the metal to allow it to recrystallise to a softer, unstressed structure. In quenching, the steel is heated and plunged into water, the rapid cooling leaving it with a fine, very hard, 'martensitic' structure. The temperature from which the iron is quenched depends on its carbon content, lower carbons requiring higher quench temperatures. A slower quench can be given using oil, or a more severe quench by the use of salt water. After quenching, the steel is very hard, but is also brittle. This is overcome by tempering; reheating the steel to allow a partial recrystallisation, which produces a tough, strong steel. It is also possible to selectively quench a cutting edge, leaving it very hard but backed and supported by tough metal. Theophilus recommended quenching in goat's urine or, still more interestingly, the urine of a red-headed boy. He does not, however, mention tempering which is not referred to until the sixteenth century. It is possible that he was using a 'slack quench', in which the steel is dipped into the water and removed, giving a partial quench.

During smelting, the iron absorbs carbon from the charcoal and, while most of this is re-oxidised in the tuyère zone, iron blooms were not homogeneous and would contain areas with a higher carbon content, which could be utilised as steel. A metallographic examination of the 4.5kg bloom of iron found in the eighth- to ninth-century Stidriggs hoard showed it to be a good steel containing a 0.7 per cent carbon. It is possible that the small sample taken was not typical

of the whole bloom, but the result is still remarkable. The other method of obtaining steel was to introduce carbon into the iron by heating it to around 900°C and holding it at that temperature so that the iron absorbed carbon from the charcoal. Experiments have shown that it takes six hours for carbon to penetrate to a depth of 2mm. Care was needed to ensure that the air from the bellows did not oxidise the newly introduced carbon. A disadvantage of phosphoric iron was that this alloy would not take up carbon, making it impossible to turn it into steel. If steel was to be made, it was necessary to obtain a supply of iron which did not contain phosphorus, ruling out many of the native ores.

Iron smithing

The methods used to work iron are very different from those used to work other metals, as it is worked hot, by forging and hammer welding. Iron is very difficult to work at normal temperature, but becomes highly malleable when heated to between 700°C and 1,250°C, a usefully wide range of working temperatures. During working, the surface of the iron oxidises and sand is used as a flux to protect it. This, and some iron, forms the hammer scale which survives well and provides a record of the activities of a blacksmith on a site, the scale appearing as bright specks when soil samples are x-rayed. Fluxing with sand also keeps the surface of the iron clean and free from oxides, aiding hammer or fire welding, one of the most important parts of the smith's craft. The two pieces of iron to be joined are heated to about 1,200°C, placed together and hammered: fusion occurs and the two pieces become one. The first hammer blow will express the molten sand/iron flux and give an immediate metal/metal contact. This process is aided by the presence of slag in wrought iron, which also acts as a flux. Iron is a poor conductor of heat and by selectively heating parts of the work piece, it is possible to bend and form it to the required shapes. Forging causes the slag in wrought iron to be formed into lines along the object's length, which can provide a valuable guide to the way in which it had been formed. It is these slag stringers that give corroded wrought iron its fibrous appearance.

Hammer slag is commonly found on Anglo-Saxon settlement sites and it appears that domestic iron working, as opposed to smelting, was widespread, although few actual forges have been identified. It has been suggested that in the Anglo-Saxon period 'every man was his own smith' but this widespread evidence for smithing may have been due to the activities of itinerant blacksmiths. Certainly, most iron objects suggest at least an adequate level of expertise and were probably the work of specialist smiths. Evidence of urban smiths is widespread in the Later Saxon period.

Iron was distributed from the smelter in the form of bars, which could be thinned down and cut up for use. The easiest method of cutting iron is to use a chisel or 'set' on the red-hot bar. Recent practice and practicality suggests that the set would be mounted in a handle to keep the hand away from the hot metal and the hammer blow, but no example of this tool has been found in an Anglo-Saxon context. There is a well-used chisel suitable for cutting metal from Thetford (**62E**).

Smithing tools

Most of the tools used by the blacksmith underwent remarkably little change from the Iron Age until recent times. The tongs, hammers and files have remained the same although the massive cast steel anvil is a comparatively recent innovation.

TONGS

A pair of tongs was found in grave 115 at Sibertswold, Kent and in a seventh- to eighth-century context at Shakenoak, Oxfordshire. There, they were associated with slag and iron ore, suggesting that smelting was taking place. The Tattershall Thorpe grave contained a pair of tongs that can be dated to the seventh century (**58B**). Tongs were found on the Ramsbury, Wiltshire smelting site where they were associated with a hearth. A pair of tongs from Flixborough, Lincolnshire were fitted with a clip that would allow them to be locked (**58A**).

ANVILS

A stake anvil was found in the seventh-century, Tattershall Thorpe, smith's grave (**59A**) and a beaked anvil was found at Coppergate (**59B**) where it was dated to AD 930-75. The Coppergate find is a small, 'L'-shaped beaked anvil, a type that also occurs in the Mästermyr, Gotland tool box, alongside plain stake anvils, resembling the anvil from Tattershall Thorpe. These small anvils were placed in a socket, cut into a tree-stump or a log, which secured them and took the shock of the hammer blows. The anvil being used in the eleventh-century Caedmon manuscript in the Bodleian Library is clearly set in a wooden base (**60**). At Ramsbury it appears that a block of sarson stone was being used, a practice that may have been more common than the evidence suggests.

HAMMERS

Anglo-Saxon hammer heads appear to have been remarkably consistent in shape, with a rectangular face, a square eye and a narrow rectangular pane (**61**). The best surviving example is perhaps the hammer from Thetford (**61C**), which weighs 605g and is described as a 'hand sledge' in the report. It probably

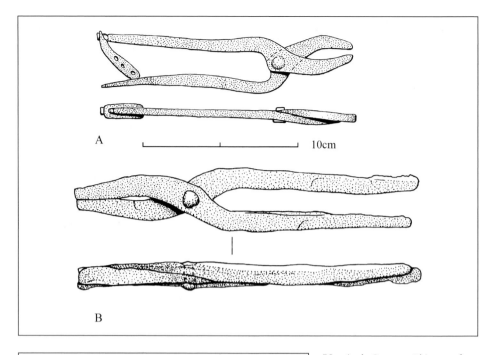

A

10cm

B

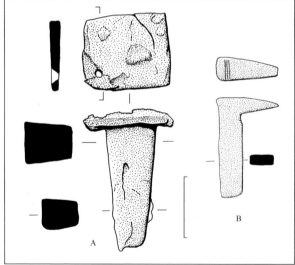

58 *Anglo-Saxon smith's tongs from Flixborough, eighth to ninth century, and Tattershall Thorpe, seventh century.* Drawings by the author; **B** after Hinton, 2000

59 *Anvils.*
A *from the Tattershall Thorpe, Lincolnshire grave, seventh century and,* **B** *Coppergate, York, AD 930-975.* Drawings by the author; **A** after Hinton, 2000; **B** after Ottaway, 1992

dates to the eleventh century. Three hammer heads were found at Coppergate, York, the largest of which weighed 658g and originally had the same shape as the Thetford example, although both faces were heavily (and dangerously) burred over by extensive use. This mass falls within the range of 400-750g for Viking period smithing hammers in Scandinavia. The Coppergate excavation also produced a small hammer with a round face and a wedge-shaped cross pane that would have been suitable for fine iron work or the working of non-ferrous metals. Three hammers were found in the seventh-century Tattershall

Thorpe smith's grave, which weighed 450g, 150g and 33g (**61A** & **B**). The lighter weights of these hammers reflects the finer work in which this man had been engaged. X-ray examinations of these hammer heads revealed traces of the iron wedges that had secured them to the shafts.

CHISELS, PUNCHES AND GRAVERS (**62**)
In the absence of drills, punches would have been used to make holes through hot metal. A well-used punch was found in the Tattershall Thorpe grave (**62A**) and punches are known from Coppergate and Thetford (**62C** & **D**). A number of double-ended, tanged tools were found at Coppergate. These appear to have been designed to have handles and may have been gravers for hand cutting metal.

FILES
A file is not an abrasive, but a tool whose sharp teeth actually cut the metal. To do this, the teeth needed to be very hard and Theophilus tells us that they were made from soft iron, covered in steel. After the file was shaped, the teeth were cut with a chisel and the file heated and quenched to harden it. The quenching process Theophilus describes involved heating the file to red heat and covering it with a mixture of burnt ox horn and salt; heating is continued until the file is removed from the hearth and plunged into water. The use of this coating would have had little effect other than possibly preventing some decarburisation. Little work has been done on the metallurgy of Anglo-Saxon files; an example from Anglo-Scandinavian deposits at York consisted of two ferritic/phosphoric iron strips which had been welded together, and had probably been carburised and quenched, after the teeth had been cut. The

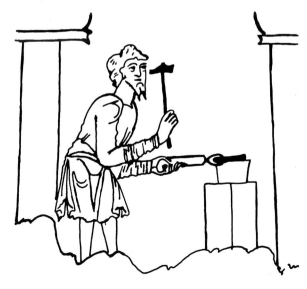

60 *An Anglo-Saxon smith at work. Drawing of a smith at an anvil, eleventh century. The anvil is set in a block of wood to absorb the shock of the hammer. He holds the work piece in a pair of tongs and is using a hammer of characteristic Anglo-Saxon form.* Drawing by the author based on a detail from the Caedmon manuscript, Bodleian Library MS Junius II

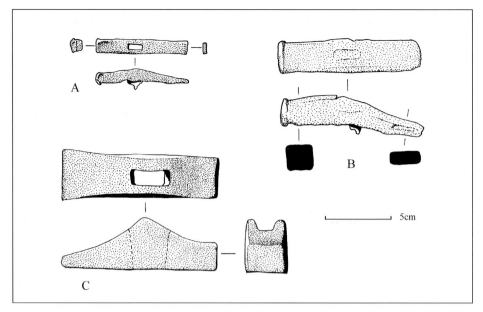

61 *Anglo-Saxon hammers:* **A** *&* **B** *from Tattershall Thorpe; and* **C** *from Thetford.*
The form of Anglo-Saxon hammers seems to have been remarkably constant over time, the Tattershall Thorpe
hammers are seventh-century, and the example from Thetford is eleventh-century. **A** & **B** drawn by the
author after Hinton, 2000; **C** drawn by the author after Rogerson and Dallas, 1984

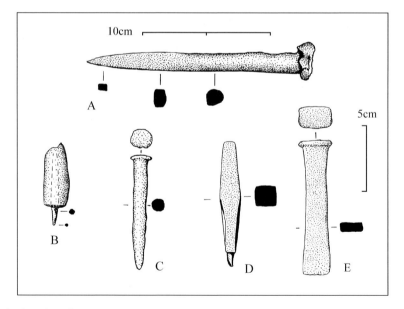

62 *Chisels and punches.*
A *chisel;* **B** *engraving tool or awl, iron set in a box wood (?) handle; both Tattershall Thorpe, seventh*
century. Drawing by the author after Hinton, 2000; **C** *punch, Coppergate, Anglo-Scandinavian.*
Drawing by the author after Ottaway; **D** & **E** *cold chisel and punch, Thetford, eleventh century.*
Drawing by the author after Rogerson and Dallas, 1984

Anglo-Saxon files found so far all have triangular-shaped teeth on all four faces (**63**). These were cut at 90° or nearly 90° to the sides. Files found in the late seventh-century Tattershall Thorpe smith's grave were identical to those from tenth-century Coppergate. Traces of the wooden handles survived – one was probably alder, another could not be identified, but was branch wood, not timber. Due to the difficulties of getting the teeth sufficiently hard, it is likely that these files would only have been used on softer metals and antler.

SNIPS OR SHEARS (**64**)

These were used for cutting thin sheet metal, particularly non-ferrous alloys. A pair of snips from Coppergate had neat scrolls on the ends of its curving handles; the handles on a pair of shears from Tattershall Thorpe both curved up in a way that would have given the user greater power and control.

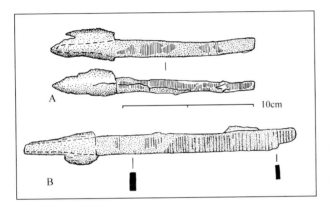

63 Iron files from the Tattershall Thorpe, Lincolnshire smith's grave, seventh century. Drawings by the author after Hinton, 2000

*64 Snips or shears for cutting metal. **A** Tattershall Thorpe, Lincolnshire, seventh century; **B** Coppergate, Anglo-Scandinavian. Drawings by the author after Hinton, 2000 and Ottaway 1992*

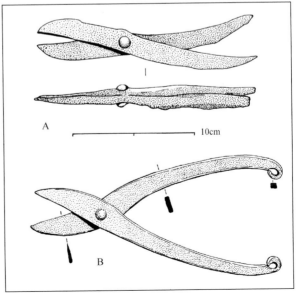

WHETSTONES (**65**)

Anglo-Saxon whetstones have been divided broadly into three groups, these being:

Whetstones made from greywackes from Scotland, Wales and Brittany (**65A**)
Whetstones made from a range of quartzose, micaceous sandstones, silt stones and sandy limestones which had origins relatively close to their findspots (**65B**).
Whetstones made from Norwegian schist (**65C**).

In the early Anglo-Saxon period, the general practice was to use any suitable local stone to make whetstones, although there are some exceptions – whetstones of

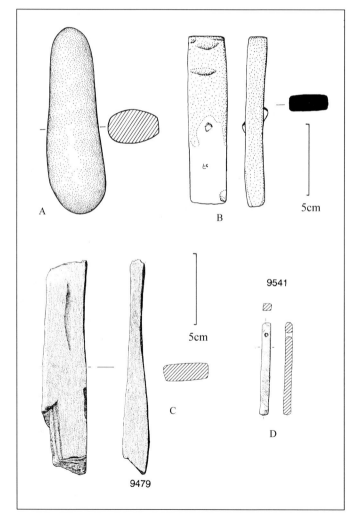

65 *Anglo-Saxon and Anglo-Scandinavian whetstones.*
A *Whetstone made from a sand-silt greywacke, Fonaby, Grave 24,* **B** *whetstone made from a local silt stone, Cleatham urn 52, both Early Anglo-Saxon.*
C *schist, Coppergate,*
D *perforated Phyllite whetstone, Coppergate, both tenth century.* Drawings,
A & **B** by the author;
C & **D** from Mainman and Rogers, 2000, courtesy of the York Archaeological Trust

Kentish ragstone, and some greywacke whetstones appear to have been circulated. Most whetstones come from graves of seventh-century date, although at Cleatham they were being placed in urns at the beginning of the sequence, but became more common later on. In the early Anglo-Saxon period, whetstones seem to have had an importance beyond that of utility, as is suggested by the carved sceptre/whetstone from Sutton Hoo and the example carved with a human head from Hough on the Hill, Lincolnshire. A massive 463mm-long whetstone was found set upright in the ground near to a seventh-century grave at Uncleby, Yorkshire.

The excavations at Coppergate produced 29 cylindrical stones, apparently from rotary grindstones. These range in size from 50mm in diameter to about 80mm and have holes through their centres. So far as it is known, these are unique to Anglo-Scandinavian York, but a rotary grindstone is shown in use on the Utrecht Psalter of *c*.AD 850. This is large, apparently with a diameter of about 500mm, and is turned through a simple crank. It is being used to grind a sword, with the operator leaning over the stone, in the position adopted by scythe grinders in the recent past.

Piling and pattern welding

When iron was carburised, the carbon could only be absorbed by its surface. Piling was a method of distributing the carbon more evenly through the iron, by doubling the bar over and hammer-welding it onto itself. By doing this repeatedly, a structure was built up which consisted of multiple layers of ferrite and carbon steel. This was much tougher than wrought iron and could be heat-treated. Care was needed when carrying out this amount of work on steel as there was a danger of oxidising the carbon and converting it back to iron. Piling was also carried out using a combination of ferritic and phosphoric iron. In some cases, it is possible that a piled effect occurred as a side effect during smelting or heating, as segregation of the phosphorus or carbon occurred.

In pattern welding, strips of piled steel or iron are twisted along their length and then hammered flat, giving a coarse version of piling (**66**). Two or more of these strips were laid alongside each other and hammer-welded and, in the case of a blade, strips of carbon steel were welded along the sides to form cutting edges. When ground and polished, the twisted bars forming a pattern-welded blade will show as angled lines, or another decorative device, along its length. This technique does little to make the blade stronger and its benefits were purely decorative and psychological. In addition to pattern welding being used on weapons, some weaving swords were decorated in this way.

66 *The process of making a pattern-welded blade.*
Strips of iron, **A** *are twisted and hammered flat to give a pattern of oblique lines,* **B**. *Four of these strips are fire-welded onto an iron core,* **C** *and two strips of steel,* **D** *and* **E** *welded to them to form the cutting edges. When complete the blade is ground and polished to reveal the chevrons left by the pattern welding.* Drawing by the author after Gilmour 1984

The smith's products

KNIVES

Knives are the most common iron object found on Anglo-Saxon sites and it seems that most people would carry a small knife for eating and as a general purpose tool. Most Anglo-Saxon knives were 'whittle tanged' with a long tang which passed deeply into a horn or wooden handle. While corrosion often hides the details, some Anglo-Saxon knife blades were finely shaped with, on occasion, narrow fullers along one, or both sides of the blade. In the tenth century we see some remarkable iron 'seax' knife/swords with inlaid blades (**colour plate 3**).

In the Middle and Later Saxon periods, whittle tanged knives were supplemented by some more unusual types. Folding knives had a blade which can be folded back into its handle, which terminates in a spike (**67A**). These knives have been found in Middle Saxon contexts at Thwing, East Yorkshire and in Anglo-Scandinavian deposits at Coppergate. Pivoting knives had two conjoined blades secured into the handle by a single rivet (**67B**). By swivelling the blades, it is possible to put one inside the handle and bring its counterpart into use. The function of pivoting knives is not known; scribes are often shown holding a knife and it has been suggested that they were used in writing, but they could have been general-purpose knives of a particularly ingenious type. Pivoting knives were in use during the eighth to the eleventh centuries.

The blades of some Anglo-Saxon knives have been subjected to metallographic examination and it has been possible to see how they were made. They appear to have been of a higher quality than the knives of the Roman and medieval periods – heat-treated steel blades were more common and the process better carried out. There were five basic methods of making a knife blade, most of which were intended to make economical use of steel, which was time consuming to make, and therefore valuable (**68**). The main part of the blade was usually made from ferritic or phosphoric iron onto which a steel cutting edge was added. The cheapest method was to add a steel tip to the blade, but this would only work until the edge was sharpened away. Some knives, which now appear to have been made only of ferritic or phosphoric iron, may originally have been steel-tipped. A more satisfactory method of steeling a blade was to sandwich the steel between two layers of soft ferritic or phosphoric iron. This had the advantage that re-sharpening would continually reveal more of the steel core. Occasionally knife blades are found to have piled structures consisting of multiple layers of iron and steel, a technique that seems to have been reserved for edge tools.

SPEARHEADS

These were the most common weapon in Anglo-Saxon England and are often found in graves. They were made in one piece, the socket being forged flat and then folded around a mandrel to form the tube (**69**). The defining feature of Anglo-Saxon spearheads is their open sockets – in most other periods the joint is closed. The majority of Anglo-Saxon spearheads have simple lozenge-sectioned blades, but there are examples that are more elaborate, with one side of each face of the blade being grooved or recessed so that, if seen in section, the blade has a 'Z' shape. This section would make the blade more rigid (try it with a piece of paper). It would be interesting to see more metallographic work carried out on spearheads, as this can give surprising results, as in the case

67 *Anglo-Saxon folding (**A**) and pivoting (**B**) knives, from Coppergate, York.*
Folding knives have a blade that can be swivelled into its case for carrying and were in use from the eighth to the tenth centuries. Pivoting knives have a blade that swivels to give two blade shapes. They were used from the eighth to the eleventh century. Illustrations from Ottaway, 1992, courtesy of the York Archaeological Trust

68 *Methods used to 'steel' the cutting edge of a knife or blade.* Illustration by the author after Tylecote and Gilmour 1986

69 *The stages by which an iron spearhead was forged.* Drawing by the author, based on Tylecote, 1987

of Brian Gilmour's analysis of a seventh-century spearhead from Broom Hill Quarry, Sandy, Bedfordshire (**70**). Visual examination did not suggest that this weapon was anything exciting – it had a simple leaf-shaped blade which had been damaged in an encounter with a plough. X-rays, however, revealed that the blade was composite and possibly pattern-welded, and it was decided to take a metallographic section. This showed that the blade was made from four pieces of metal, welded together – the socket and the central section of the blade were made from low carbon iron and the two cutting edges were made from a medium carbon steel. These had been heated to around 800-850°C and water quenched giving a martensitic structure with a hardness of 847HV. No attempt had been made to temper this hard and brittle structure. The most remarkable aspect of this weapon was a 2.5mm wide chevron of phosphoric iron running between the cutting edges and the central section of the blade. This imparted nothing to the strength of the blade and must be seen as a decorative feature, probably enhanced by polishing. To make this spearhead, three types of iron had been selected and skilfully worked to give the best results.

low carbon iron
central piece

phosphoritic iron strip

steel edge piece

70 *Spearhead from Broom Hill Quarry, Bedfordshire.*
Metallographic work by Brian Gilmour showed the remarkable complexity of this seventh-century spearhead. The socket and the central section of the blade were made from low carbon wrought iron; the cutting edges were made from hardened carbon steel and, between the two was a chevron of phosphoric iron. Drawing by kind courtesy of Dr Brian Gilmour

SHIELD BOSSES (**71**)

Shield bosses are quite complex objects and it is interesting to see how they were made. They are relatively large, having to be big enough to accommodate a man's fist, and have a thin metal section which would present some problems to the smith. A modern metal worker would make a boss in pieces, which would then be welded together. This was not the method adopted by the Anglo-Saxons, who made their shield bosses in one piece. Heinrich Härke examined a large number of Anglo-Saxon carinated bosses, but none showed any sign of a welded joint. It can be very difficult to identify a well-executed hammer weld, as crystal growth occurs across the joint, and welds are usually identified by the pattern of slag lines. It would, however, be difficult to make a hammer weld along the carination of a shield boss, and if they were welded at least some would show signs of separating along this line of weakness. The lines of slag inclusions in shield bosses also supports their being made from a single piece of wrought iron; the exceptions being some early bosses where the top of the cone and apex of the boss were inserted. The laboratory examination of shield bosses by Chris Salter showed that they were made from an iron which contained little or no carbon: this was very soft, in one case with a hardness of only 80.3HV. Some, at least, of the tall seventh-century shield bosses were fabricated, and have a seam running down the side of the cone. The elegant late 'sugar loaf' type shield boss from Fatheringdown, Surrey had a tall cone made from iron segments joined by radial ribs.

The process of making a carinated shield boss would start from an iron bar, which would be forged into a disc (**71A**). Working at a high temperature, a hollow was formed in the centre of this disc (**71B**). It was then possible to start to hammer the sides of the hollow over an iron stake, thinning and raising them to form a cone (**71C**). The excess metal was then turned in to make the side-wall (**71D**). Once this was formed, the angle was again changed and the flange formed (**71E**). The metal section of shield bosses varies; the flange is thin, being around 1.0mm and 2.0mm. Above this, the thickness increases – the side walls are usually around 2.5mm and the cone is 2.3-2.8mm. This gradation was tricky work – the metal was thin and could tear, and it would need frequent annealing and reheating. The danger area was the apex of the cone where there was a tendency for the iron to thin as forging progressed. This may well explain why the apex on some early bosses was inserted separately, perhaps as a repair, or as part of the manufacturing process, removing a problem area.

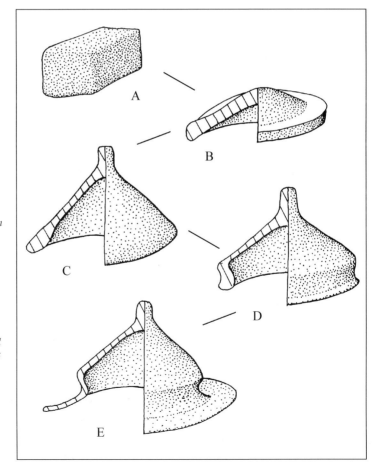

71 *The making of an iron shield boss. These complex objects were wrought from a single piece of iron. The iron billet (**A**) was hammered into a disc and its centre depressed (**B**). Forging continued and the boss was raised (**C**). The side walls were then turned (**D**) and the flange formed (**E**).* Drawing by the author after Härke and Salter 1984

LOCKS AND KEYS

The frequency with which locks and keys are found on Anglo-Saxon sites is somewhat depressing, suggesting that people were no more trustworthy a thousand years ago than they are now. Keys, both functional and in the symbolic form of girdle-hangers, are common finds in the graves of Early Anglo-Saxon women. Locks are also sometimes found in early graves: Grave 1 at Castledyke, the Barton on Humber cemetery, contained a small barrel padlock and an imported Frankish jug of seventh-century date. The excavation of Middle and Late Anglo-Saxon sites has produced large numbers of locks and keys, which are often highly ingenious. Both the reports on the finds from Coppergate (Ottaway 1992) and Winchester (Biddle 1990) contain excellent accounts of Anglo-Saxon locks.

The Anglo-Saxons used both mounted locks and padlocks and a number of different mechanisms were employed. The basic form of padlock consisted of a metal cylinder or box into which a hasp was pushed, fitted with barbed springs (**72**). These were pinched together as they entered the lock and then sprang out, making it impossible to withdraw the hasp. The key consisted of a short bar, on the end of which was a ring, shaped to go around the barbed springs and compress them, so allowing the hasp to be withdrawn. Barrel padlocks existed in a variety of forms, with the key being introduced from either the end or the side of the barrel. Most of the keys found in early graves were designed to operate a slide lock. The key was pushed into the lock and the projections on it reached through the wooden bolt to compress wooden leaf springs and release the bolt.

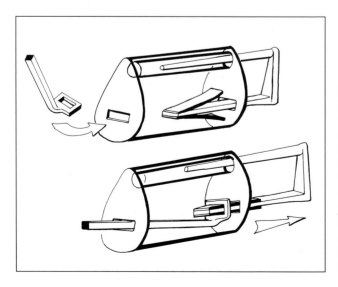

72 *Mechanism of an Anglo-Saxon sprung padlock. The key is inserted through a slot in the end of the iron barrel. It engages the two barbs on the hasp, compressing them so that it can be withdrawn. To close the lock, the barbed bar is pushed through the hole in the cylinder so that the barbs spring out, stopping the hasp from being withdrawn. Drawing by the author*

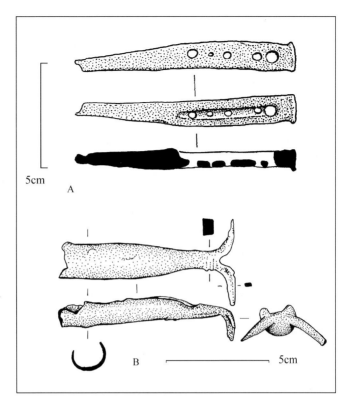

73 *Mystery objects.*
A *perforated iron bar, possibly a nail plate or dowel plate;* **B** *soldering lamp; both from the Tattershall Thorpe Lincolnshire grave, seventh century.* Drawing by the author after Hinton, 2000

5cm

A

B

5cm

MAIL

Indirect sources suggest that mail, although not common, was well known in the Anglo-Saxon period. There are references to its use in Anglo-Saxon literature (in particular, *Beowulf*), and depictions of it in art, as on the eighth-century Franks casket. Later wills make bequests of mail. In spite of this, only two surviving examples of Anglo-Saxon mail are known, the seventh-century mail coat from Sutton Hoo, and the mail drape from the eighth-century Coppergate helmet. The condition of the Sutton Hoo mail, rusted into a solid block, makes analysis difficult, but the rings were about 8mm in diameter and some of them were closed by copper rivets. Better preservation and detailed examination allowed much more to be said about the mail drape on the Coppergate helmet. This was made from 1.0mm diameter iron wire made up into 1,947 rings each with an outside diameter of 8mm. It is likely that the rings were made by spiralling iron wire around a mandrel. The wire was then cut obliquely with a chisel, so that the spiral fell into individual rings. Two methods were used to close the Coppergate rings – hammer welding or riveting. The welded rings would have been made first and, as welding was impossible on the assembled mail, these were linked by riveted rings, each being passed through two rings in the row above and two in the row below. Experimental work showed that

hammer welding these tiny rings required great skill. With wire that was only 1.0mm in diameter, heat loss was very rapid, and great speed was needed to move the ring from the hearth to the anvil. To rivet the rings, their two ends were flattened out to about 1.5mm wide, and overlapped by 4.0mm. Using a hardened steel drill, 0.8/0.9mm diameter holes were made through the over-lapping ends and iron rivets inserted.

There has been some discussion as to how the 49m of iron wire needed to make the Coppergate mail was made. The best indication of the process are marks left by a hammer or grooved swage, or the striations left by the wire's passage through the plate, but unfortunately corrosion has damaged the surface of the rings forming the Coppergate mail. In modern technology, wire is made by pulling the metal through a series of tapering holes in a draw-plate, each with a progressively smaller diameter. The possible draw-plate from the Tattershall Thorpe smith's grave must be rejected on practical grounds (see wire making, below) but there was a draw-plate in the tenth-century Viking Bygland grave. The anvil from Coppergate (**59B**) bears grooves which, combined with a grooved swage, could have been used to make wire. A narrow strip of metal cut from the edge of a sheet was placed

A

B

74 *Bells:* **A** *Tattershall Thorpe, Lincolnshire;* **B** *Flixborough, Lincolnshire. Copper-coated iron bells occur in tool hoards like Flixborough (eighth to ninth century) and Mästermyr, Gotland, Sweden (tenth to eleventh century) and in the Tattershall Thorpe smith's grave (seventh century). They may have been used by craftsmen to announce their arrival on reaching a settlement. Drawings by the author;* **A** *after Hinton 2000*

between the anvil and swage and the swage tapped with a hammer to round the strip and form the wire.

BRASSING

This is a process seen on iron bells, the surfaces of which are often coated with copper alloy (**74**). Brass-covered iron bells were made in recent times in Scandinavia which show how the technique was carried out. The iron bell was covered inside and out with copper strips and a lump of charcoal (presumably to maintain a reducing atmosphere) was placed in its centre. The bell was then covered in clay, to which horse dung or straw had been added to make it permeable, and heated to a high temperature, turning it over to make sure that the coating was evenly applied.

The bells themselves are made from a single sheet of iron, which was folded into shape and brazed to ensure that it would ring (or at least clank). One of these bells was found in an early Anglo-Saxon context at Sutton Courtnay, Berkshire and they remained in use over a long period of time. Their main function was probably as cow-bells, but they achieved some dignity when used by Irish monks during the early Christian period. They are also sometimes associated with craftsmen, examples being found in the Flixborough tool hoard, the Tattershall Thorpe smith's grave and the Swedish Mästermyr hoard, which contained three bells.

INLAYING

In this technique, a groove is cut into the surface of the metal and a piece of wire, made from a contrasting metal or alloy, is placed into it. The surface of the inlay is then tapped with a hammer to lock the wire into place. Inlaying is most successful when the metal being inlaid is softer and more malleable than the metal into which it is being placed. It can then expand into the groove and remain secure, particularly if the sides of the groove are slightly undercut. Inlaying was most commonly carried out on iron objects, but also occurs on copper alloy. Because of the corroded state of most iron objects, inlaying is often only revealed by radiography. The technique was used on a series of iron buckles of probable fifth-century date, but also appears on some later objects such as a series of fine seaxes of ninth- or tenth-century date, some of which are inlaid with bronze, copper, niello or silver, sometimes in combination. The fine ninth-century seax from Sittingbourne is inlaid in all four materials as a *tour de force* of inlaying (**colour plate 3**).

ETCHING

References are sometimes found in the archaeological literature to metal being 'etched'. While this term is sometimes used as a synonym for engraving it is

better if its use is restricted to the process by which metal is eroded by the action of an acid. It is unlikely that metal was etched before AD 1250–1300 when a method of making nitric acid reached Europe. The only acid available to the Anglo-Saxons was vinegar, dilute acetic acid. This may have been of use in enhancing the decorative effect on a pattern-welded blade but could not have been used to cut a line into metal.

ᚣ

9

NON-FERROUS
METALWORKING

Small metal objects, particularly those made from copper alloys, are one of the most common survivals from the Anglo-Saxon period. They can be dated in general terms and assigned to a cultural milieu (Anglian, Saxon, Kentish) making them useful in historical terms. With large numbers of Anglo-Saxon metal objects now being recorded by the Portable Antiquities Scheme, we are in a position to begin to understand the period in a way that was previously inconceivable. We are seeing an information explosion.

Workshops

The evidence for non-ferrous metalworking in Anglo-Saxon England is sparse, particularly when compared to sites in Scandinavia and the Celtic west. Workshops have been excavated at Helgö in Sweden, Ribe in Denmark, Dunadd in Argyll, the Motte of Mark in Kirkcudbrightshire, Dinas Powys in Wales and Garranes in Ireland. In England there is some limited evidence for Early Anglo-Saxon metalworking at Mucking, Essex and Winterton, Lincolnshire, and Middle Anglo-Saxon metalworking at Hartlepool, Wharram Percy and Carlisle.

The best Anglo-Saxon metalworking shop in England is the tenth-century example from Faccombe (Netherton) Northamptonshire. Inside a timber building measuring around 12.5m by 7.5m, three hearths were found, each measuring 2m by 3m. These were dug down into the clay subsoil which had been burnt red. They contained only some charcoal. Around these hearths were four smaller hearths, each around 500mm in diameter. Crucible

fragments were found in one of these hearths, and in another, a crucible containing traces of gold was found standing on a bed of charcoal. Two more large hearths and eight small charcoal-filled pits containing copper alloy waste were found outside the building. The small hearths were interpreted as being used for melting the metal, while the larger ones were used for heating the moulds ready for casting.

Writing in the early twelfth century, Theophilus describes what must have been a model monastic goldsmiths' workshop as would have existed at a major complex like that depicted in the plan of the monastery at St Gall, Switzerland in around AD 820. Theophilus calls for good light (a pre-requisite for any fine work), with the bottoms of the windows no more than a foot off the floor. The bench was set low over a timber-lined pit into which the workmen dangled their legs. This pit may have been intended to help with the recovery of gold and silver filings. A fire screen 'four fingers thick' was built out from the wall by hammering clay between two wooden boards. 'Four fingers' above the ground is a tuyère one finger in diameter, through which the bellows operate. A hearth, made from clay and horse dung, is built in front of the clay screen. Behind it was the bellows, protected from the heat of the hearth by the fire screen. This description corresponds to what is illustrated in two manuscripts, the Harley and the Utrecht Psalters, although these hearths are shown as being raised to table-top height.

Alloys used

Most Anglo-Saxon non-ferrous metals were used in the form of alloys, that is combinations of two or more metals, usually combined together in the molten state to form solid solutions and compounds. These give alloys properties which are strikingly different from the properties of their parent metals. The melting points usually range between those of the component metals; pure copper melts at 1,083°C, but an alloy containing 10 per cent of tin will have a melting point of around 1,020°C, the melting point falling still further with increasing additions of tin. Alloys often have greatly improved physical properties compared to pure metals, being stronger, harder and usually easier to cast.

Analyses have shown that a bewildering range of copper alloys were used in the Early Anglo-Saxon period, leading to the suggestion that their industry was based on recycled Roman and imported scrap metal. This should cause no surprise – all of the British deposits of copper and tin ore lie to the west in areas that long remained under Celtic control. It is notable that Celtic copper alloys of the period appear to have been made from new metal. In general

terms, the copper alloys used by the Anglo-Saxons were bronze, an alloy of copper and tin; brass, an alloy of copper and zinc and 'gun metal', a copper/tin/zinc alloy. The percentages used varied wildly.

Although zinc is a component part of brass, it was unknown as a metal in the west until the sixteenth century. Zinc melts at 420°C and boils at about 950°C, but unfortunately a temperature of around 1,000°C is needed to reduce the ore to metal and, unless precautions are taken, the metal boils off as feather-like dross. Prior to the sixteenth century, brass was made by a process in which pulverised calamine (zinc carbonate, $ZnCO_3$) was mixed with charcoal and placed in a hot crucible. This was then filled with copper and covered with charcoal to provide a reducing atmosphere. This allows the calamine to be reduced to zinc vapour which is absorbed by the copper to give brass.

Methods of working non-ferrous alloys

Although some alloys present special problems or advantages, most non-ferrous metals are worked using the same range of techniques. Two basic methods are used: casting and forging, although these methods are frequently combined, particularly as every wrought object starts out as a casting which must be forged down to give the thin sheet metal, bar or wire.

The casting of non-ferrous metals
Pure copper melts at 1,083°C, silver at 960.5°C and gold at 1,063°C. Alloying would, as was described above, reduce these melting points, but in order to cast metal it is necessary to heat it to well above its melting point. This 'super-heat' is needed to allow for heat loss as the crucible is moved from hearth to mould (a real problem when casting small amounts of metal) and to allow the metal to flow into the mould before it loses its fluidity and freezes. In view of this, a forced draught would be necessary to get a sufficiently high temperature in the hearth. This would be achieved by means of bellows.

The bellows used by Anglo-Saxon metalworkers would be made out of wood and leather. According to Theophilus, bellows were made from the whole skin of a ram, the neck of which contained a wooden plug into which an iron pipe was placed. This led into the clay tuyère through which the air blast was carried into the fire. Other parts of Theophilus' description are difficult to follow, but it seems there was a simple valve at the rear end of the skin which was opened and closed manually as the bellows were pushed in and out. No mention is made of the non-return valve needed to prevent hot gases from the hearth being drawn into the skin, with dire consequences.

Crucibles

Crucibles are vital in the making of castings. They need to be tough, as they have to stand high temperatures for long periods of time without breaking or sagging. To achieve these properties, many crucibles were made from clay containing large quantities of quartz – this would make it difficult to model, but a crucible has a simple shape and, once fired, it would be become very strong. Stamford ware crucibles were extensively used in the later Saxon period. These were wheel-thrown and made in a clay which contained a low level of fluxing impurities making them heat resistant and ideal for high temperature work (**colour plate 17**).

Anglo-Saxon crucibles survive only as small fragments, making reconstruction difficult, but most were bag-shaped with rounded bottoms, allowing them to stand on the coals in the hearth and removing the vulnerable angle between the sides and base (**75C** & **D**). They tended to be deep with constricted mouths to help the metal retain its heat and reduce the area exposed to air and oxidation. This is important when casting silver, which absorbs oxygen, leading to porosity in the finished casting. A seventh- or eighth-century crucible from Hartlepool may have been fitted with a lid which would have protected the melt. This also had a lug by which it could be held for pouring. An eighth-century lidded crucible was also found at Wharram Percy. Some tiny thimble-shaped examples are known with diameters of only 24mm. The small quantity of metal these held would have cooled very quickly and the

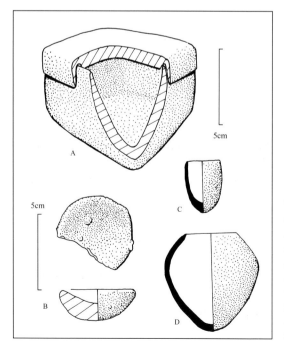

75 *Pottery vessels from York, used for refining and casting metal, Anglo-Scandinavian.*
A *reconstruction of a parting vessel used for separating gold from silver;* **B** *cupel for separating silver from lead;*
C-D *crucibles: the smaller one was locally made, the larger vessel was made at the Stamford kiln. Drawings by the author from Bayley 1992*

76 (Right) *Fragments of a mould for casting Early Anglo-Saxon brooches.*
Fragments of a clay mould for casting a great square-headed brooch found in the fill of a Grubenhaus *at Mucking, Essex.* Illustration by the author after Jones, 1978

77 (Below) *Mould fragments from the Hartlepool Anglo-Saxon monastery, eighth to ninth century. These fragments were found in the backfill of a palisade trench.* Illustration courtesy of Tees Archaeology, copyright Tees Archaeology 2003

5cm

A B C 5cm

transfer from hearth to mould would have had to be done in 2-4 seconds. Crucibles at York typically had diameters of 60-90mm.

Moulds

The basic principle involved in making a casting is simple – the metal is heated up to above its melting point and then poured into a mould cavity which has the shape of the required object. On cooling, the casting is broken from the mould, cleaned, dressed and is ready for use or further processing. The breaking of moulds to remove the castings gives them a very poor rate of survival. Fragments of moulds for casting a sixth-century great square-headed brooch were found in a *Grubenhaus* at Mucking, Essex (**76**). Excavations at the monastic site at Hartlepool, Cleveland, produced a mould for an eighth-century interlace decorated cross and two decorative mounts (**77**). Eighth-century moulds are known from Wharram Percy and we have a late Saxon strap-end mould from Carlisle.

78 *Brooch casting.*
A possible method by which the moulds for Anglo-Saxon brooches were made: **A** *– a pattern is made to give the outline shape of the brooch;* **B** *– this is bedded into a block of clay/sand mix and a casting gate cut;* **C** *– the second half of the mould is then made on top of the part just made;* **D** *– the two halves are separated and the patterns for the spring lugs and catch plate are pressed into one side of the mould;* **E** *– the decoration is cut into the face of the other half mould. The two halves are then put together, baked, heated and the molten metal poured in.* Drawings by the author

To make a mould, a model or pattern in the form of the required casting is first made (**78**). Having dusted the pattern with something like soot or stone dust to stop the clay adhering, it is then pressed into a pad of soft clay or a clay/sand mix, transferring the shape of half of the pattern into the clay. The back of a brooch is moulded first, probably to avoid the risk of damaging the more delicate and important part of the casting during later work. It is important that clay does not overlap the edges of the pattern so that it can be removed from the mould. The mould half is then allowed to dry and harden a little before it is again dusted and a second pad of clay modelled against the first. This takes the shape of both the other half of the pattern and the face of the previously made half mould, ensuring that the two halves will be correctly aligned for casting. Once the clay has started to harden, but before it starts to shrink, the two halves of the mould are separated and the pattern removed. If it has not already been done, the funnel-shaped pouring basin and the in-gate through which the metal flows into the mould are cut into the clay. The foot of a mis-cast small-long brooch from Winterton, Lincolnshire still retains its casting gate (**79**). It has been suggested that the catch plate and the spring lugs were added at this stage by pressing the separate patterns into the soft clay. This would make moulding easier and is supported by a square-headed brooch recently found at East Leake, Nottinghamshire where these fittings had been omitted (or forgotten) and had to be soldered onto the back of the finished casting. The two halves of the mould are then placed together and fully dried, ready for baking and use.

The other method of making a casting mould is the lost wax, investment or *cire perdue* process. Elegant in its simplicity, the process involves the making of a model of the required casting, together with the casting gate, in wax – a very easy material to work. The wax model (**80**) is covered in layers of clay/sand, if necessary starting with a fine slurry to capture details. Once the mould is

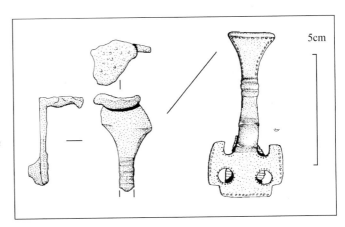

79 *Foot of a mis-cast small long brooch from Winterton, Lincolnshire.*
At the top of the casting is the pouring basin and ingate through which the metal entered the mould. Also shown is an Early Anglo-Saxon small-long brooch from grave 48 at the Cleatham cemetery, Lincolnshire, which has a similar foot to the Winterton fragment.
Drawing by the author

5cm

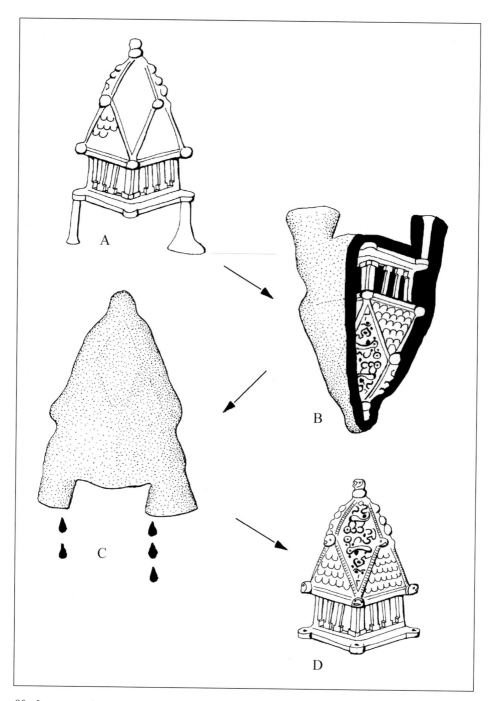

80 *Lost wax casting.*
This process was used to make the Pershore 'censer' cover. A model of the object, together with the casting gates and risers is made in wax, **A**. *This is then covered in a layer, or layers, of fine clay/sand,* **B**. *The mould is then inverted and heated, melting out the wax and firing the clay,* **C**. *The mould is now turned upright and the molten metal poured in. Once the metal is cool the mould is broken open and the casting removed.* Drawing by the author

complete it is inverted and heated, melting the wax which drains out through the in-gate. Heating also fires the one-piece clay mould so that it is ready for use. The disadvantage of the lost-wax process is that it results in the destruction of both the mould and the pattern, which must be renewed for each casting. With the possible exception of the great gold buckle from Sutton Hoo, we so far only have evidence for the use of two-part moulds in England prior to the tenth century. The lost wax process must have been used to make the so-called censer covers, such as the example from Pershore (**colour plate 25**). The tenth-century bells from St Oswald's Priory, Gloucester and the Old Minster, Winchester were also made using variants of this process. Theophilus, writing in the early twelfth century, gives a detailed account of the use of the lost wax process, describing the casting of a bell by the same method as was used at Gloucester and Winchester. This involves the making of the inner shape of the bell on a rotating horizontal spindle. This was then covered with sheets of wax with the same thickness as the bell, any decoration added, and the wax covered in clay. At this stage, the central spindle was removed and the shape of the bell's suspension fittings added in wax which was also then covered in clay. The mould was placed in a pit and heated to dry it, remove the wax and heat it for casting. After casting, the mould was removed and the core broken so that the metal, which contracted on cooling, did not tear on the still solid sand.

There has been some debate regarding the nature of the patterns or models used in the production of clay moulds. A small number of lead models of Anglo-Saxon brooches are known and it has been suggested that these were used as patterns. Certainly, lead would be suitable for use in this way, it being easy to cast and will take detail which can cut directly into its surface. Lead would be strong enough to survive the moulding process. An objection to the use of lead patterns comes from an examination of pairs of Anglo-Saxon cruciform brooches. It was found that, although paired brooches generally look like each other, they differed in detail and it was unlikely that they were made from the same pattern. This might suggest that one-use, lost wax patterns were being used, but if this was the case why were they being used in two-part moulds? It may be that the process of removing the soft wax pattern was too difficult and that it was easier to melt it out. Complex, multi-stage mould-making processes have been suggested, but would have offered no advantages to the original craftsman.

I would like to suggest a further possible way in which the moulds might have been made which takes advantage of the fact that the clay from which the moulds were made is, itself, a highly mouldable material. Morten Axboe has observed that the sharply angular animal or interlace decoration used on Germanic metal work is easier to cut in the negative than in the positive, finished, form. If a sharp rib is required as part of a decorative scheme it is easier to cut it into the face of a negative mould than to cut away all of the

surrounding material to make it in the positive. It is possible that a pattern was used to make a mould for the general form of a brooch and then the decorative detail was cut, in the negative, directly in the clay (**78**). Clay is an easy material to work, and if covered with a damp rag will stay workable indefinitely. This would explain the variation we see between pairs of brooches and does offer the advantage of being a simple, direct process.

It is important that the decoration is added at the mould stage. Experimental work carried out by Coatsworth and Pinder showed that while it was not difficult to cut 'chip-carved' and interlaced designs into bone or antler it was very difficult to cut these designs into the metal once it was cast. They suggested that most of the work on the decoration was done at the model stage, and then this was finished on the casting.

A further technique possibly employed is the production of thin castings using the first half of the mould as a pattern to make the second part. Coatsworth and Pinder suggested that having made the first half of the mould, the pattern was removed. The second mould half was then made on top of the first, making in effect a positive copy of it. Clay was then pared off this positive copy to give the required metal section and details such as the pin and catch mechanism were added. When the two halves were re-united, the thickness of the clay removed from the positive gave the metal thickness. An alternative would be to make the first half of the mould as before and then line it with a layer of cloth, possibly wax soaked, of the same thickness as the required metal section (**81**). The second half mould would then be made off the first, the mould opened and the cloth removed before casting. This would ensure that the metal section was correct and explain the textile impressions found on the backs of some thin section castings (**82**).

The largest gold castings we have from the Anglo-Saxon period are the great seventh-century buckles from Taplow and from Sutton Hoo, the latter weighing 412.7g (0.91lb). Most other gold objects were fabricated from sheet metal which was more economical and took advantage of the ease with which gold can be joined. The Sutton Hoo buckle was cast as a thin, open-backed shell, and its buckle tongue was hollow-cast in two parts and soldered together. Viewed from the back the great gold buckle from Sutton Hoo shows the outline of its decorated face in a smeared, waxy way. Coatsworth and Pinder are surely right in suggesting the use of wax in the making of this *tour de force*, although it may not have been used in the lost-wax process.

Modern practice is to heat small moulds to around 350-400°C before casting metal into them – failure to do this would result in the metal not flowing into the thinner parts of the casting. During the casting process, the air in the mould will expand in volume due to contact with the hot metal. This, and the gases produced, must be allowed to escape or the mould will not

81 *Casting a small, thin metal object.*
Suggested method for making the silver face mount from Messingham (82): **A** – *solid pattern-made wax or clay in the required form;* **B** – *one half of a mould is made off this pattern;* **C** – *the pattern is removed;* **D** – *the mould is lined with cloth or wax impregnated cloth;* **E** – *a second half-mould is made off the first half;* **F** – *when separated, the cloth is removed, leaving a narrow space for the metal to flow into;* **G** – *the finished casting, with a cloth impression on its back.* Drawings by the author

82 *Eighth-century silver gilt mount from Messingham, Lincolnshire.*
This object, approximately 10mm in width, is made from very thin cast metal and its hollow back bears the
impression of cloth which was used in its manufacture. Photograph by Mike Hemblade, North
Lincolnshire Museum

fill properly. Much of the air would be able to escape through the joint
between the two halves of the mould and, if the clay/sand mix is sufficiently
porous, gases will also be able to escape through the mould walls.

Once the casting has been made, it will need 'fettling' to remove the
casting gates and the 'flash' where the metal has run into the joints between
the mould halves. In the case of a brooch, it would be necessary to drill a hole
through the lug or lugs to take the iron chord that secured the coiled pin-
spring. On many cruciform brooches the knobs were fixed onto the ends of
this pin, a feature that gave the brooches their 'cruciform' shape. This practice
was continued on some of the late 'florid' brooches on which pins, cast inte-
grally on the main body of the brooch, were located through loops on the
backs of separately cast knobs and then secured with rivets. This complicated
procedure seems to have offered few advantages over casting the whole
brooch in one piece. The other procedure required in completing a brooch
was to bend the catch plate around so that it could secure the pin. To cast the
catch plate already folded around would have called for the use of a separate
mould-piece which must have been used to make some very early brooches
which have a box-like catch.

Ingot moulds (**colour plate 17**)

Non-ferrous alloys destined for making wire or rods were cast into ingot moulds, the surviving examples of which suggest that the preferred shape was a finger-like ingot which could easily be worked up into wire. These moulds appear to have been used open with no upper part. At Hamwic, two limestone ingot moulds were found which probably dated to the eighth century. Both limestone and sandstone were used to make moulds at York, but at Thetford chalk was used. It can only be assumed that these were used to cast alloys with a low melting point such as pewter. Some of the York ingot moulds were found to be made from soapstone (steatite or talc schist), a highly refractory material that is easily carved. This is not available locally and must have been imported from Scandinavia or northern Scotland. When analysed, it has been found that many Anglo-Saxon ingot moulds had been used for casting silver.

Sheet metal work

Prior to the introduction of rolled sheet metal, all thin metal objects had to start out as ingots. In the case of relatively large objects like bowls it is likely that the first step was to cast a metal disc which would then be wrought down to the required thickness and shape. This would be done using a hammer and a metal stake set into a heavy wooden block. The basic difference between the hammer working of non-ferrous metals and iron is that iron was usually worked hot, while non-ferrous metals were worked cold. As the hammering of any non-ferrous alloy continues, it will work-harden, eventually reaching a point where the embrittled metal will split. To overcome this, the metal must be annealed, that is heated up to its re-crystallisation temperature to render the metal workable once more. It would have been necessary to anneal the work piece many times during the making of a sheet metal object.

The largest sheet metal objects found in Anglo-Saxon contexts are copper alloy hanging bowls. These objects are interesting in that they are commonly found in Early Anglo-Saxon contexts, but the decoration they bear is sub-Roman Celtic. In modern practice, these bowls would be made by 'spinning', a disc of sheet metal is set rapidly revolving on a lathe and then, using levers, the metal is forced over a wooden mandrel so as to take its shape. While this idea is attractive, some problems exist. No bowl seen by the writer has any trace in its centre of the hole required to attach it to the mandrel, and furthermore it is doubtful if an Anglo-Saxon pole lathe possessed either the speed or power needed for the spinning process. These bowls must have been raised by hand, but may then have been finished by spinning over a turned wooden mandrel.

Fabrication

The most important requirement for the fabrication of objects from their component parts is some method of joining the pieces together, permanently and unobtrusively.

SOLDERING AND BRAZING

Two methods of soldering were used by the Anglo-Saxons – 'soft' and 'hard' soldering. In 'soft' soldering, an alloy is used that contains a high proportion of lead or tin and has a melting point of less than 450°C. Soft solders act like glue and join the metal parts together with little or no diffusion. Many Early Anglo-Saxon brooches have applied 'silver' panels, some of which were soldered into place. Some of the examples seen by the writer appear to have been attached using soft solder.

Brazing or 'hard soldering' depends on the principle that alloys have different melting points and by choosing a brazing medium with a lower melting point than the work piece, it is possible to make a joint before the work piece melts. The usual practice was to heat up the components to be joined to around 800°C while securing them in the required position. The solder, with its lower melting point, is touched on to the joint and melts, being drawn into the gap by capillary action. As its composition is similar to that of the components, the solder diffuses into them, forming a very strong joint. In fine work, the brazing alloy may have been applied to the joint in small pieces before heating began. Fluxes were used to prevent the surfaces of the solder and metal oxidising, which would prevent fusion, and ensure that the solder flowed easily. It is not known what flux the Anglo-Saxons used; modern practice is to use borax (sodium tetraborate), but it is not known when this came into use. Common salt can be used as a flux and may well have been used by the Anglo-Saxons.

An object that has been described as a 'soldering lamp' was found in the Tattershall Thorpe grave (**73B**) and similar channelled objects have been found at Coppergate where it was suggested that they were soldering lamps. These are thought to have contained beef fat and a wick; air was blown through a mouth-pipe onto the flame giving intense, directed heat that could be used in soldering precious and non-ferrous alloys.

EUTECTIC SOLDERING

This ancient process for joining precious metals is known by a number of names (granulation soldering, diffusion bonding etc.), but all refer to a single, elegant practice. It involves the use of a copper salt which is mixed with an adhesive and possibly a flux. This is used to attach filigree wire or granulated pellets onto the surface of the object to be decorated and the work piece is

heated. As the temperature rises, the organic component of the adhesive carbonises and the carbon reduces the copper salt to copper. This is absorbed by the gold or silver to form an alloy with a lower melting point than the components, and this new molten alloy will be carried into the joint by capillary action, pulling the components together to form a strong, tight joint. Eutectic soldering was used in the laying of filigree gold wire onto the surface of gold objects (**colour plate 23**), but, while apparently simple, it was not easy to carry out. The melting point of the eutectic was not much less than that of the work piece and great care was required, particularly as the base onto which the wire was laid was usually very thin.

RIVETING

Rivets were used in the assembly and the repair of Anglo-Saxon metal objects. The process is simple – the two parts to be joined are fixed together and a hole drilled through them. A rivet made from a short section of copper alloy or iron wire is placed through the hole and its ends are hammered, thus expanding them and clamping the pieces together. While few analyses have been carried out, the rivets usually appear to be a different colour to the rest of the object suggesting that they were made from a softer and more malleable alloy. Gold objects were sometimes assembled using rivets formed from a piece of sheet gold which was rolled into a cylinder and its two ends split and splayed out to hold the components together.

Wire making

The manufacture of wire was an important part of the Anglo-Saxon metalworker's repertoire, as wire formed the basis of filigree decoration. Some of the wire used was remarkably fine, having a diameter of only 0.2mm. Coatsworth and Pinder have described the three methods of making wire that were available to the Anglo-Saxons: strip-twisting, block-twisting and wire drawing. In the strip-twisting technique, a narrow strip is cut from the edge of a sheet of metal. This is then twisted until it forms a helical tube with an open centre. This tube is then rolled between two smooth blocks of stone or metal which compresses the tube which will, in the case of gold, cold weld to form a round-sectioned wire. In block-twisting, a square-sectioned length of wire is tightly twisted so that its four corners form a tight spiral which is then rolled between two blocks to smooth it and produce round-sectioned wire.

It has been shown that fine drawn wire was used by the late ninth century onwards, for instance on the silver scourge from the Trewhiddle hoard. This was made using trichinopoly work or 'French knitting' in which the wire is wound around and lifted over four pins to produce a tube extending through a hole in a bobbin. There has been some speculation that an object found in

the seventh-century Tattershall Thorpe smith's grave was a draw plate for making wire (**73A**). This consists of an iron bar with a groove down one side through which are five holes; on one end of the bar is a blunt point, the other bears signs of being hammered. Similar objects were found in the Swedish late Viking hoard from Mästermyr and the mid-tenth-century Viking smith's grave at Bygland, Norway. The Bygland find is particularly interesting as this grave also contained an elongated oval plate through which were a number of small holes. If this is a draw-plate (and there can be little doubt that it is) then the perforated bars must have had some other function. In addition to this, the holes through the perforated bars are too large for wire drawing; to reduce a wire with a diameter of more that 3mm requires more than human strength. The holes are also not graded in size to allow for the gradual reduction of the diameter of the wire. A better interpretation of these bars is that they were used to hold nails while the heads were being forged.

Beaded wire

Beaded wire was used by the Anglo-Saxons in filigree work. Theophilus gives two methods of making beaded wire – one, his *organarium*, would seem to have been a two-part metal jig, the face of each part bearing a groove containing half the section of the required beading. Gold or silver wire was laid in the grooves and the two parts placed together and hammered as the wire was turned, forming the beading. As each section was complete, the wire was moved on and a further length of wire beaded. The other method described by Theophilus is simpler and is more suited to making fine wire. It consisted of a tool, 'as thin as a straw, a finger long and nearly square, but wider on one side. Their tangs, on which handles were put, curved upwards. On [the] underside a longitudinal strip is dug out and filed like a furrow, and the edges on both sides of this are filed sharp.' This is best interpreted as a rolling swage, which was rolled back and forth over the wire to manually form the beading.

The beaded wire would have been fused onto the surface of the metal using the 'eutectic soldering' technique described above. This method could also have been used for granulation, in which small pellets of gold or silver are fused onto the surface of the metal, although granulation was not common on Anglo-Saxon jewellery. The pellets could be made by cutting tiny pieces of metal and heating them to their melting point on a flat surface. As they melted, the surface tension of the metal would pull them into a spherical shape.

Coining

After a hiatus following the Roman withdrawal from Britain, coins were again struck around AD 650 with the issue of gold *thrymsas* in south-east England. With an increasing shortage of gold, these coins were debased with

silver and copper and, by the end of the seventh century, they were replaced by small silver coins, now referred to as *sceattas*, but probably known to the Anglo-Saxons as pennies. This series of coins continued until the 780s when King Offa of Mercia instituted a series of true silver pennies of outstanding quality which set the standard for the rest of the Anglo-Saxon period. Offa's pennies were based on coins of the Carolingian King Peppin III, and had the same weight as the *sceattas*, but were thinner, giving a larger diameter and allowing the die-cutter a greater area in which to display his talents. These usually bore the names of the king and the people he ruled, together with the name of the moneyer who issued the coins. Some of Offa's coins bear an image, not of him, but of Cynethryth, his queen. Anglo-Saxon pennies were made from a good silver alloy and enjoyed a very high reputation throughout Europe. The Later Anglo-Saxon period saw coins being withdrawn and replaced every six years from AD 973 to the end of Cnut's reign. By the time of the Conquest, coins were replaced every two or three years, probably as a method of taxation (for every 12 demonitised old pennies, you got 10 new ones). There were many mints in operation at this time, with coins being struck, at one time or another, at over a hundred centres, the largest of which had up to 50 working moneyers.

A remarkable feature of Anglo-Saxon pennies is that they are round. When one looks at Roman coins or medieval silver coins, they only approximate to being circular; some, like the Tealby issue of Henry II, can be any shape. It is clear that Anglo-Saxon coins were cut out using a ring-punch, but the difficulty was maintaining the correct coin weight, which was not easily achieved when rolled sheet metal was not available. Some method, such as a sleeve, must have been used to ensure that the upper and lower dies remained in register during striking.

Some Anglo-Saxon coiner's dies survive. Two iron dies for striking silver pennies were found at Coppergate (**colour plate 18**). One was for striking coins of the St Peter's issue of the Vikings of York, dated to AD 920-27. The other find was part of a die for striking coins of King Athelstan which dated to AD 927-39. An iron die found in Lincoln bore an incomplete inscription for coins of Athelred II, struck by the Lincoln moneyer Colgrim in AD 991-7. This suggested that dies were actually being made at the mints and not circulated from a centre. Lincoln, however, was a major mint at this time and may itself have assumed the role of a die making centre. It is interesting how it was possible to cut the inscription into the iron die and yet have it hard enough to survive prolonged hard use in the striking of coins. We cannot cut metallographic sections from such important objects as coin dies, but X radiography showed the Coppergate St Peter die to consist of two layers of iron, fire-welded together. This might be a result of the die being produced by

welding a layer of ferritic iron onto a disc of high carbon steel. The coin inscription could then be cut into the soft ferritic disc and the whole die heated. This would allow carbon to diffuse into the ferrite, converting it to steel, and the die could then be hardened by quenching it. The face of an iron die for striking coins of Cnut from the Thames Exchange in London had a separate steel tip attached to a wrought iron shaft. As the upper die, the 'pile', took the direct blow of the hammer, it had a much shorter life than the lower 'trussel' and it was customary to supply two pile dies for every trussel die and to put the more complex side of the coin on the trussel.

More information on how dies were made comes from the lead trial pieces found at Coppergate, York (**colour plate 18**). These were struck from unused dies and the soft metal has preserved traces of the setting out lines used by the die cutter. Starting with a block of iron, circles were scribed onto it with a pair of compasses. A small number of stamps (dots, straight lines and curves) were then combined to form the letters, special stamps being used to make any symbols or the portrait.

10

PRECIOUS METALS

The supply of gold and silver

While both gold and silver occur in the British Isles, it is unlikely that the Anglo-Saxons had direct access to these sources which lay in the west beyond the Celtic frontier. The Anglo-Saxons were probably dependent upon residual Roman metal and external supplies for their raw material. Much of the gold used in the early period came from melted down coins and it has been possible to correlate the composition of gold objects with that of contemporary coins. The ultimate origin of the gold was coinage received by Merovingian kings as subsidies from the Byzantine Empire, some of which was passed along as diplomatic gifts to friendly kingdoms and allies. Kent, with its links with the Continent, was better placed to receive a share of this gold than other Anglo-Saxon kingdoms which were largely dependent on recycled metal and Kentish largesse. Gifts would be exchanged between other kings – no two of the 37 Merovingian gold *tremisses* found in the Sutton Hoo purse came from the same mint, suggesting that they were intended to show the extent of the donor's influence. The use of gold was at its height in the late sixth to seventh centuries, but diminished as the supply of coins from Byzantium dried up. Silver then became the standard metal for coinage and there was an increasing use of silver for jewellery.

Silver is also found in the British Isles, and while it is unlikely that it was mined in the early part of the Anglo-Saxon period, these deposits were probably exploited from the later ninth century. Prior to this, the supply of silver was probably largely based on residual Roman metal and imports obtained though trade, as is suggested by the discovery of Frisian *sceattas* in England. While the Vikings imported some silver *dirhams* from the Arab world, their activities probably resulted in a decrease rather than an increase in the supply of silver.

In the ninth century, gilding, which had been favoured in the sixth to the eighth centuries, was replaced by silver as the preferred finish. This change may have come about through a change in fashion, or a shortage of gold caused by a failure of supply and the growing use of the metal to make sacred objects. Silver was usually used in conjunction with niello to give a striking black and white effect seen to advantage on objects decorated in the Trewhiddle style such as the Fuller brooch (**colour plate 1**) and the Witham sword (**83**).

83 *The ninth-century sword from the River Witham at Fiskerton, Lincolnshire.*
This magnificent weapon is decorated with silver mounts in the 'Trewhiddle' style. Typical are the animals, plants and geometric motifs, fitted into small frames and inlaid with black niello for contrast. Drawing by Dianne Leahy

Alloys used

Precious metals were commonly alloyed with other metals to improve their strength and hardness and to make them go further. Modern gold objects generally contain 75 per cent (18 carat) gold alloyed with other metals. This alloy has a good colour, is not too soft and is easy to work. An examination of the seventh-century gold objects from the Sutton Hoo burial showed that most of them were finer than 18 carat, the finest alloy being the gold sword pommel which contained 97 per cent gold. The poorest object also came from the hilt of the sword; one of the filigree mounts contained only 70 per cent gold. Most of the gold alloys are therefore similar to those used by modern goldsmiths. The Sutton Hoo report also includes the analysis of 28 gold objects from other locations in England. This suggests that, while the fineness of the Sutton Hoo gold can be paralleled in Kent, poorer alloys were used elsewhere in the country.

Cupellation and parting

In addition to the deliberate alloying of precious metals, it was also necessary to be able to refine them and separate the component metals in an alloy. Gold and silver were separated from base metals by means of the cupellation process. This involved placing the alloy in a small (c.50-100mm diameter), shallow 'cupel', made from clay and bone ash (**77B**), and covering it with a sheet of lead and a heap of charcoal. An air blast was applied and the temperature taken to around 1,000°C. The lead was oxidised to lithage, which then oxidises any other base metals present, the oxides being absorbed by the lithage, which itself is absorbed by the bone ash lining of the cupel. Tin and zinc will not be absorbed and, if a bronze or brass is being cupellated, Theophilus recommended that scraps of glass be added as an additional fluxing agent. The process continues with more lead being added and lithage being scraped off the top of the cupel to expose the surface of the metal to the air blast. When the process is complete, a pellet of refined precious metal is left in the base of the cupel. The lithage can then be re-smelted to extract lead and any other oxidised base metals. Excavations at Coppergate produced evidence for cupellation in the form of cupels and lithage cakes. None of these were complete, but it appears that they were around 80-150mm in diameter and 10-15mm thick. Cupels have also been found at Hamwic. Small cupels were also used to assay silver, the alloy being weighed before and after cupellation, the difference showing the purity of the silver. A ninth-century touch stone was found at Winchester. This is a technique of assaying the gold

content of an alloy by comparing its colour against the colour of needles of known composition. The sample and the needles are touched onto a piece of fine grained stone and the colours matched.

In the case of an alloy of gold and silver, a process known as 'partition' was used to separate them. The gold/silver alloy was beaten into thin sheets which were laid in a sealed pottery container, interleaved with common salt and finely crushed tile (**75A**). The sealed container was then heated in a furnace to a temperature below the melting point of the alloy, and held at that temperature for, according to Theophilus, 'a day and a night'. At this temperature, the salt reacts with the silver in the alloy forming silver chloride which is absorbed by the tile fragments and the clay vessel. The gold remains unchanged and, once the process is complete, the silver can be extracted from the silver chloride. Fragments of parting vessels have been found in late Anglo-Saxon contexts at York and Winchester.

The decoration of metal objects

While gold objects were usually fabricated, it appears that most of the shaping of copper alloy and silver objects was carried out by casting. There are exceptions – the early ninth-century hoard from Sevington, Wiltshire contained five strap end blanks, two of copper alloy and three of silver which had been rough-shaped by hammering and were awaiting finishing by chiselling and filing.

Stamp decoration
Stamp decoration was used on many early Anglo-Saxon metal objects and the use of ring-dot is ubiquitous. The skill in stamping comes in the cutting of the iron punch. Attempts have been made to use stamp impressions to link Anglo-Saxon objects to particular workshops, but although this work is interesting, the results so far have been inconclusive. Ring-dot decoration does not, for the most part, appear to have been stamped, but cut with some form of radial cutter, probably being twisted around a centre punch impression.

Cut decoration
Some linear decoration was cut with a file but the use of gravers was perhaps more common and it is sometimes possible to see marks left by the rocking action of the point as it was worked through the metal. Some graving tools survive, as in the example from Tattershall Thorpe (**62B**), and the tanged tools from Coppergate. The sharp profile seen on some Anglo-Saxon decoration suggests that it had been finished with a chisel after casting. In 'chasing', the tool is tapped with a hammer as it is moved across the surface of the metal,

leaving behind it an impressed rather than an incised line; in an impressed line the metal is displaced to one side and not removed, as in incision.

Repoussé

Repoussé is a method of decorating metal objects in which thin sheet metal is laid over a yielding material such as pitch and, using punches to push the metal down, the required design is formed in relief on the underside. It was used on some sleeve clasps and was employed on the mounts used on buckets. The gilt copper alloy casing which covers the tenth-century reliquary from Winchester was almost certainly made using the repoussé technique, supplemented by chasing, in which detail was added to the design from the front, using a chisel. The lovely silver-gilt bowl from Ormside, Cumbria was also made using the repoussé technique. This dates from the second half of the eighth century and is made from two concentric hemispherical shells, the outer decorated with plants, birds and beasts with a simple liner concealing the hollowed back of the repoussé.

Pressblech

Thin decorative plaques bearing impressed decoration are common finds from Anglo-Saxon England occurring on sleeve-clasps, brooches and, most notably, the helmet from Sutton Hoo, with its appliqués bearing strange dancing warriors. Pressblech involves the use of a die over which thin sheet metal (gold, silver or copper alloy) is forced so that it takes on the design. Experiments were carried out by Coatsworth and Pinder to determine how a Pressblech die was used. The obvious method, pushing the foil over the die with a pointed tool, was found to be difficult. It was discovered that the best method involves placing the foil on top of the die and covering it with a leather pad. A blow on the top of the pad produced a good impression. The panels of Pressblech that decorated the Sutton Hoo helmet are made from tinned copper alloy and not, as one might expect, a more precious metal. Dies for making mounts similar to those used on the Sutton Hoo helmet have been found at Torslunda in Sweden. A number of Pressblech dies are known from England, and they are becoming increasingly common (**84**).

Filigree (**colour plate 23**)

Filigree consists of lengths of gold or silver wire which are twisted and/or beaded and laid on the surface of the metal in simple abstract or interlaced animal designs. Sometimes the decoration is elaborated by the use of finer wires running parallel to the main strands, or by laying double strands of counter-twisted wire next to each other to give a herring-bone effect. The wire strands were attached using the eutectic soldering technique. Beaded wire

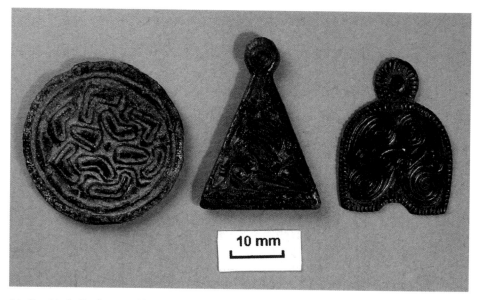

84 Pressblech *dies from, Ingoldmells, Lincolnshire (left), North Ferriby, Yorkshire (centre), Ketsby, Lincolnshire (right).*
Dies used to make decorative foils which were applied to larger objects. The Ingoldmells die bears the ribbon-like decoration of Anglo-Saxon Style II and dates from the later sixth to seventh century; the North Ferriby die is decorated in Style I and dates from the sixth century. The spiral decoration on the Ketsby die shows it to be Hiberno-Saxon work of the seventh century. Photograph by Mike Hemblade, North Lincolnshire Museum

was most commonly used on Anglo-Saxon jewellery in the late sixth and seventh centuries.

Gilding (**colour plates 2, 15 & 16**)

In the Anglo-Saxon period gilding was carried out using the mercury or fire gilding process. This method uses the affinity of mercury for gold, silver and copper alloy. The gold was dissolved by dropping leaf into boiling mercury. Medieval accounts tell us that the correct proportion was seven parts of mercury to one of gold. The surface to be gilded was carefully cleaned and the amalgam painted on and the object heated. At a temperature of 357°C, the mercury boiled off, leaving a very thin layer of gold bonded with the surface of the silver or copper alloy. An alternative process involves amalgamating the surface to be gilded with clean mercury and then applying layers of gold leaf. These dissolved, and once the required thickness had been built up, the object is heated as before. This low working temperature allows gilding and niello to be used together, so long as the higher melting point niello was applied first. Mercury is highly toxic and the dangers of using it were recognised by Theophilus, who advised against working with mercury when hungry because of the dangers of the fumes. Mercury is not found in England and must have

been imported from Italy, Spain or Yugoslavia. A sealed capsule containing a few drops of mercury was found in a grave containing smith's tools at Hérouvillette near Caen, Normandy.

Tinning

Tinning involves covering the surface of the metal with a layer of metallic tin. This can be done in two ways, both of which depend on tin's low melting point of 232°C. In one method, the surface to be coated was covered with a flux, perhaps pine rosin. The object was then dipped into molten tin, the excess tin then being wiped away with a rag or a piece of leather. Alternatively, the object to be tinned was held in a reducing flame such as a charcoal fire, and its surface rubbed with a stick of tin so that the metal flowed over it.

Niello

Niello has a shiny black surface which, when set in contrast with metals, was used to great effect. Three basic compositions were used in the past: silver/ sulphur, copper/sulphur or copper/silver/sulphur. Niello was used in the seventh century, appearing on plated disc brooches and the great gold buckle from Sutton Hoo. It became common in the ninth century when it was much used on 'Trewhiddle style' metal work. In the Trewhiddle style, the area to be decorated was usually divided into geometric fields into which were fitted animals and other motifs, set against a niello background. This can be seen on the Witham sword (**83**) and Fuller brooch (**colour plate 1**). The style is found throughout the British Isles from the eponymous Trewhiddle near St Austell in Cornwall to Talnotrie in Kirkcudbrightshire.

Analysis carried out on niello by Susan La Niece showed that the composition of Anglo-Saxon niello differed from that used by the Romans. While the Romans used copper sulphide or silver sulphide, it is not until the later fifth century that we see the use of silver/copper/sulphide. The process of making niello described by Theophilus includes the use of lead, which is a feature of later niello. Put simply, his process involves making an alloy of copper/silver in a crucible. Sulphur was placed in the bottom of a second crucible and a mixture of lead and sulphur is made in a small copper vessel. The lead/sulphur mixture is poured into the molten copper/silver and stirred with a piece of charcoal. This mixture is then poured over the sulphur in the second crucible; once this has melted together it is poured into an iron mould, but while still hot it is hammered into thin sheets so that it can be broken up for use. The niello was ground into a fine powder and stored in goose quills for use. To apply niello, Theophilus applied water containing a little flux (borax?) to the surface to be inlaid. This would have been recessed to hold the niello, which was carefully deposited from a quill. The work piece was then heated, the

niello melting at around 680°C and fusing to the surface. Theophilus also described how to apply niello to engraved lines. A rod of niello is heated to red heat and, using a pair of tongs, rubbed on the work piece. When the area is covered, the work piece is taken out of the fire and the excess niello removed with a file to reveal the incised decoration. Niello remains brittle and care is called for in any subsequent treatment of the decorated area.

Enamelling

The basis of enamelling is fusing glass to the surface of a metal object. As glass can be coloured with metal oxides, the process gives opportunities for bright decoration. Enamels were applied by grinding the glass in water and laying the paste into the areas to be decorated. Once the paste was dry, the object was heated until the enamel melted and fused to the surface of the metal. The metal surface was sometimes roughened to allow the enamel a better key to secure it in place. Enamelling was used in two ways: *cloisonné* where the inlay was applied into interlocking cells made from flattened wire; and *champlevé* in which the enamel was laid into recesses cut into the surface of the metal.

Champlevé enamel was frequently used on hanging bowls, a strange group of objects whose decoration is Celtic, but which are almost exclusively found in seventh-century Anglo-Saxon graves. The technique also appears in a limited way on early Anglo-Saxon metalwork where it consists of simple motifs such as annulets or bulls-eyes (**85**). As enamelling was not used in the Germanic homelands, it may have come from the strong Romano-British tradition of enamel decoration. However, the composition of Anglo-Saxon enamel differs from that used earlier. Enamel is not common in the Middle Anglo-Saxon period, but was occasionally used on Trewhiddle-style strap ends. It was used on the Alfred Jewel, where an enamelled figure was set beneath a re-used Roman crystal. Enamel becomes more common at the end of the Anglo-Saxon period when it was used on a series of small round brooches (**colour plate 19**).

Garnet inlay

This technique represents one of the chief glories of Anglo-Saxon craftsmanship. The best of the work, its intricate, interlocking red stones animated by the corrugated gold foil lying beneath them, presents an enduring image (**86 & colour plate 23**). Garnets occur in rocks and alluvial deposits all over Europe, but few of these sources yield gem quality stones. The stones used by the Anglo-Saxons may have come from Bohemia, but sources as far away as Sri Lanka have been suggested. Garnets were used in two ways – *cabochon* and *cloisonné*. In *cabochon*, the stone generally has a rounded, pebble-like shape, and polishing was restricted to smoothing the surface. In *cloisonné* work, the garnets

85 *Early Anglo-Saxon enamel work.*
On the upper end of sixth-century cruciform brooch fragment from Scopwick, Lincolnshire is an incised ring that contains traces of red enamel. The other object is a mount from a seventh-century hanging bowl found at South Ferriby, Lincolnshire. It is decorated in Celtic style and was inlaid with coloured enamel. Photograph by Mike Hemblade, North Lincolnshire Museum

10 mm

were formed into thin plates which were then cut to geometric shapes and placed in cells, often forming lattice-like designs or, occasionally, with the cells separated by plain areas of gold in what is called 'lidded *cloisonné*'. Gold *cloisonné* cells are soldered to the base-plate and to each other. The walls of the cells were about 1.0mm thick, and could be easily bent to shape with a pair of tweezers. The cells then received a layer of a white paste, on which the corrugated gold foil was laid. Analysis has shown the composition of this paste to be varied, consisting of calcite, quartz, clay and wax alone, or in combinations. In some cases, the paste layer was used to ensure that the surfaces of the garnets were smooth and level. When placed in the cells, the garnets often pinched the edges of the foils which helped secure them in place. The tops of the cell walls may have been slightly expanded, further locking the stones, foil and paste into place. When garnet *cloisonné* was used with copper alloy, different techniques were employed. On composite brooches only the major dividing walls were soldered to the base-plate, the subsidiary walls were merely stuck into the paste

86 *Exploded diagram showing the elements that went into the construction of the Kingston brooch.*
A – *the central boss;* **B** – *the cut garnets;* **C** – *the patterned gold foils lining the cells;* **D** – *the cloisonné cells made from gold;* **E** – *beaded wires forming a rim;* **F** – *the base plate;* **G** – *reeded (grooved) gold strip;* **H** – *the back plate.* Drawing by A. McFayden, from Coatsworth and Pinder, 2002, courtesy of Betty Coatsworth, Mike Pinder and Angus McFayden

lining of the cells. The garnets and foils used on a gilt copper alloy buckle from the Cleatham cemetery in Lincolnshire appear to have been placed in a cast tray attached to the backing plate.

Mention has already been made of the corrugated gold foils placed beneath the garnets. These tiny slips of metal are, in themselves, remarkable pieces of work. They are thin, being 0.010-0.025mm thick. The waffle-like corrugations on their surface can be amazingly fine, sometimes being cut at 5.5 lines per millimetre. These foils must have been made using the *Pressblech* technique, but it is difficult to see how a die could be made to this level of fineness. Meeks and Holmes, however, were able to make a reducing engine using only technologies available to the Anglo-Saxons. This device would allow a pattern to be copied at a much reduced scale. A die for making foils was found at Wijnaldum in the Netherlands. This measures 17.4mm by 16.1mm and was coarsely cut and not really comparable to what is seen on the English jewellery.

The cutting of the garnets for use in *cloisonné* work presents us with some difficulties, particularly as they were employed in large numbers, as at Sutton Hoo where 4,333 cut garnets were used. The garnets used were thin, the few examples that have been measured being 0.50mm – 0.73mm on St Cuthbert's cross, and two of the loose garnets found in the Tattershall Thorpe smith's grave were recorded as being 1 and 2mm thick. It is difficult to see how this thinness could be achieved. Unlike diamond, garnet has no natural cleavage and it is impossible to use its crystalline structure to split it into thin layers. If struck, a garnet will simply shatter. Some attempts have been made to suggest natural mechanisms that would produce cleavage, but all seem unsatisfactory. The most likely explanation is that the stones were cut by the laborious use of abrasives, perhaps starting from relatively thin natural crystals/pebbles. Garnet, depending upon its type, has a hardness of between 6 and 7.5 on the *Mohs* scale. Theophilus describes how rock crystal (7 *Mohs*), onyx (6.5 *Mohs*), emerald (7.5-8.0 *Mohs*), jasper (6.5 *Mohs*) and chalcedony (6.5 *Mohs*) could be cut using an iron saw on which was sprinkled sharp sand mixed with water. The iron saw was guided between two pairs of pegs to keep it on line, the grains of sand becoming embedded in the soft iron and cutting the stone. For a hard stone which Theophilus calls *hyacinth* (possibly sapphire, 9 *Mohs*) he recommended the use of emery, a natural mixture of corundum (9 *Mohs*) with magnetite, haematite or spinel. It can be seen that even without the use of emery, Theophilus was cutting hard stones. Once the garnets had been cut, they could be further thinned and finished by grinding and polishing. This could be achieved by mounting the garnets in large groups on the face of a flat stone and working them against a second stone onto which abrasive and water were applied. As work progressed, successively finer abrasives would have been

employed. Traditionally, resin and brick dust have been used to fix stones to a slab for polishing, after which they can be easily removed by warming. Many of the garnets used in jewellery have cut edges suggesting that they were shaped using a revolving wheel made from soft iron or copper with sand as an abrasive medium. It is possible that a copper alloy open work wheel found in the Tattershall Thorpe grave was a lapidary's wheel. Jewellers in Iran mounted their cutting wheel on a special lathe, the spindle of which was turned with a fiddle-bow. Simple shapes such as rectangles could have been cut while the stones were still mounted on the polishing stone, but for more complex shapes, individual stones were probably mounted on a 'dop stick' for cutting. At Sutton Hoo, some garnets were not flat but had been shaped for three-dimensional use, as on the corner of an object.

On some rare occasions, the Anglo-Saxons would reverse the normal practice and would set gold into garnet. Garnets on the heads of a pair of silver square-headed brooches from Lyminge, Kent had tiny 2.5mm-diameter rings drilled into them which were filled with gold. The Holderness Cross has an annular recess drilled into its central garnet which is likely to have held a gold or perhaps an enamel ring. Unlike other stones, garnets can survive high temperature so long as thermal shock, caused by rapid changes in temperature, is avoided. These annular holes would have been made using a copper tube filled with a fine abrasive and water, and rotated using a bow drill.

There has been some discussion as to whether or not the cut garnets were traded as finished stones or slabs of polished stone ready for cutting into the required shapes. It has been found that the thickness of garnets was remarkably constant over large areas of Europe at any one time. This, and the wide distribution of some unusual shapes, suggests that many of the stones were being cut at a central workshop, which may well have been outside England. The six pieces of garnet (two cut to shape, three irregular and one chip) in the Tattershall Thorpe smith's grave may have been recovered from scrap. It is notable that some garnets were cut to fit the object into which they were incorporated even when this was curved or domed. It seems that the jeweller was able to directly control the shape of the stones on at least some occasions.

Many pieces of Anglo-Saxon jewellery contain, as part of their decoration, a boss made up of a matt white material, which has usually suffered somewhat over the centuries. This material is often described in the earlier literature as 'meerschaum', but its true nature has been the subject of some discussion. Susan La Niece analysed the white material from 38 pieces of Anglo-Saxon jewellery and found that three materials were used: shell, magnesite and/or christoballite, bone or ivory.

Lead and lead alloys

Lead was one of the few non-ferrous metals that was locally available to the Anglo-Saxons, being found in the Derbyshire Peak District. It was being used at an early date: Bede records how Eaberht, Bishop of Lindisfarne (AD 688-98) covered the whole of the oak church there with sheet lead and, a little earlier, Eddius' *Life of St Wilfrid* describes repairs to York Minster which included leading the roof. In AD 835, an estate at Wirksworth in the Derbyshire Peak District was required to supply the Archbishop of Canterbury with lead to the value of 300 shillings a year. The Domesday Survey showed that the Peak District continued to be an important source of lead.

Mention has already been made of the possible use of lead to make patterns for use in the making of casting moulds. In the Late Saxon period, lead was used to make jewellery and dress fittings. These consist of disc brooches decorated with simple geometric designs and strap ends, some of which bear devolved Winchester-style acanthus leaf decoration. They were not patterns for making castings, but the strap ends are split to hold the end of the strap and the backs of the brooches bear the fittings for iron pins, traces of which sometimes survive. It is likely that some of these lead objects were cast in moulds cut into antler. Antler moulds were found at the Viking age settlement at Haithabu, Schleswig-Holstein and in England at Southampton. These moulds were initially seen as being used for casting models for use in the lost wax process, but experimental work has shown that antler can stand repeated exposure to small quantities of molten lead without suffering anything more than some discoloration. Lead, in its pure form, melts at 327°C, but, by alloying it with other metals, its melting point can be greatly reduced. This jewellery is sometimes referred to as being made of 'pewter', that is an alloy of lead and tin. Mis-cast objects show that lead and pewter jewellery was being made at Coppergate.

The largest lead objects to have survived from the Anglo-Saxon period are the cylindrical tanks that have been found in Middle Saxon contexts, occasionally containing tools (**colour plates 7A** & **B**). These are usually around 500mm in diameter and 300mm deep and were made in two or more parts, the base and one or more pieces forming the side wall. These were cast flat in open sand moulds and rolled around to form a cylinder. The components were melted together with a hot iron. The quality of the finish is often very poor although some examples are decorated.

The function of these tanks is not understood. Three tool hoards (Flixborough, Stidriggs and Westley Waterless) have been found in lead tanks, but they would make inconvenient toolboxes. Most of them are fitted with two small iron carrying rings and the Flixborough hoard contained two hooked

iron rings that would have allowed the tanks to be carried on a pole. Jane Cowgill thought the tank from Riby Crossroads, Lincolnshire may never have been watertight, but three lead tanks found near Garton on the Yorkshire Wolds had sooting on their bases which had been burned through and repaired in places. They were found in association with tenth-century material.

11

THE PLACE OF THE CRAFTSMAN IN ANGLO-SAXON SOCIETY

In looking at the way in which crafts and manufacture were organised in Anglo-Saxon England, we move away from the relatively secure discussion of the way in which materials were worked into a much more subjective area. What was the status of Anglo-Saxon craft workers? How were they employed and on what sort of terms? Were they permanently settled in workshops or itinerant, travelling from client to client? These are difficult questions to answer, and indeed it is likely that there are no absolute truths as conditions varied with time, place and the individuals involved.

It is unlikely that Anglo-Saxon communities were ever self-sufficient. Even if they had the skills to make all the objects they needed, the difficulties of obtaining raw materials would have to be overcome. Some activities were widespread. Most sites produce evidence for textile manufacture, and smithing slag is commonly found. Smithing would have been based on bought-in iron, but whether it was carried out within the community or by an itinerant craftsman is difficult to determine. Some specialised products such as steeled blades must have been the work of professionals. Some pots were domestic products, but pottery was being widely distributed even in the Early Anglo-Saxon period. By Middle Saxon times, Ipswich ware and Maxey-type wares were being widely distributed. In the Early Anglo-Saxon period the main cultural regions of England had their own fashions in dress fittings. These tended to be generally standardised suggesting unified metalworking traditions. The absence, in England, of large metalworking sites like Helgö in Sweden which produced 10,000 mould fragments, suggests that metalworking was dispersed and was probably being carried out by itinerant workers. These may have been operating through local

lords or at fairs, *wics* or other gatherings. We might wonder what, in the absence of coins, was the basis of this distribution? The word 'barter' should join 'ritual' on the list of forbidden words in archaeology. 'Trade' is only marginally better. We are probably looking at a highly complex pattern of customs and relationships. The only easily negotiable asset produced by Early Anglo-Saxon communities was cloth which might have formed the basis of exchange.

Some crafts needed to be permanently based. Iron extraction must be near to sources of ore and fuel and the vegetable tanning of leather takes many months to complete. These activities are likely to have been based on, and around, estate centres and later towns. With the establishment of Christianity, monasteries would have provided a settled basis for production. The church was a major patron and individual monks and nuns are recorded as excelling in crafts, but it is doubtful if much of this was available to the laity. The re-emergence of towns provided a powerful stimulus to manufacture. Here were large collections of people who were not directly involved in the production of food and supported themselves by their skills. They were aided in this by a strong currency, and excavation has revealed evidence for intensive craft activity in late Saxon towns. One can only look in awe at the manufacturing potential of an Anglo-Saxon town. The comparatively small area of Anglo-Scandinavian York that has been excavated has shown them to have been engaged in working gold, silver, copper alloy, lead, iron, wood, bone, leather, and textile, using these materials to make a wide range of objects. These towns were productive power houses.

Even when we do get relatively large amounts of craft debris, caution is needed when interpreting it. Some sites have yielded large quantities of comb-making debris but, as Arthur MacGregor pointed out, even on the richest continental sites the number of combs, when divided by the period of occupation, suggests a production rate of only a few combs per year, a figure that could not support a full-time craftsman. It is possible that antler working and other craft activities were not full-time occupations and that the craftsmen were also engaged in other pursuits. Coatsworth and Pinder estimated that all of the surviving gold and garnet jewellery dating from the late fifth to the eighth century could be made in the working lifetime of one man. Clearly a number of individuals were concerned and even counting objects that have failed to survive, it is likely that these people spent much of their time working in materials other than gold.

The status of Anglo-Saxon craft workers is difficult to determine: were they honoured members of society, as the Welsh law-codes suggest, or were they slaves? Anglo-Saxon England was a slave-owning society and it is possible that some of the crafts people were 'unfree'. The will of Wynflæd, a prosperous woman in the mid-tenth century, bequeathed two slaves, *ane crencestre and ane*

semestre – 'a woman weaver and a seamstress' to her granddaughter, Eadgifu. An unfree status need not, however, imply degradation; these women were clearly seen as being of value. Textile working, particularly embroidery, was seen as an appropriate activity for a woman of rank: in the eleventh century, the lady Æðelswið rejected the idea of marriage and retired with her *puellulae* (maidens) to spend her time at weaving and embroidery in gold thread. The status of these 'maidens' is unclear; they may have been unfree. St Adomnán complained that the nuns of Coldingham were spending their time 'weaving elaborate garments with which to adorn themselves, as if they were brides, thus imperilling their virginity'. Fortunately their virtue was saved when the monastery burnt down in AD 686. In the earliest English law code, that of King Æthelbert of Kent issued *c*.AD 602/3, the king's smith was protected by a special *wergeld* – a *leodgeld*, which meant that anyone killing him would be subject to a substantial fine of 100 Kentish shillings. The laws of West Saxon king Ine, issued in AD 688-694, allow a *gesithcund* man to take his smith, his reeve and his children's nurse with him when he moves district. This may suggest that these workers were usually tied to an estate and could not move without official sanction. In Ælfric's *Colloquey*, an early eleventh-century book demonstrating Latin conversation, the smith is a figure of fun, while the monk prays and the ploughman feeds us all, the smith is seen only as a source of sparks and noise.

Until the introduction of the treadle loom in the eleventh century, textile work appears to have been an exclusively feminine pursuit; indeed it is likely that the Old English word for woman, *wif* (hence 'wife' and 'woman' *wifman*) comes from the word for weaving. Certainly our word 'spinster' comes directly from the word for spinning thread. Men were referred to as the sex that carried weapons – *wæpman*, and women the sex that did the weaving – *wifman*. This distinction is carried through into the grave: weapons are found with men and textile working tools, particularly spindle whorls, but sometimes weaving swords or pin-beaters, are found with women, as badges of their gender and status.

It is unfortunate that tools, with the exception of those used for weaving, were not included in Anglo-Saxon graves. Exceptions are the Tattershall Thorpe smith's grave which looks more continental than English, the antler plane found in a grave at Sarre, Kent and a few tools found with cremation burials at Spong Hill, Norfolk. Some continental graves contain tools, but they are hardly common. Another source of information is tool hoards of which six are known.

Flixborough, North Lincolnshire (**colour plates 7a & b**)
This is now in the North Lincolnshire Museum, Scunthorpe. It contained five axes (four T-shaped), two adzes, two round-shaves, three spoon bits, a bill/slasher, a two-leaf iron shoe from a tool, two hooked iron rings, an iron bell and its clapper and a small piece of lead. The hoard is likely to date from

the eighth or ninth century and would be used by someone who was engaged in heavy carpentry such as house or ship building. The hoard was found within two cylindrical lead tanks, one inverted inside the other.

Nazeing, Essex
This is in the Epping Forest Museum at Waltham Abbey. The find consisted of four axes, a plough share, four spearheads, a small, fine hammer, knife, chisel, gouge, fish trident, copper alloy cup and a riveted copper alloy ring. The mixed nature of this suggests that it was deposited as scrap metal, probably in the eleventh century.

Hurbuck, Co. Durham
The hoard is in the British Museum. It contained two swords, four scythes, two rings (possibly buckles) a spoon-bit, an iron bar, two adzes, six axes (three T-shaped), a ferrule and a pick. All look like scrap metal. This hoard dated from the late ninth or early tenth century.

Crayke, East Yorkshire
This hoard is now in the Hull and East Riding Museum in Hull. It contained two swords (one broken) plus a sword fragment, two figure-of-eight horse-bit links, three rings, a T-shaped axe (broken), a hook or fastener, a socketed gouge, a chisel and nine chisel blanks, four possible knives, a wall hook, iron hoop fragments, six bars, a horse-shoe fragment, and three scraps of iron. Again this hoard looks like scrap metal and was perhaps deposited in the ninth century.

Stidriggs, Dumfries
The hoard is in the Dumfries Museum. It contained the remains of two T-shaped axes, an adze, two coulters, two iron staples, an iron ring, two possible spoon bits, a socketed gouge, a tanged awl, a hammer head fragment, a draw-knife, round-shave fragments, fish trident and a rectangular iron (steel?) block measuring 158 x 137 x 52mm and weighing 4.5kg. While this may have been an anvil, some slag was present suggesting that it was not fully prepared for use. These objects were found in a lead tank. A radiocarbon date on wood found with the hoard gave a date of AD 775-892 at one standard deviation.

Westley Waterless, Cambridgeshire
This is now in the collection of the Cambridge Museum of Archaeology and Ethnography. The hoard contained a bill or slasher, two spearheads, steelyard weight, holdfasts, a spoon-bit, coulter, staples, hasps, part of a possible draw-knife, and an iron block (*c.*150 x 170 x 50mm). These were found in a cylindrical lead tank.

In addition to these, we have the Tattershall Thorpe finds. These came from a seventh-century grave and are now in the City and County Museum Lincoln. The grave contained the tools of someone who was engaged in fine metal work: a small anvil, three hammers, tongs, snips for cutting metal, nail bar (?), files, punches, an awl, knife, soldering lamp (?), iron bell, metal scrap and six cut garnets. Other finds suggested that the individual in this grave either came from the continent or had continental links. This grave was by itself and not part of a larger cemetery suggesting that there was something unusual about it. It is possible that this man was a stranger and was therefore buried away from the local cemetery.

Few of these hoards contain what might be thought of as a balanced tool-kit: the combination of weapons, woodworking tools and agricultural implements, often broken, suggests that most of them were deposited as scrap. They tell us little about the way in which crafts operated other than that iron was recycled. The exceptions are Flixborough (**colour plate 7a**), which looks like the tool kit of someone engaged in heavy joinery (ship or house building), and Tattershall Thorpe, which seems to contain the tools used by someone doing light metalwork. None of the British hoards compare with the great tool hoard from Mästermyr, Gotland, Sweden, whose owner clearly was equally at home working in wood or metal. The discovery of three of these hoards in cylindrical lead tanks is interesting (Flixborough, Westley Waterless and Stidriggs). David Hinton suggested that the tools found in the lead tanks were being deliberately buried on the death of their owner. While this is difficult to prove, it is clear that the Flixborough tools would not have fitted between the two conjoined lead tanks if their wooden handles were still in place. Both the Flixborough hoard and the Tattershall Thorpe grave contained copper-coated iron bells (**74**) and three were found in the Mästermyr hoard. It is possible that the craftsmen used these bells when plying their trade. King Wihtred's law code of c.AD 695 provided that, 'if a man from a distance or a foreigner goes off the track, and he neither shouts or blows a horn, he is assumed to be a thief, to be killed or redeemed'. In view of this, a stranger would be well advised to use something like a bell to announce his presence or arrival. It would also announce his presence to potential customers.

Not all Anglo-Saxon craftsmen are nameless. Best known is the legendary Weland the Smith who is depicted on the early eighth-century Franks Casket and whose story is best recorded in a thirteenth-century Icelandic manuscript. Weland was a smith of great renown who was captured by a king, Nithhad, and set to work as his goldsmith. To make sure that Weland did not escape, Nithhad placed him on an island and cut his hamstrings, leaving him crippled. Weland managed to entice the king's sons to his island and killed them, turning their skulls into silver mounted cups for Nithhad, their eyes into jewels for the queen,

171

and used their teeth to make brooches for her daughter, whom Weland drugged and raped. He then escaped by making himself wings, but not before telling Nithhad the fate of his sons and letting him know that he is to be a grandfather. It is difficult to know what, if anything, this tells us about the relationship between a craftsman and his patron, it represents an extreme case, but aristocratic patrons can be difficult. The full story shows that a craftsman could be expected to work in a range of different materials, iron, gold and silver. At most sites where evidence has been found for the working of precious metals, they formed only a small part of what was being made.

Other craft workers are remembered for reasons other than their skills. St Dunstan, who was Archbishop of Canterbury in AD 959-88, was celebrated as a calligrapher, goldsmith and worker in other metals who once caught the devil's nose in his tongs. We have one drawing which was probably his work, but nothing else survives and his reputation as a craftsman seems to have appeared after his death. Mannig, an eleventh-century abbot of Evesham, had a high reputation as a painter and goldsmith, and St Edith (obit. AD 984), a nun at Wilton and a natural daughter of King Edgar, was a noted embroideress, musician, calligrapher and painter. The assumption that all manuscripts were written by monks is wrong; some were the work of nuns. A craftsman could advance through his abilities, Spearhafoc 'sparrowhawk' started as a monk at Bury St Edmunds; he became Abbott of Abingdon and, in AD 1050, was appointed Bishop of London. It was at this stage he disappeared, as did the gold and jewels provided to make a new crown for the king (Edward the Confessor) and the bishop's treasury.

Of the thousands of objects that have survived from the Anglo-Saxon period, a small number bear the names of their makers. Coatsworth and Pinder found 14 objects with inscription referring to their maker, but as we have only 51 items with inscriptions of any kind these 14 (29 per cent) might be seen as a good proportion. A seventh-century composite disc brooch from Markshall, Norfolk bears an inscription reading *luda:gibœtæsigilæ* or 'Luda repaired (the) brooch', representing an early example of an advertisement. A ninth-century gold ring from Lancashire, now in the British Museum, bears the inscription +*aedred mec ah eanred mec agrof* or 'Aedred owns me, Eanred engraved me', demonstrating that the name of the ring's maker was sufficiently important to be recorded. A similar formula appears on the late ninth-century Sittingbourne seax, which bears on one face of the blade the words *s[i]gebereht me ah*, translated as 'S[i]gebereht owns me' and on the other side +*biorthelm me worte*, 'Biorthelm made me' (**colour plate 3**). The Pershore, Worcestershire 'censer cover' also has an inscription which reads *godric me wuorht* or 'Godric made me' (**colour plate 25**). Some of the great works of the Anglo-Saxon age involved more than one craftsman. The Lindisfarne Gospels were copied and illustrated by Eadfrith (Bishop of Lindisfarne AD

698-721), bound by his successor, Æthelwold, and the jewelled covers made by Billfrith, the anchorite.

Some craftsmen had their names consigned to a merciful anonymity. Bede records that:

> I knew a brother (and would that I had not) who was placed in a noble monastery, but himself lived an ignoble life. I could give his name if it were any use. The brethren and elders of the place often rebuked him and admonished him to turn towards a more chaste way of life but although he would not listen to them, nevertheless they suffered him patiently because they needed his outward service; for he was a smith of remarkable skill. He gave himself to drunkenness and the other pleasures of a loose life. He preferred to remain in his workshop by day and by night rather than take part in the singing of psalms and praying in the church and listening with the brethren to the word of life. And so it befell that man, as some are accustomed to say, that he who does not wish to enter the gate of the church in humility and of his own accord is bound to be led against his will into the gate of hell as a man condemned.

> Bede Ecclesiastical History V, 14 (Tr. Peter Hunter Blair, 1976)

This man was granted a vision of hell on his death-bed and was buried in the furthest corner of the monastery. Not all monk smiths were destined to go to hell:

> Let me recall with wondrous tales a brother, who could control and shape metals of the iron variety. His hammer under wise guidance crashed on to the iron placed under it in different positions on the anvil, while the forge roared. He had been called Cwicwine by his father in solicitude. In his lifetime God endowed him with the grace due to his merits, and crowned him with great honour, as a man noble in the eyes of his friends.

> Æthelwulf, *De Abbatibus*, 278 and ff (Tr. A. Campbell)

Æthelwulf's comments capture the feeling of wonder in watching skilled hands working their magic on raw materials, turning them, through a rain of hammer blows and sparks, into things of beauty and utility. Things that we can admire and enjoy a thousand years after they were made.

GLOSSARY

Adze
Axe-like tool, the blade of which is at right angles to the handle, used for dressing timber.

Alloy
A mixture of two or more metals, or metal and non-metallic elements. It often has properties that are markedly different from the parent metals.

Alum
Crystalline potassium aluminium sulphate $(K_2SO_4.Al_2(SO_4)_3.24H_2O)$ used as a mordant to fix dyes, although in early times other astringent metal salts were also known as 'alum'. Alum was also used in the 'tawing' of leather.

Annealing
To heat a metal to allow re-crystallisation; softening and removing stresses caused by working.

Barde
A board-like projection on the bow and stern of a boat to improve the vessel's directional stability.

Bill
Pole-mounted blade used for clearing scrub.

Bloom
The spongy mass of wrought iron produced by an early smelting furnace.

Bow lathe
A small lathe in which the work piece is turned by a bow, the string of which encircles it.

Bowl furnace
A shallow furnace used in the smelting of iron in which the blast is angled through the charge.

Brassing
To coat the surface of iron with brass or copper alloy.

Brazing
To join two pieces of metal together using a high melting point alloy which diffuses into them, making a strong joint.

Breast auger
A drill fitted with a freely rotating disc on the top of the cross bar. This was braced against the user's chest so that increased pressure could be applied.

Cabochon
Smooth, pebble-like gem, polished but uncut.

Cames
H-sectioned lengths of lead rod used to secure the glass in a window.

Carat
A measure of the fineness of gold; pure gold is 24 carat.

Carburisation
The exposure of ferritic iron to carbon at high temperate so that carbon is absorbed by the iron to form steel.

Carinated
A sharp change in the profile of a vessel or object.

Carpet page
A highly decorated page in an illuminated manuscript, so-called because it looks like a carpet.

Carvel construction
A method of boat building where the main strength is in the frame, onto which the planks are laid, edge to edge.

Cementite
Iron carbide, (Fe_3C). A very hard, brittle compound – an important component of steel.

Champlevé
Enamel laid into recesses cut into the surface of the metal.

Chasing
A method of decoration which is impressed from above, using blunt chisels.

Claw-tholes
Thorn-shaped projections on the gunwale of a boat, into which the oars are engaged for rowing.

Cire perdue
See lost wax.

Clench bolt
A method of fixing timbers (typically of a ship) together. The bolt has a square or round sectioned shaft and a flattened, mushroom-shaped head. Its shaft is pushed through a hole drilled through the timbers to be fixed, and a washer (rove), put over it. The shaft is then hammered, expanding it and locking the timbers into place.

Clinker construction
A method of ship building in which planks (strakes) overlap each other and are secured with clench bolts. The frames are secondary and inserted into the completed hull.

Cloisonné
A method of decoration in which enamel or garnets are laid into conjoined cells.

Copperas
Ferrous sulphate ($FeSO_4.7H_2O$, also known as green vitriol). Used in the making of oak-gall inks.

Couched
Embroidery in which threads are laid over the surface and then sewn down.

Creaser
Device resembling a pair of tweezers, which is heated and run down the moistened, cut edges of leather, sealing them and impressing a decorative line parallel to the edge.

Croze
Tool used by a cooper to cut grooves around the inside of a barrel which hold the heads.

Cuir bouilli
A type of hardened leather used as armour.

Cullet
Scrap glass awaiting re-melting.

Cupellation
A method of extracting silver from lead by placing it in a cupel and oxidising the lead in an air blast.

Dendrochronology
A method of dating timbers by matching the pattern of growth rings with a known sequence.

Distaff
The rod on which fibres are wound for spinning.

Draw-plate
A metal plate containing a series of successively smaller conical holes through which wire is pulled to reduce its diameter.

Enamelling
The fusing of coloured glass to the surface of metal.

Etching
To selectively erode the surface of a metal using a powerful acid.

Eutectic soldering
Process for joining precious metals by the use of a copper salt which is mixed with an adhesive and possibly a flux. The work piece is stuck together with this mixture and heated. The organic component of the adhesive carbonises and reduces the copper salt to copper, which is absorbed by the gold or silver to form a lower melting point alloy (a eutectic). This is carried into the joint by capillary action, forming a strong, tight bond.

Felloes
The segments making up the rim of a wooden wheel.

Ferritic iron
Almost pure iron with less than 0.05 per cent carbon; it is highly malleable but soft and weak.

Fettling
The process of dressing an object after casting, removing excess metal and cleaning its surface.

Filigree
Decoration consisting of fine strands of gold or silver wire welded to a surface.

Filler or **Temper**
Material added to clay before it is used for potting to improve its workability and properties.

Fire welding
A method of welding pieces of iron together by heating them and hammering them together. Fusion occurs and the two pieces become one.

Flux
1. A material which lowers the melting point of glass, or other materials.
2. A material such as borax or salt used to shield metal surfaces during soldering or fusing.

Francisca
A throwing axe with a curved blade.

Gilding
The decoration of a surface by the application of a thin layer of gold.

Granulation
Small pellets of precious metal attached to a surface as decoration.

Groze
To trim the edges of a pane of glass with a pair of pincers.

Grubenhaus
A building constructed over a pit, which may have formed the floor or have been planked over. Plural: *Grubenhäuser*.

Hanging bowls
Thin copper alloy bowls often with elaborate mounts decorated in late Celtic style, but usually found in Anglo-Saxon graves.

Heckling
To prepare flax fibres for spinning by pulling them through a set of long iron spikes, a heckle.

Heddle rod
A rod on a loom which is tied to alternate warp threads by loops or 'heddles'. When raised, it lifts every other thread forming a second shed through the warp.

Horizontal loom
Loom on which the warp is horizontal. Treadles, operating through pulleys, pull multiple heddles rods, quickly producing the different sheds through which the shuttle is passed.

HV
Hardness on the Vickers pyramid scale.

Ipswich ware
Pottery made in Ipswich and distributed through East Anglia and beyond during the Middle Anglo-Saxon period. It was made on a slow wheel, but was well fired and strong.

Lath walled
Method of making a vessel by using a strip of thin wood bent around to form a cylinder and then sewn.

Linen smoother
A bun-shaped block of glass used to polish linen, perhaps after laundering.

Logboat
Boat formed from a tree-trunk.

Lost wax process
A method of making castings in which a wax model is made of the object and is then covered in clay. This is heated, melting out the wax and firing the clay. Metal is then poured into the space left by the wax. This is also known as *cir perdue* and investment casting.

Mandrel
The driving stock in a lathe.

Martensite
The fine grained product of quenching steel. It is very hard, but also brittle and is usually modified by tempering before use.

Maxey-type ware
A type of pottery found in the East Midlands during the Middle Anglo-Saxon period. It is roughly shaped and contains large amounts of crushed fossil shell.

Meerschaum
The name once used for a white substance which is found on some Anglo-Saxon brooches. Analysis of this material has shown it to have come from a number of sources, but so far no real Meerschaum has been identified.

Metallography
The examination of the micro-structure of a metal by cutting sections which are polished, etched and examined under a reflecting microscope.

Millefiori
A technique in which coloured glass rods are fused together to form flower-like patterns.

Mohs Scale
Scale used to describe the hardness of minerals. The softest is talc, Mohs 1, the hardest diamond, Mohs 10. Each mineral will scratch all those with a lower number.

Mordant
A substance, usually a metallic salt, used to make an otherwise unstable dye fast on textiles. The most common mordant is alum.

Mosaic glass
Glass (usually beads) made up of coloured glass sticks laid radially so that their ends form a pattern.

Motif piece
A bone on which a craftsman has worked out designs by cutting them into the surface.

Niello
A shiny black silver/copper/sulphide laid into grooves on the surface, typically of silver to give a black on white decorative effect.

Parchment
The skin of any animal prepared for use as a writing medium.

Parting
A method of separating an alloyed gold from silver, using brick dust and common salt. At high temperature the silver reacts with the salt to form silver chloride, leaving the gold untouched.

Pattern welding
A method of decorating a blade by twisting strips of iron and then hammering them flat to produce a pattern of diagonal lines. A number of these strips are welded together to give a herring-bone effect.

Pearlite
A tough constituent of steel which consists of laminated layers of cementite and ferrite.

Petrology
The study and analysis of minerals which can provide valuable information on the source of ceramics.

Pewter
A soft, low melting point, alloy of lead and tin.

Phosphoric iron
An iron naturally containing phosphorus which gives it better properties than that of ferritic iron, but prevents it being carburised to make steel.

Piled textiles
Fabrics which have tufts of fibre woven into them to give a 'hairy' fabric effect.

Piled steel
Piling was a method of distributing the carbon more evenly through the iron by folding a bar of carburised iron double and hammer welding. By repeatedly doing this a strong, lamellar structure was produced.

Pin beater
A bone or antler pin used on a loom to push the weft threads into place.

Pole lathe
A treadle-driven lathe on which the cut is made with the work piece revolving in one direction, the cutter is then withdrawn and a springy pole, acting through a cord wound around the work piece, returns it to the start position for the next cut.

Pressblech
A method of making decorative foil *appliqués* by forcing thin sheet metal over a die.

Purlins
The timbers that run along the length of a roof, parallel to the ridge and provide intermediate support to the rafters.

Quenching and tempering
A carbon steel is heated to a high temperature and plunged into water or oil. This results in a very hard, but brittle, *martensitic* structure. This is then heated to a lower temperature to give a softer, but tougher, microstructure.

Quires
A section of eight or ten pages which makes up a book – also gatherings or signatures.

Radial splitting
Timber split on lines from the outside of the log towards its centre, giving planks with a slightly wedge-shaped section.

Rand
A triangular-sectioned strip of leather sewn between the sole and uppers to render it more watertight.

Reed
A device consisting of two rods linked by cords which run between the warp threads on a horizontal loom. By pulling the reed back the weft is compacted.

Repoussé
A technique of decorating thin metal objects by raising the design by hammering from beneath.

Reticella
Glass decorated by fusing twisted, multi-coloured strands of glass onto its surface.

Retting
Placing the stems of flax plants into a water-filled pit to allow bacteriological action to break down their woody structure.

Rippler
A coarse-toothed wooden comb used to remove the seeds and leaves from flax stems before retting.

Rolag
A roll of wool which rested on the spinster's arm during spinning and from which fibres were fed into the revolving thread.

Rove
A diamond-shaped washer placed over the end of a clench bolt before it is hammered, riveting it into place.

Sceattas
A small Anglo-Saxon silver coin. The term was not applied to coins before the seventeen century, the Anglo-Saxons probably called them pennies.

Scutching knife
A heavy paddle-like blade which was used to remove the tough outer covering from the flax fibres.

Shaft furnace
A low tower-like furnace, blown from its base and used in the smelting of iron.

Shed
An opening between the warp threads through which the weft was passed. By using heddles to change the shed it was possible to make complex weaves.

Shed rod
A rod across a warp-weighted loom which separated alternate threads of the warp, providing a shed through which the weft was passed.

Slag pit furnace
An early north European type of iron-smelting furnace which consisted of a shaft built over a pit packed with straw. During operation, the slag burnt its way into the straw and was separated from the iron bloom.

Slice
A broad chisel-like tool mounted on a long shaft and used to cut joints in areas where an axe or an adze could not reach.

Snips
Strong shears used to cut sheet metal.

Soldering
The joining together of parts of a work piece using a low melting point alloy. No fusion occurs.

Spindle whorl
The small, perforated fly-wheel used to keep a drop spindle revolving.

Stadda
A double saw used in recent times to cut the teeth on a bone comb. The device may have been used by the Anglo-Saxons.

Stamford ware
Finely made pottery made in and around the Lincolnshire town. It was wheel-thrown and was sometimes glazed.

Stave construction
A method of building consisting of large conjoined vertical posts.

Steel
An alloy of iron and carbon.

Strakes
1. The planks forming the hull of a boat.
2. Strips of iron nailed to the rim of a wheel to protect it.

Super heat
The temperature above its melting point that a metal must be raised to for casting.

Swage
A grooved tool used in the forging of rod or wire.

Sweating
This involved the use of bacterial action to break down the outer layer of a hide so that it could be scraped away before tanning.

Tabby or **Plain weave**
The simplest form of woven cloth consisting of horizontal, weft threads being passed over and under alternate warp threads.

Tablet weaving
Used to make braids, the method involved the warp threads being passed through holes in the corners of a bone or wooden tablets. By turning these it was possible to change the shed and make complex weaves.

Tangential splitting
Timbers split into planks running parallel to each other across the log.

Tawing
The tanning of leather using alum, common salt, egg-yolk, flour and oil.

Tesserae
The small tiles forming a mosaic. Also the cubes as which glass was traded during the Anglo-Saxon period.

Thetford-type ware
Late Anglo-Saxon wheel-thrown pottery.

Thrymsas
Small, early, Anglo-Saxon gold coins. The word comes from *tremissis* but is of seventeenth-century origin.

Timber
'Wood' from trees large enough to yield beams and planks used in building.

Tinning
Coating the surface of an iron or copper alloy object with low melting point, tin. This was attractive and resistant to corrosion.

Torksey ware
Late Anglo-Saxon wheel-thrown pottery from Lincolnshire.

Touch stone
A piece of fine-grained stone used to assess the fineness of gold. The piece to be assayed was touched on the stone and the colour of the streak that it left was compared to streaks left by alloys of known composition.

Tremisses
A Late Roman gold coin, originally a third of a *solidus*. Most were issued on the continent, English examples are known as 'thrymsas'.

Trenails
A wooden dowel used to pin planks or timbers together.

Trewhiddle style
A style of decoration used in the ninth century. It consisted of animal, plant and geometric motifs set in small geometric panels.

Trichinopoly
A method of weaving a cylindrical cord by lifting threads over pins; also known as 'French knitting'.

Trussel and pile
The upper (pile) and lower (trussel) halves of a pair of dies for striking coins.

Turn-shoe
A method of making a shoe. The sole and the upper are sewn together inside-out. When sewn the shoe is turned inside-out, so that the stitching is protected inside the shoe.

Tuyère
The clay tube through which the air blast enters a furnace or hearth.

Twill weave
A weave in which the weft threads passed over two or more warp threads. As, on each pass, the weft stepped over one warp, it was possible to produce a cloth patterned with diagonal lines or diamonds.

Two-beam loom
The two-beam loom consists of a vertical frame across which are two cylindrical cross-beams, both fitted with handles, so that they can be revolved, one paying out the warp and the other taking up the woven cloth. These looms were also used for tapestry weaving.

Vellum
Originally calf skin, but now any animal skin, prepared as a writing medium.

Vermilion
Mercuric sulphide (HgS), used as a colour on manuscripts.

Wall plate
The beam running around the top of the walls of a building, on which the roof rested.

Warp
1. The lengthways laid threads of a loom through which the weft is passed.
2. To prepare these threads for mounting on a loom.

Warp-weighted loom
A loom on which the warps are kept under tension by attaching them to annular clay weights.

Weaving sword
A blunt iron baton found in the graves of women and considered to have been used to beat the weft threads on a warp-weighted loom into place.

Weft
The transverse threads on a loom.

Wergeld
The fine payable for killing or injuring someone. It was payable by the culprit, his family or lord, to the victim, his family or lord and was graduated according to the victim's rank.

Whetstones
A sharpening stone, also known as a honestone.

Winchester style
A style of decoration used in the tenth century. It is dominated by the use of acanthus leaf decoration, which is often florid. Birds and animals also appear.

Winchester ware
Late Anglo-Saxon pottery, wheel thrown and glazed.

Wood
Round wood, fast grown wood from trees less that 280mm in diameter, often grown in coppice.

Wool combs
These were used in the preparation of wool for spinning, the wool being picked up on one comb and pulled off it with the other, aligning the fibres.

Wrought iron
The main product of Anglo-Saxon smelting. It was mainly ferritic iron with a low carbon content, but contained stringers of slag (fayalite). It was highly malleable, but was soft and weak.

FURTHER READING

Arnold, C. 1997 *The Archaeology of the Anglo-Saxon Kingdoms*, London. (Contains a very good account of Anglo-Saxon crafts and many interesting ideas.)

Arwidsson, G. & Berg G. 1983 *The Mästermyr Find, A Viking Age Toolchest from Gotland*, Stockholme. (A first rate account of this remarkable find: if only we had one like it from England.)

Axboe, M. 1984 'Positive and negative versions in the making of chip-carved ornament' in *Universitets Oldsaksammlings Skrifter, ny rekke* 5, 31-42.

Backhouse, J., Turner D.H. & Webster L. 1984 *The Golden Age of Anglo-Saxon Art, 966-1066*, London. (Exhibition catalogue, authoritative and very useful.)

Batiscombe, C.F. 1956 *The relics of St Cuthbert*, Oxford University Press. (A detailed report and analysis of the finds from this important grave.)

Bayley, J. 1992 *Anglo-Scandinavian Non-Ferrous Metalworking 16-22 Coppergate*, The Archaeology of York, vol. 17.7, York, published by the Council for British Archaeology for the York Archaeological Trust.

Bayley, J. 1993 'Precious metalworking in Anglo-Saxon England' in C. Eluère (ed.) *Outils et Ateliers d'Orfèvres des Temps Anciens*, Saint-Germain-en-Laye.

Bayley, J. 2003 'Bead making in Viking York' in *Current Archaeology*, No. 186, vol. 16, No. 6, 252-3.

Bayley, J., Bryant, R. & Heighway C. 1993 'A tenth-century bell-pit and bell-mould from St Oswald's Priory, Gloucester' in *Medieval Archaeology*, vol. 37, 224-236.

Biddle, M. 1990 'Object and Economy in Medieval Winchester' in *Winchester Studies* 7ii, Oxford, Clarendon Press.

Bimson, M. 1985 'Dark-Age garnet cutting' in *Anglo-Saxon Studies in Archaeology and History*, 4, 125-8.

Blair, P. Hunter 1976 *Northumbria in the Days of Bede*. (A most excellent and readable account.)

Blair C. & Blair J. 1991 'Copper alloys' in Blair and Ramsay (eds) 1991, 81-106.

Blair J. & Ramsay N. (eds) 1991 *English Medieval Industries* London, Hambledon.

Brodribb, A.C.C., Hands, A.R. & Walker D.R. 1972, *Excavations at Shakenoak III*, privately printed. (An important report with some interesting material.)

Brown, P.D. & Schweitzer, F. 1973, 'X ray fluorescent B analysis of Anglo-Saxon jewellery' in *Archaeometry*, 15 (2) 175-92.

Bruce-Mitford, R. 1975 *The Sutton Hoo Ship Burial Vol. 1, Excavations, Background, The Ship, Dating and Inventory*, London, The British Museum.

Bruce-Mitford, R. 1978 *The Sutton Hoo Ship Burial, vol. 2, Arms, Armour and Regalia*, London.

Bruce-Mitford, R. 1983 (ed.) A.C. Evans *The Sutton Hoo Ship Burial, vol. 3, Late Roman and Byzantine Silver, Hanging bowls, Drinking Vessels, Cauldrons and other Containers, Textiles, the Lyre, Pottery Bottle and other items*, London. (The finds from this remarkable grave analysed in great detail by the foremost specialists.)

Buckton, D. 1986 'Late tenth- and eleventh-century *cloisonné* enamel brooches' in *Medieval Archaeology*, vol. 30, 8-18. (Good account of these interesting brooches.)

Budny, M. & Tweddle, D. 1986 'Early medieval textiles at Maaseik, Belgium' in *Antiquaries Journal*, vol. 65, 353-389. (Detailed account of these remarkable textiles.)

Campbell, J. (ed.) 1982 *The Anglo-Saxons*, Oxford, Phaidon. (A series of essays which provide a useful introduction to the period.)

Campbell, E. & Lane, A. 1993 'A Celtic and Germanic interaction in Dalriada: the seventh-century metalworking site and Dunadd' in R.M. Spearman & J. Higgitt (eds) *The Age of Migrating Ideas*, Stroud.

Coatsworth, E. & Pinder, M. 2002 *The Art of the Anglo-Saxon Goldsmith*, Woodbridge, Boydell & Brewer. (The authoritative account of Anglo-Saxon gold work and much more; both the technology and the cultural context are discussed.)

Crossley, D.W. (ed.) 1981 *Medieval Industry*, Council for British Archaeology Research Report No. 40, London, CBA.

Crossley, D.W. 1981 'Medieval iron smelting' in Crossley, D.W. (ed.) 1981

Crowfoot, E. & Chadwick Hawkes, S. 1967 'Early Anglo-Saxon gold braids' in *Medieval Archaeology* 11, 42-86. (Detailed account of these braids and their significance.)

Darrah, R. 1982 'Working unseasoned oak' in S. McGrail (ed.) *Woodworking Techniques before AD 1500*, BAR International Series, 129, 219-29. (Good account of experimental work on splitting timbers.)

de Hamal, C. 1992 *Scribes and Illuminators*, London, The British Museum. (A first rate account of the topic, very readable.)

Dickinson, T. & Härke, H. 1992 'Early Anglo-Saxon Shields', *Archaeologia*, vol. 110.

Drinkall, G. & Foreman, M. 1998, *The Anglo-Saxon Cemetery at Castledyke South Barton on Humber*, Sheffied. (Very useful account of this important Anglian cemetery.)

Dodwell, C.R. 1982 *Anglo-Saxon Art: a New Perspective*, Manchester University Press. (A detailed discussion of the historical background to Anglo-Saxon art.)

Dunning, G.C., Hurst, J.G., Myres, J.N.L. & Tischler 1959 'Anglo-Saxon pottery: a symposium' in *Medieval Archaeology* 3, 1-78. (A useful account of the state of knowledge in 1959.)

Evans, A.C. 1986 *The Sutton Hoo Ship Burial*, London, The British Museum. (A popular but very useful account of the burial and the finds.)

Evison, V.I. 1975. 'Pagan Saxon whetstones' in *Antiquaries Journal*, LV, 70-85.

Evison, V.I. 1987 *Dover: Buckland Anglo-Saxon cemetery*, London. (A detailed account of the finds from this important Kentish cemetery.)

Fairbrother, J.R. 1990 *Faccombe Netherton: Excavations of a Saxon and Medieval Manorial Complex*, British Museum Occ. Pap. 74, London. (Report on a metalworking site.)

Geddes, J. 1991 'Iron' in Blair and Ramsay (eds) 1991, 167-88. (Some discussion of Anglo-Saxon iron.)

Gilmour, B. 1984 'X radiographs of two objects: the weaving batten (24/3) and the sword (40/5)' in C. Hills, K. Penn & R. Rickett, *The Anglo-Saxon Cemetery at Spong Hill, North Elmham, Part III: Catalogue in Inhumations*, East Anglian Archaeological Report 21, Gressenhall.

Goodburn, D. 1993 'Fragments of a tenth-century timber arcade from Vintner's Place on the London Waterfront' in *Medieval Archaeology*, vol. 37, 78-92.

Goodman, W.L. 1964 *The History of Woodworking Tools*, London. (Very good account of the topic.)

Guido, M. 1999 *The Glass Beads of Anglo-Saxon England c.AD 400-700*, (ed.) M. Welch, Woodbridge, Boydell

Hall, R. 1984 *The Excavations at York, Viking Dig*, London. (Good popular account.)

Härke, H. & Salter, C. 1984 'A technical and metallurgical study of three Anglo-Saxon

shield bosses' in *Anglo-Saxon Studies in Archaeology and History* 3, 55-62.

Haslem, J. 1980 'A Middle Saxon iron smelting site at Ramsbury, Wiltshire' in *Medieval Archaeology* 24, 1-68. (A detailed account of this important iron working site.)

Hawthawne, J.G. & Smith, C.S. 1979 *Theophilus, on Divers Arts*, New York, Dover. (An excellent translation and commentary on this important text).

Henderson, J. 1999 'Technological aspects of Anglo-Saxon glass beads' in Guido, 1999, 81-8.

Henderson, J. 2000 *The Science and Archaeology of materials, An investigation of Inorganic Materials*, London, Routledge. (An excellent recent account of inorganic materials.)

Hines, J. 1997 *A New Corpus of Anglo-Saxon Square-headed Brooches*, Woodbridge, Boydell. (In-depth study of the important brooches.)

Hinton, D., Keene, S. & Qualmann, K. 1981 'The Winchester reliquary' in *Medieval Archaeology*, vol. 25, 45-77. (Detailed description of this important object and how it was made.)

Hinton, D.A. 1996 (ed.) *The Gold, Silver and other Non-ferrous Alloy Objects from Hamwic, Southampton Finds 2*, Stroud.

Hinton, D.A. 2000 *A Smith in Lindsey, the Anglo-Saxon Grave at Tattershall Thorpe, Lincolnshire*, in the Society for Medieval Archaeological Journal. (Excellent account of this important find.)

Hodges, H. 1976 'Artifacts' in *An Introduction to Early Materials and Technology*, London, Baker. (Now somewhat dated but still a useful general account of technology.)

Hughes, M.J., Cowell, M.R., Oddy, W.A. & Werner, A.E.A. 1978 'Report on the analysis of the gold of the Sutton Hoo jewellery and some comparative material' in Appendix C in Bruce-Mitford 1978, 618-25.

Hunter, J. & Heyworth, M. 1998, *The Hamwic Glass*, Council for British Archaeology Research Report 116, York.

Hurst, J.G. 1976, 'The pottery' in D.M. Wilson (ed.) 1976, 283-348. (A useful account of the study of Anglo-Saxon pottery as it was in 1976; things have moved on since then, but this remains of interest.)

Jensen, S. 1991 *The Vikings of Ribe*, Ribe, Denmark. (An excellent account of the evidence for crafts found during excavations at important Viking settlements.)

Jones, M.U. 1980 'Metallurgical finds from a multi-period settlement at Mucking, Essex' in W.A. Oddy (ed.) 1980.

Lamm, C. 1980 'Early Medieval metalworking on Helgö in central Sweden' in W.A. Oddy (ed.) 1980.

La Niece, S. 1990 'Silver plating on copper, bronze and brass' in *Antiquaries Journal*, vol. 70:1, 102-14.

Losco-Bradley, S. & Kinsley, G. 2002 *Catholme, An Anglo-Saxon Settlement on the Trent Gravels in Staffordshire*, Department of Archaeology, University of Nottingham. (An excellent report on this important site.)

Loyn, H. 1962 *Anglo-Saxon England and the Norman Conquest*, London. (A useful and enjoyable book.)

McCarthy, M. & Brooks, C. 1988 *Medieval Pottery in Britain AD 900-1600*, Leicester, UP. (A useful account of the manufacture of pottery and the pottery used in the later Anglo-Saxon period.)

MacGregor, A. 1982 Anglo-Scandinavian Finds from Lloyds Bank, Pavement and Other Sites, London, published by the Council for British Archaeology for the York Archaeological Trust.

MacGregor, A. 1985 *Bone, Antler, Ivory and Horn, the Technology of Skeletal Materials Since the Roman Period*, London, Croom Helm. (Still the standard work on this subject, excellent with many useful illustrations.)

MacGregor A. & Currey, J. 1983 'Mechanical properties as conditioning factors in the bone and antler industry of the third to the thirteenth century AD' in the *Journal of Archaeological Science*, 10, 71-7.

MacGregor, A., Mainman, A.J. & Rogers, N.S.H. 1999 *Bone, Antler, Ivory and Horn from Anglo-Scandinavian and Medieval York* in *The Archaeology of York, The Small Finds*, 17/12, York, published by the Council for British Archaeology for the York Archaeological Trust.

Mainman, A.J. & Rogers, N.S.H. 2000 'Finds from Anglo-Scandinavian York' in *The Archaeology of York, The Small Finds*, 17/14. York, published by the Council for British Archaeology for the York Archaeological Trust. (An important collection of material described in detail.)

Meeks, M.D. & Holmes, R. 1985 'The Sutton Hoo garnet jewellery: an examination of some gold backing foils and a study of their possible manufacturing techniques' in *Anglo-Saxon Studies in Archaeology and History*, 4, 143-57.

Millett, M. & James, S. 1983 'Excavations at Cowdery's Down, Basingstoke, Hampshire 1978-81' in the *Archaeological Journal* vol. 140. (The excellent account of the excavation of the Anglo-Saxon buildings at Cowdery's Down.)

Milne, G. & Richards J.D. 1992, Wharram, A Study of Settlement on the Yorkshire Wolds, VII, Two Anglo-Saxon Buildings and Associated Finds, York University Archaeological Publications, 9 (Eighth-century metal casting debris found in a *Grubenhaus*.)

Morris, C.A. 1983 'A Late Saxon hoard of iron and copper alloy artefacts from Nazeing, Essex' in *Medieval Archaeology*, vol. 27, 27-39. (Detailed description and discussion of this important find.)

Morris, C.A. 2000 *Wood and Woodworking in Anglo-Scandinavian and Medieval York, The Archaeology of York, the Small Finds* 17/13, York, published by the Council for British Archaeology for the York Archaeological Trust.

Oddy, W.A. 1980 (ed.) *Aspects of Early Metallurgy*, Brit. Mus. Occ. Pap. 17, London.

Oddy, W.A. 1980 'Gilding and tinning in Anglo-Saxon England' in W.A. Oddy (ed.) *Aspects of Early Metallurgy*, Brit. Mus. Occ. Pap. 17, London.

Oddy, W.A. 1983, 'Bronze alloys in Dark Age Europe' in R.L.S. Bruce-Mitford (ed.) *The Sutton Hoo Ship Burial*, III, London, The British Museum, 945-61.

Ottaway, P. 1992 'Anglo-Scandinavian Ironwork from Coppergate', *The Archaeology of York, The Small Finds*, 17/6, London.

Rackham, O. 1986 *The History of the Countryside*, London, Dent. (An excellent account of the development of the English landscape.)

Rahtz, P.A. & Meeson, R. 1992 *An Anglo-Saxon Watermill at Tamworth*, CBA Research Report 83, London.

Roesdahl, E., Graham-Campbell, J., Connor, P. & Pearson, K. 1981 *The Vikings in England and their Danish Homeland*, London, Anglo-Danish Project.

Rogers, N.S.H. 1993 *Anglian and other Finds from 46-54 Fishergate*, Archaeology of York 17/9, London.

Rogers, P. Walton 1997 *Textile Production from 16-22 Coppergate*, York, Council for British Archaeology for York Archaeological Trust.

Rogers, P. Walton 2001 'The re-appearance of the old Roman loom in medieval England' in P. Walton Rogers, L. Bender Jørgensen & A. Rast-Eicher (eds), *The Roman Textile Industry and its Influence, A Birthday Tribute to John Peter Wild*, Oxford, Oxbow.

Rogerson, A. & Dallas, C. 1984 *Excavations in Thetford, 1948-59 and 1973-80*, East Anglian Archaeology Report 22, Gressenhall.

Salaman, R.A. 1986 *Dictionary of Leather working Tools, c.1700-1950* revised edition.

Salaman, R.A. 1992 *Dictionary of Woodworking Tools*, revised edition. (These two authoritative books describe both the tools and the way in which they were used.)

Saxl, H. 1957 'A note on parchment', in Singer *et al.* 1957.

Sherwood Taylor, F.A. 1957 *A History of Industrial Chemistry,* London, Heinemann.

Sherwood Taylor, F. & Singer, C. 1957 'Pre-scientific chemical industry' in Singer *et. al.* 1957.

Singer, C., Holmyard, E.J., Hall, A.R., Williams, T.I. (eds) 1957 *A History of Technology, Vol. II The Mediterranean Civilizations and the Middle Ages,* Oxford, The Clarendon Press.

Speake, G. 1989 *A Saxon Bed Burial on Swallowcliffe Down,* English Heritage Archaeological Reports 10. (An excellent account of Anglo-Saxon beds.)

Stenton, F. (ed.) 1957 *The Bayeux Tapestry,* London.

Stiff, M. 2003, 'Anglo-Saxon vessel glass' in *Current Archaeology,* No. 186, vol. 16, No. 6, 250-1.

Taylor, J. & Webster, L. 1984 'A late Saxon strap-end from mould from Carlisle' in *Medieval Archaelolgy,* 28, 178-81.

Tweddle, D. 1986 *Finds from Parliament Street and Other Sites in the City Centre,* London, published by the Council for British Archaeology for the York Archaeological Trust.

Tweddle, D. 1992 'The Anglian Helmet from Coppergate', *The Archaeology of York, The Small Finds,* Council for British Archaeology, York. (Detailed account of the find and how it was made.)

Tylecote, R.F. 1967 'The bloomery site at West Runton, Norfolk' *Norfolk Archaeology* 34, 187-214.

Tylecote, R.F. 1976 *A History of Metallurgy,* London, The Metals Society.

Tylecote, R.F. 1987 *The Early History of Metallurgy in Europe,* Harlow, Longman.

Tylecote, R.F. & Gilmour, B.J.J. 1986 *The metallography of Early Ferrous Edged Tools and Edged Weapons,* British Archaeological Reports, British Series, 155 Oxford.

Vince, A. 1991 (ed.) *Aspects of Saxo-Norman London: II Finds and Environmental Evidence,* London, London and Middlesex Archaeological Society.

Waterer, J.W. 1957 'Leather' in Singer *et. al.* 1957.

Webster, L. & Backhouse, J. 1991 *The Making of England Anglo-Saxon Art and Culture, AD 600-900,* London. (The authoritative and excellent catalogue for the 1991 exhibition at the British Museum.)

Welch, M. 1992 *Anglo-Saxon England,* English Heritage/Batsford.

West, S. 1985 *West Stow, the Anglo-Saxon Village,* 2 vols. Ipswich, Suffolk County Planning Department.

Wilson, D.M. 1961 'The Anglo-Saxon bookbinding at Fulda (Codex Bonifatianus I)' *Antiquaries Journal* Vol. 41, 199-217.

Wilson, D.M. 1976 'Craft and industry' in D.M. Wilson (ed.), 253-81. (An attempt to do in one chapter what the present writer tried to do in a book, well referenced and author-itative, this remains an important piece of work.)

Wilson, D.M. 1976 (ed.) *The Archaeology of Anglo-Saxon England,* London, Methuen.

Wilson, D.M. 1984 *Anglo-Saxon Art from the Seventh Century to the Norman Conquest,* London. (An excellent review of the subject.)

Whitfield, N. 1990 'Round wire in the Early Middle Ages' in *Jewellery Studies* 4, 13-28.

In addition to the books and papers listed above, anyone who wishes to look further into Anglo-Saxon crafts, life and society should look at the internet, particularly at sites maintained by re-enactment groups such as *Angelcynn* and *Regia Anglorum.* These are excellent, and contain a wealth of information, but other groups are also doing good work. Any search engine will find them.

INDEX